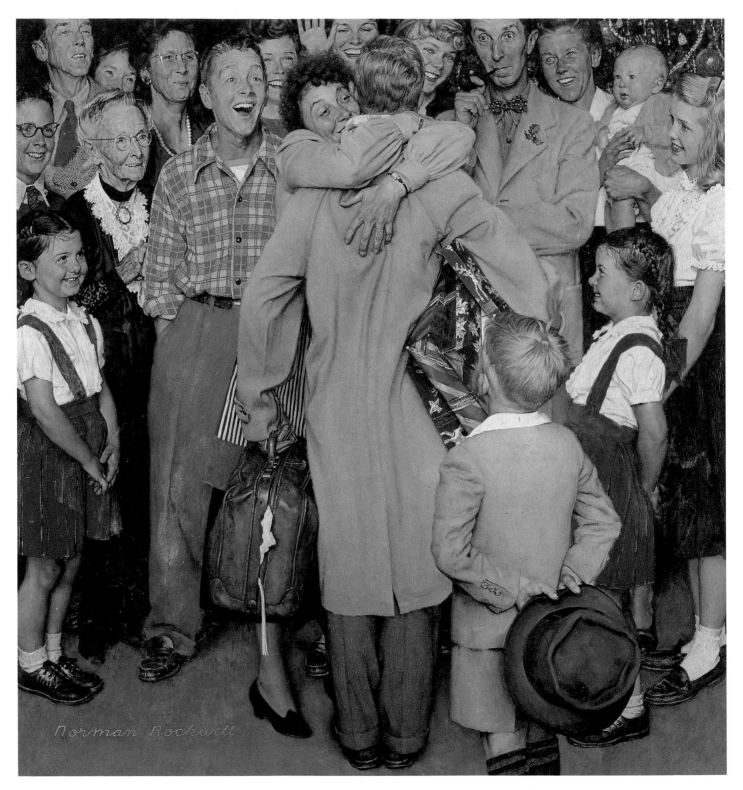

Rockwell

Pictures for the American People

Maureen Hart Hennessey
and
Anne Knutson

High Museum of Art
ATLANTA, GEORGIA

The Norman Rockwell Museum
STOCKBRIDGE, MASSACHUSETTS

Harry N. Abrams, Inc.
NEW YORK, NEW YORK

This catalogue was made possible by The Henry Luce Foundation.

Ford Motor Company

The exhibition and its national tour are made possible by
Ford Motor Company.

This exhibition and its accompanying catalogue are made possible by
The Henry Luce Foundation.

Additional support was provided by The Curtis Publishing Company
and The Norman Rockwell Estate Licensing Company.

Education programs for the national tour are made possible by Fidelity Investments
and through the Fidelity Foundation.

NORMAN ROCKWELL EXHIBITION ITINERARY

November 6, 1999–January 30, 2000
High Museum of Art, Atlanta

February 26–May 21, 2000
Chicago Historical Society

June 17–September 24, 2000
The Corcoran Gallery of Art, Washington, D.C.

October 28–December 31, 2000
San Diego Museum of Art

January 27–May 6, 2001
Phoenix Art Museum

June 9–October 8, 2001
The Norman Rockwell Museum at Stockbridge

November 16, 2001–March 3, 2002
Solomon R. Guggenheim Museum, New York

For the High Museum of Art

Kelly Morris, Manager of Publications
Anna Bloomfield, Associate Editor
Melissa Duffes Wargo, Assistant Editor

Distributed in 1999 by Harry N. Abrams, Incorporated, New York

ABRAMS Harry N. Abrams, Inc.
100 Fifth Avenue
New York, N.Y. 10011
www.abramsbooks.com

Library of Congress Catalog Card Number: 99-73071
ISBN: 0-8109-6392-2

Page 1: Norman Rockwell posing for Pan Am advertisement, 1955
Page 2: *Christmas Homecoming*, 1948
Endsheets: *The Gossips* (study), 1948

Designed by Ed Marquand with the assistance of Vivian Larkins
Produced by Marquand Books, Inc., Seattle
Printed by CS Graphics Pte., Ltd., Singapore

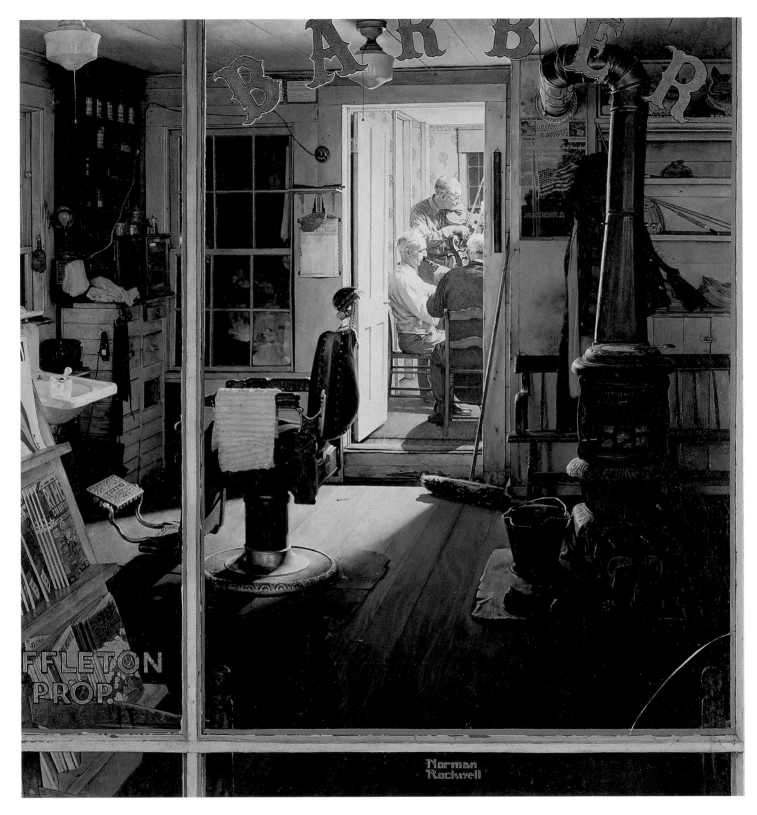

Shuffleton's Barbershop, 1950

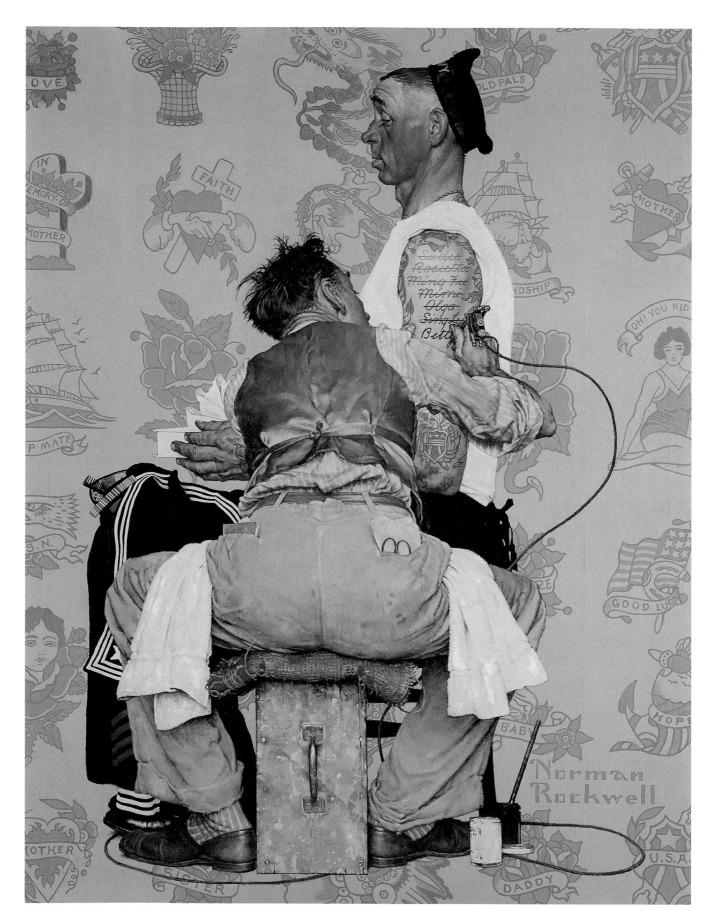

Tattoo Artist, 1944

Contents

Sponsors' Acknowledgments

The Henry Luce Foundation's national program in American art is dedicated exclusively to American fine and decorative arts scholarship. Since its inception in 1982, the program has awarded $60 million to some 165 art organizations in thirty-five states and the District of Columbia, all to support the advancement of American art.

The Henry Luce Foundation is proud to sponsor *Norman Rockwell: Pictures for the American People*, the first major exhibition in thirty years of the work of this American icon. The extensive national tour presents a unique opportunity to share Rockwell's work with audiences all across the country and to assess its significance in American art. The Foundation welcomes this impressive exhibition to its roster of projects enhancing the study of American art history.

The Henry Luce Foundation applauds The Norman Rockwell Museum at Stockbridge and the High Museum of Art for bringing together Rockwell's popular images for a new generation of American art lovers.

Henry Luce III
Chairman and CEO
The Henry Luce Foundation

All of us at Ford Motor Company are proud to sponsor the exhibition *Norman Rockwell: Pictures for the American People* as it travels to seven cities in the United States. My grandfather, Henry Ford, was an admirer of Norman Rockwell's work, and Rockwell created four major paintings that include images of early Ford cars. It is most fitting that Ford Motor Company can now help to bring these original masterpieces to thousands of Americans for the first time.

Rockwell's art captured the optimism and the ambition of America during the tumultuous century just past. His timeless images reflect the aspirations and values of many Americans in a bygone era, and he caught the spirit of Main Street, USA, as no other artist of the twentieth century has.

We salute the High Museum of Art in Atlanta and The Norman Rockwell Museum in Stockbridge for organizing this landmark exhibition. We hope that you will enjoy the exhibition and this catalogue and the opportunity to revisit American history as portrayed through these wonderful pictures. We at Ford feel that we played a part in this history, and we will continue to do so in the coming millennium.

William Clay Ford, Jr.
Chairman
Ford Motor Company

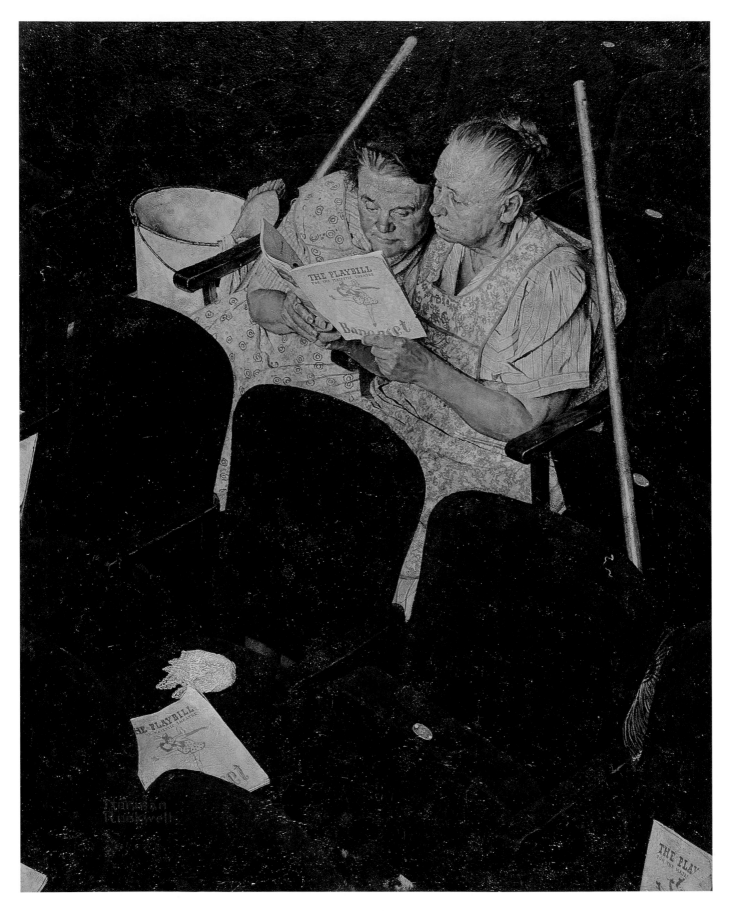

Charwomen in Theater, 1946

Directors' Acknowledgments

Norman Rockwell: Pictures for the American People is the culmination of a dream that began many years ago at The Norman Rockwell Museum at Stockbridge and was brought to fruition through an extraordinary partnership with the High Museum of Art in Atlanta. That dream was to bring Norman Rockwell's art to audiences that, for reasons of geography or economics, could not come to The Norman Rockwell Museum, nestled in the beautiful Berkshire Hills of western Massachusetts. *Norman Rockwell: Pictures for the American People* and its accompanying catalogue are the result of the special collaboration between these two institutions, which have shared responsibility for all aspects of the project. In addition, the generosity and dedication of a number of individuals, both within our institutions and outside, have made it possible to bring these paintings to the nation.

We are indebted to the Rockwell family for their support and encouragement over many years and particularly for their interest and involvement in this exhibition. Norman Rockwell's sons—Jarvis, Tom, and Peter (who is a contributor to the catalogue)—and their families have generously donated their time, expertise, and reproduction rights, as well as financial support, for which we are most grateful. We also wish to acknowledge the Trustees of the Norman Rockwell Art Collection Trust—Jarvis Rockwell, Tom Rockwell, and Arthur Abelman—for their trust and support.

This exhibition and its tour to seven American museums would not be possible without the very generous support of the Ford Motor Company and William Clay Ford, Jr., Chairman, who have taken a leadership role as national exhibition sponsor as well as supporting local costs at each of the venues. We are especially grateful to Mabel H. Cabot, Director of Corporate Programming at Ford, for her visionary involvement in the exhibition.

We are pleased and honored to have received an important grant from The Henry Luce Foundation in support of the exhibition and catalogue. In particular, we would like to thank Henry Luce III, Chairman and CEO; John Cook, President; and Ellen Holtzman, Program Director for the Arts, for their support and guidance.

Joan SerVaas Durham and the SerVaas family of the Curtis Publishing Company have been most gracious in providing in-kind assistance for the reproduction rights of works originally presented in *The Saturday Evening Post*. With their support, we have been able to share images from the exhibition more broadly, through educational materials, a web site, and other promotional efforts.

The High Museum of Art is especially grateful to Mr. and Mrs. William Parker and their family for their early interest in the exhibition and their critical financial support.

Our five venue partners are to be acknowledged for recognizing the importance of this exhibition. The goal of national outreach has been achieved with the exhibition's tour to the Chicago Historical Society, The Corcoran Gallery of Art in Washington, D.C., the San Diego Museum of Art, the Phoenix Art Museum, and the Solomon R. Guggenheim Museum in New York. Douglas Greenberg in Chicago, David C. Levy at the Corcoran, Steven L. Brezzo in San Diego, James K. Ballinger of Phoenix, Thomas Krens at the Guggenheim, and their staffs have been most supportive partners as this project has taken shape.

We owe a special debt of gratitude to the individuals and institutions that lent their Norman Rockwell original artwork, particularly for a tour of this length. We are grateful to Mr. Phillip Grace; Mr. T. Marshall Hahn, Jr.; Illustration House, New York; Mr. Baxter Jones; the Don McNeill Family; Emmet, Toni, and Tessa Stephenson; and the family of Ken and Katharine Stuart, as well as those private collectors who wish to remain anonymous. The public institutions that have generously agreed to participate include:

The Berkshire Museum, Pittsfield, Massachusetts; the Brooklyn Museum of Art; the Burlington Public School District, Vermont; the Farnsworth Art Museum, Rockland, Maine; Los Angeles County Museum of Art; The National Air and Space Museum, Smithsonian Institution, Washington, D.C.; the National Baseball Hall of Fame and Museum, Inc., Cooperstown, New York; National Museum of American Illustration, Newport, Rhode Island; the U.S. Army Center of Military History, Washington, D.C.; and the Wadsworth Atheneum, Hartford, Connecticut. Without the cooperation of lenders such as these, *Norman Rockwell: Pictures for the American People* would not have the richness and depth that it does. We thank them for agreeing to share their paintings with the public.

Collaborations are always the result of many individual contributions. The Co-curators of the exhibition, Maureen Hart Hennessey of The Norman Rockwell Museum, Anne Knutson, Guest Curator for the High Museum of Art, and Judy L. Larson, Executive Director of the Art Museum of Western Virginia, should be highly commended for bringing two very different institutions together in the development of this project. Curatorial staff from both institutions played a critical role in planning and implementation. For the High Museum of Art, Jennifer Ray, Exhibitions Coordinator, masterfully managed the day-to-day details of this exhibition. Linda Merrill, Curator of American Art, brought her prodigious skills as an editor to this project, and Laurie Carter, Curatorial Assistant, helped us tie up many loose ends. Michael E. Shapiro, Deputy Director and Chief Curator at the High, provided important guidance and counsel. In Stockbridge, Linda Szekely, Curator of the Norman

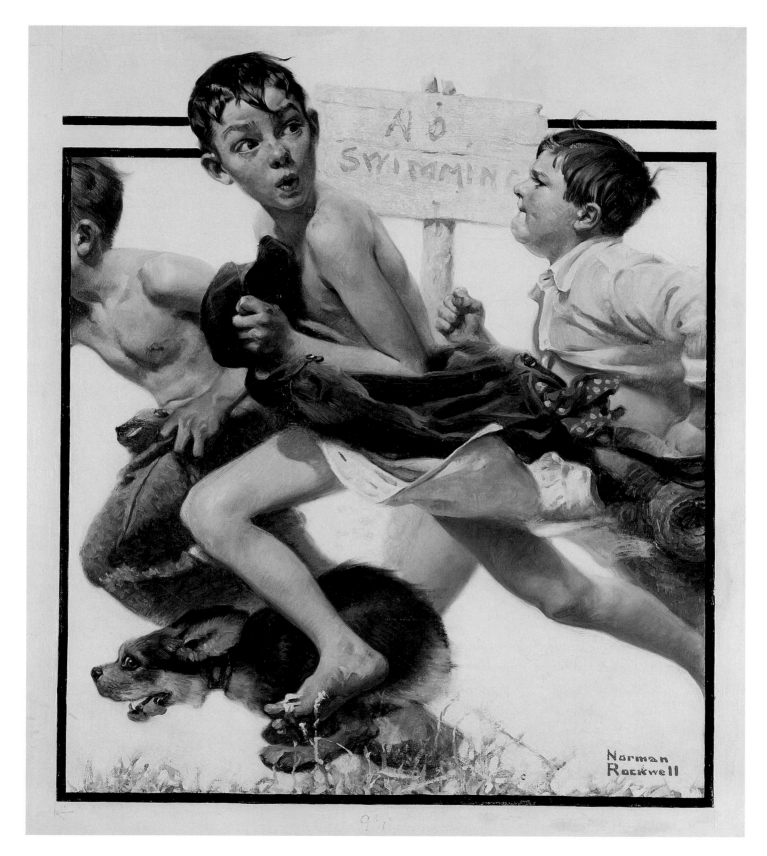

No Swimming, 1921

Rockwell Collections, provided indispensable archival research, thoughtful and insightful review of the essays and other written material, and her in-depth knowledge of the artist and his work. Curatorial Assistants Pamela Mendelsohn and Kelley Pagano managed the Rockwell photographic library, particularly for the catalogue, with thoroughness and good humor.

Kelly Morris, Manager of Publications at the High, along with Associate Editor Anna Bloomfield and Assistant Editor Melissa Wargo, did a first-rate job of editing the texts for the catalogue. Produced by Marquand Books in Seattle, the book was handsomely designed by Ed Marquand and is distributed by Harry N. Abrams.

H. Nichols B. Clark, Eleanor McDonald Storza Chair of Education at the High, and Maud V. Ayson, Associate Director for Education at The Norman Rockwell Museum, coordinated the educational programs with their colleagues Stacey Harnew, Head of School Programs, Joy Patty, Head of Adult Programs, and Shantras Lakes, Head of Family and Community Programs, in Atlanta, and Melinda Georgeson, Curator of Education, Kim Conley, Curator of Youth and Family Programs, and Stephanie Plunkett, Curator of Illustration, in Stockbridge.

Elisa Glazer, Interim Director of Development and Membership, Susan Brown, Manager of Corporate Support, and Roanne Katcher, Manager of Membership at the High, worked closely with Irma Gonzalez, Associate Director for External Relations at The Norman Rockwell Museum, and Heather Wells Heim, Director of Membership and Development. Keira Ellis, former Manager of Foundation and Government Support in Atlanta, was instrumental in helping us secure The Henry Luce Foundation grant. Sally Corbett, Manager of Public Relations in Atlanta, and Bea Snyder, Director of Marketing and Public Affairs in Stockbridge, and their staffs collaborated on the development of a national campaign and associated materials. Rhonda Matheison, Director of Finance and Operations at the High, and Martin Terrien, Associate Director of Administration at The Norman Rockwell Museum, ensured the smooth financial workings of our partnership. Marcia Meija, Retail Operations Manager at the High, and Jo Ann Losinger, Director of Earned Revenue in Stockbridge, oversaw the development of exhibition products.

Additional thanks go to the High's exhibition department, including Marjorie Harvey, Manager of Exhibitions and Design, Angela Jaeger, Graphics Technician, and Jim Waters, Chief Preparator. Finally, we are grateful to the registrars, Jody Cohen of the High and Andrew Wallace of The Norman Rockwell Museum, who ensured the safe transit of these important American works.

Our greatest gratitude goes to the people who have long embraced this artist's compelling and generous vision of America. It is our great pleasure to present this exhibition to the nation.

Ned Rifkin
Nancy and Holcombe T. Green, Jr. Director
High Museum of Art

Laurie Norton Moffatt
Director
The Norman Rockwell Museum at Stockbridge

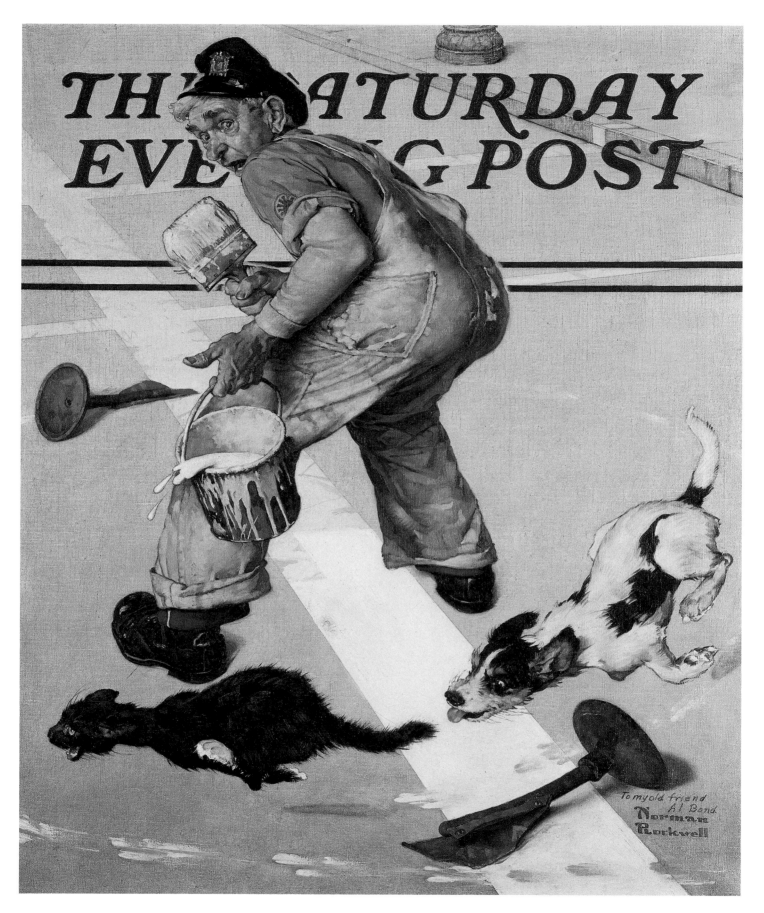

Road Line Painter's Problem, 1937

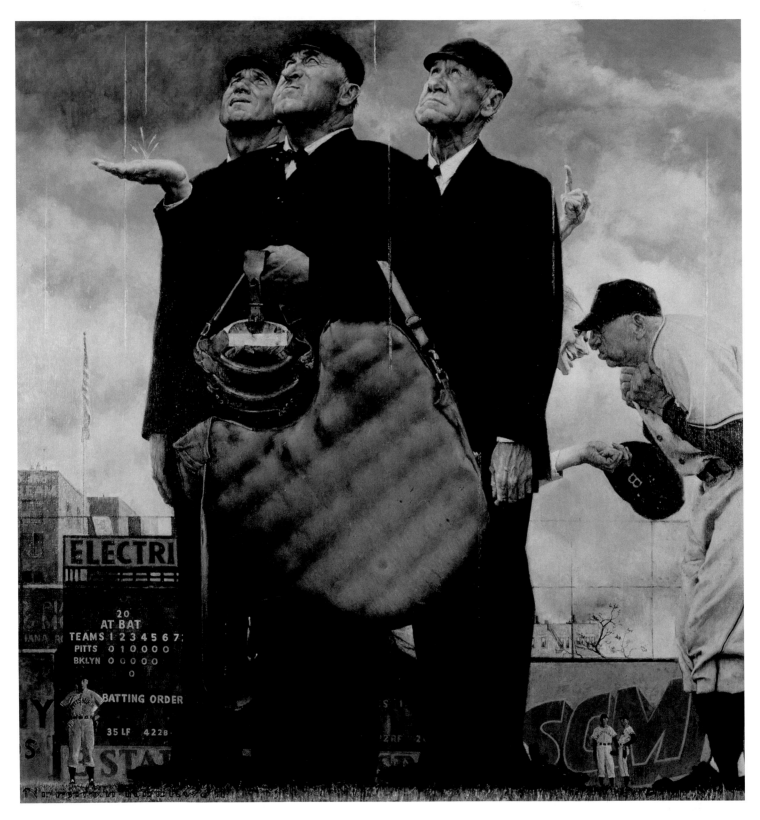

Game Called Because of Rain (Tough Call), 1949

Ned Rifkin

Why Norman Rockwell, Why Now?

Throughout history, visual artists have made images because of the need to tell stories. Many scholars believe that the earliest artists probably scratched out scenes of the hunt on cave walls to represent their goals as they set out to gather food for their family or tribe. Centuries later, artists illustrated and interpreted scenes from the Bible, giving visual form to written language and enabling the illiterate to acquire the essential feeling and overall idea of the stories. Visual art was useful to those in power because it was often the only record of battles and other historical events. Political rulers employed some of the most talented artists at court to make sure that their version of current events became the official history.

With the advent of modern art toward the end of the nineteenth century, artists increasingly determined their own subjects. This meant that they had to take their chances selling their art in a commercial art market controlled by academicians who defined a hierarchy of subjects and promulgated certain acceptable styles. As American art evolved during the early twentieth century, numerous talented painters worked in their studios in hopes of bringing their finished expressions to private galleries, where potential patrons would review, consider, and occasionally purchase their paintings. This marked the convergence of American free enterprise with the aesthetic realm.

Another tradition in visual art—one that great artists had practiced for many years—was concurrent with the rise of both romanticism, with its landscape paintings of the Barbizon school, and realism in the mid-nineteenth century. Sculptor and painter Honoré Daumier was best known for his lithographs of contemporary life in Paris, which were published and distributed widely through the popular press. Another famous French artist, Henri de Toulouse-Lautrec, and numerous other like-minded artists of the *fin de siècle*, made exceptional designs for posters advertising performers in cafés and circuses that had modest, if any, monetary value at that time, yet have proven to be highly influential and ultimately collectible.

In the early decades of this century, a young American illustrator named Norman Rockwell commenced what would be a long and

Gary Cooper as the Texan, 1930

important career as an image-maker. His own personal style was distinguished by great attention to detail and a love of the anecdotal vignette, and his work was quickly seen by viewers not in art galleries, but in their homes. Rockwell's art, like Daumier's and Toulouse-Lautrec's, was intended to be reproduced in large quantities and delivered to people on a weekly basis. His 322 cover images for *The Saturday Evening Post* alone would establish him as a primary visual influence on several generations of Americans. Rockwell existed outside of the commercial system of galleries and art museums but was indeed an artist who made his living through selling his images.

Yet at the end of what many are calling "The American Century," we have found this major talent relegated to a low rank among visual artists, while others mentioned above are lionized for their great work on posters or cartoons. Is this because of the inherent favor of European historic art over American? I think not simply.

The artists who primarily work for the world of galleries and museums are clearly taken more seriously than "mere illustrators." Is it because of the mechanical replication of their work, or that the original was considered to be less important than the printed page? Or possibly because the intended audience was not the royalty and aristocratic patrons of the past or even the most elite of the bourgeoisie, but everyman, those "commoners" who may not appreciate the nuances of "fine art." Indeed, we have seen this same phenomenon in English literature of the nineteenth century. Charles Dickens wrote his great stories in installments for popular publications, yet they are now widely considered masterful. Perhaps this explains some of the pervasive and condescending dismissal of Rockwell's achievements on the part of the large majority of art historians and critics.

It is apparent that much of the disdain for Rockwell's art springs from his consistent sentimentality about American values and the belief of his critics in the modernist canon of refinement and advancement of abstraction, the progressive invention of style, and the idea that concept should supersede subject matter and even content. Rockwell, his style, and even his name have come to embody the very antithesis of what is modern about America in this century. The small town is more prevalent than the city in his work. The figure rendered in exquisite detail dominates his work. There are no surfaces of paint in Norman Rockwell images because they were not regarded as paintings.

With the advance of time and the clarifying perspectives that distance affords to thinkers, teachers, and writers on visual art and culture, it is now time for a reconsideration of Norman Rockwell as one of the earliest American artists—and certainly the one whose work had the greatest impact—to understand how to communicate effectively through visual imagery in what is now generally called the mass media.

There is a poignant parallel to be made between Rockwell and another gifted creator of visual mass communications. Movie directors of the thirties, forties, and fifties often explored themes such as the dignity of the common man. Perhaps no one was more influential or eloquent in this particular genre than the great American film *auteur* Frank Capra. Capra and Rockwell examined life in America during the same dire period, and through their work, they advanced the values they believed flourished among the middle or working class at the time when our economy was recovering from the shock of the Great Depression. In films such as *Meet John Doe, It Happened One Night, Mr. Deeds Goes to Town,* and *Mr. Smith Goes to Washington,* Capra deftly defined how Americans saw themselves and their way of life in a young republic challenged by economic decline. He celebrated democracy and the individual, with all of his virtues and foibles.

In the United States, Capra's classic film of 1946, *It's a Wonderful Life,* is to the observation and celebration of Christmas what Rockwell's *Freedom from Want* (page 98) is to the symbolic ritual of Thanksgiving dinner. Like Capra, Rockwell was committed to a focus on the individual, the characteristic American traits of warmth, humility, and humor, and the deep-seated sentiments that are somehow tested in extreme situations. The power of these two disparate popular art forms to reach large numbers of people (for relatively modest cost) and to masterfully evoke the pathos of what it means to be an American is akin to the power of great religious art to evoke the spiritual dimension of Christianity.

In the postwar decades of this century, artists who did not produce heroic, large-scale, and abstract paintings could not hope to find their way into the annals of art history. Moreover, any artist committed to making fastidiously detailed paintings was decried as old-fashioned and out of step with the times. The distinctions between high and low culture have become the subject of much study and debate over the past several years. Andy Warhol, one of the most influential artists of his generation, identified Rockwell as one of his favorite artists. Warhol's remote and enigmatic attitudes and position statements (such as saying he wished he were a machine) are the antithesis of what Rockwell's imagery conveys. Both men were accomplished illustrators (Warhol began his career in New York doing fashion illustration)—Rockwell made icons depicting Americans interacting with their environment and one another, while Warhol identified icons such as soup cans and celebrities and replicated them to become one of the most famous, successful, and enterprising artists in history. In many ways, Warhol represents the opposite of the Rockwellian earnestness that graced magazine covers and advertisements. Despite their numerous differences, both artists arguably symbolize, through their deliberately commercial and visual achievements, vastly different but truthful dimensions of being American in this century.

In the end, art that does not engage an audience cannot communicate and, thus, cannot be expressive. The most rigorous intellect and intense emotions must still use a visual language that speaks to people if they are to be successfully understood or felt. Norman Rockwell clearly mastered the complexity of the human experience in the United States—his contemporary America—by making it seem and look simple. However, looking carefully at Rockwell discloses that his art is not a simple one—it only appears to be so. Realistic renderings that "fool the eye" demonstrate technical proficiency but do not necessarily convey soulfulness. Rockwell understood, perhaps intuitively, that illusions were comforting to many, but ultimately superficial. Somehow, in his years of generating compelling scenes of American reality, Norman Rockwell forged a cumulative portrait of real people, making meaning out of the incidental. The universal humanity that his work communicates is something that we must ultimately cherish and marvel at rather than diminish or condemn. For it is our own humanness that we risk when we deny its essential vitality and the freedom that this affords us.

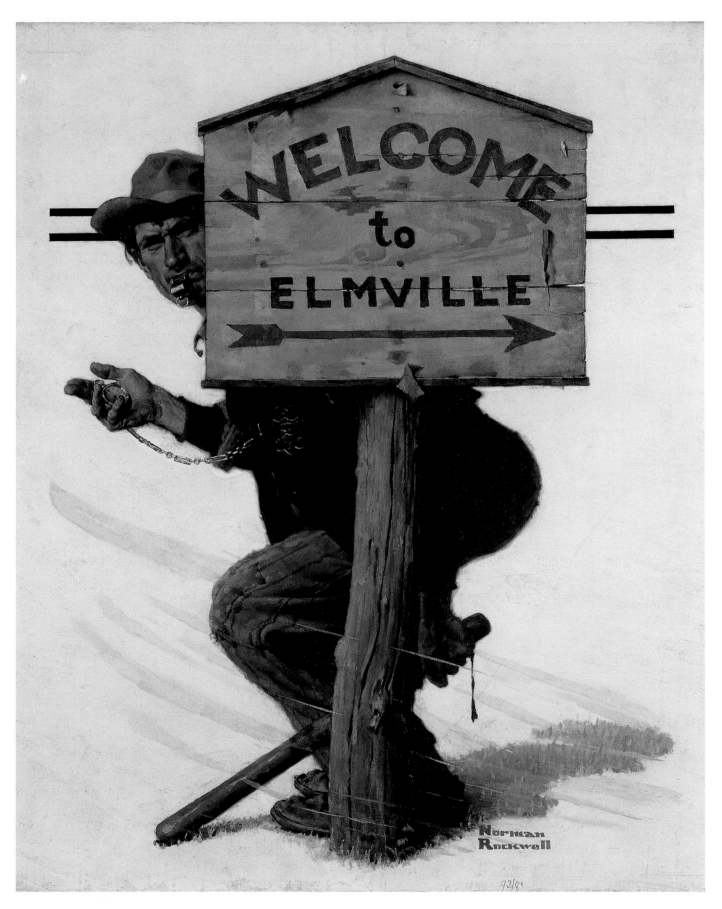

Welcome to Elmville, 1929

Good Friends, 1927

The People's Painter

Art should never try to be popular. The public should try to make itself artistic.

—Oscar Wilde

Norman Rockwell was proud of his chosen profession as an illustrator. He was a skilled storyteller whose painterly images were made for the rapidly changing era of mass media. The people adored his work, and Rockwell cared about his public. He received fan mail by the bagful. He was the people's artist. At a time when most people stared in bemusement at Jackson Pollock's dribbled paint and Picasso's fractured shapes, Rockwell was an artist they understood because he so clearly understood them.

Among artists and critics, however, Rockwell has mostly been an object of derision. The twentieth-century artistic community has never been able to abide his sentimental images and reassuring messages of American nobility. Irrefutably successful by any measure of popularity, longevity, commercial success, and mass appeal, Rockwell was a flop in the eyes of the art world. "His success was his failure," wrote Arthur Danto in a 1986 review of Rockwell's catalogue raisonné, describing his imagery as a "shovelful of stardust."[1] Rockwell's strengths as an artist were out of fashion in the context of the twentieth-century art scene. He was an anachronism for most of his career, and he knew it. Approached by young art students during a visit to the Art Institute of Chicago in 1949, he was asked by one, "You're Norman Rockwell, right?" Touched with pride at being recognized, he was stung by the comment, "My art professor says you stink!"[2]

Rockwell was occasionally troubled that he was an anomaly among the leading artists of his day. Educated in the classical traditions of Western painting, he went to Europe to study the moderns and was an admirer of Picasso and Pollock. Like many great talents, he periodically experienced bouts of self-doubt and depression, often associated with such major life changes as the end of his marriages or his departure from *The Saturday Evening Post*, his employer of forty-seven years. Rockwell sought renewed inspiration through travel, sketch classes,

remarriage, and relocation to new communities. For seven decades, he was driven to paint. Propelled to the studio seven days a week—even on birthdays, Christmases, and holidays—he simply could not *not* paint. He produced an oeuvre of nearly four thousand images, including eight hundred magazine covers and ad campaigns for more than 150 companies.

His neighbors were his models, ordinary moments his themes. "The commonplaces of America are to me the richest subjects in art," Rockwell wrote in 1936. "Boys batting flies on vacant lots; little girls playing jacks on the front steps; old men plodding home at twilight, umbrellas in hand—all of these things arouse feeling in me. Commonplaces never become tiresome. It is we who become tired when we cease to be curious and appreciative."[3]

Norman Rockwell: Pictures for the American People invites reflection on Rockwell as a force in twentieth-century American art and culture. The first major exhibition since his death in 1978, it explores the themes and iconography that shaped his contribution to the visual literature and vocabulary that defined American self-image throughout much of the century. Perhaps it will inspire reconsideration of his life's paradox—that the ingredients of his popularity doomed him to dismissal by the art establishment. *Pictures for the American People* provides the opportunity to explore the essence of what made Rockwell so popular. A working illustrator, paid to paint pictures, Rockwell's place in twentieth-century American history looms large, and it is appropriate that his work be celebrated and studied as part of the lexicon of American art and culture.

Aunt Ella Takes a Trip, 1942

Rockwell was born in 1894 in New York at the height of Impressionism, came of age during Cubism, painted and persevered through Futurism, Dada, Surrealism, and Abstract Expressionism, and ended his career at *The Saturday Evening Post* during Pop Art and Minimalism in the sixties. He launched his career when illustrators were at the height of fashion, considered celebrities on a par with today's sports heroes or movie stars. By the time his career reached its pinnacle, the art world had drawn a firm line between high and low art, between commercial illustration and fine art. A continental chasm existed between realism and abstraction. Rockwell had become hopelessly old-fashioned.

Tom Wolfe wrote—in a review of Susan Meyer's *America's Great Illustrators*—that as late as 1900, "art-ists moved back and forth from easel painting to commercial illustration without any real sense of crossing a boundary. Many of the most important innovations of the period of Art Nouveau, such as Beardsley's and Toulouse-Lautrec's, originated in commercial illustration."[4] Wolfe went on to note that "magazine illustration idealized and reshaped popular taste in a way that film would after 1920."[5] Illustrators such as Howard Chandler Christy, J. C. Leyendecker, and Rockwell created characters such as the Gibson Girl and the Arrow Collar Man that choreographed our fashions and mores in much the way that Hollywood, the media, and Madison Avenue shape our image and lifestyles today.

Rockwell held his first job as an illustrator and art editor at age eighteen, painted his first *Post* cover at twenty-two, and was a nationally known figure by the

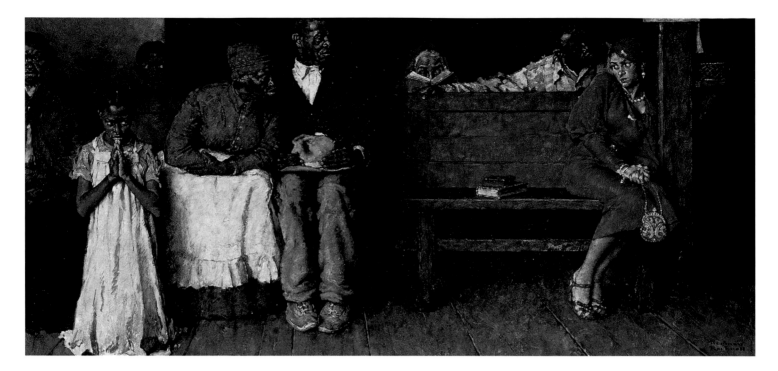

Love Ouanga, 1936

age of thirty. He touched a public who revered him through four generations, and he chronicled two world wars and the advent of telephone, radio, automobiles, television, airplanes, and rocketships. Rockwell's images were ubiquitous. Rufus Jarman reported in his 1945 profile of Rockwell in *The New Yorker* that statisticians estimated that Rockwell's Boy Scout calendars received one billion six hundred million viewings on any given day.[6] Both Steven Spielberg and Ross Perot have said that their affection for Rockwell's scouting paintings inspired them to pursue their life's work.

Rockwell's career spanned one of the most eventful periods in American history. His images convey our human shortcomings as well as our national ideals of freedom, democracy, equality, tolerance, and common decency in ways that anybody could understand. He has become an American institution. His name evokes an image of an idyllic America and is used to convey both sentiment and cynicism. Steven Spielberg recently said, "Aside from being an astonishingly good storyteller, Rockwell spoke volumes about a certain kind of American morality."[7] It is a morality based on popular values and patriotism, a morality that yearns above all for goodness to trump evil. "I can't paint evil sorts of subjects," said Rockwell.[8]

Whether it is the proud strength of *Rosie the Riveter* (page 30), the democratic principles in *The Four Freedoms* (pages 97–99, 101), the injustice of bigotry in *The Problem We All Live With* (pages 106–107), or the hopes and struggles of growing up in *Girl at Mirror* (page 153), Rockwell's paintings powerfully portray the universal truths, aspirations, and foibles of humanity. His work is part of the fabric of America, and at its best it reflects our most fundamental beliefs about who we are as a people.

Why, then, is Rockwell so controversial despite his success? One of the most enjoyable aspects of being director of The Norman Rockwell Museum is observing the continued public interest and running commentary on this paradox.

"I have always wanted everybody to like my work. I could never be satisfied with just the approval of the critics (and boy, I've certainly had to be satisfied without it) or a small group of kindred souls. So I have painted pictures that didn't disturb anybody, that I knew everyone would understand and like," wrote Rockwell in his autobiography.[9]

Being ignored is perhaps worse than receiving critical disapproval. Few twentieth-century survey exhibitions include Rockwell. Only a handful of major

museums throughout the country collect and exhibit him. A few major collectors are just starting to add him to their holdings. Art history curricula in colleges and universities routinely leave him out, and the few that include him often do so with disdain.

But as the century Rockwell chronicled draws to an end, the cultural world is taking a new look at his art. Paul Richard of *The Washington Post* referred to him as an "American Master—seriously," noting that he was "'stiffed' by the art world, who shuns him still."[10] John Updike wrote, "Widely loved like no other painter in America, yet despised in high-art circles, he pushed on, into canvases that almost transcend their folksy, crowd-pleasing subjects."[11]

Paul Johnson, British author of *A History of the American People*, wrote in *Spectator* that "twenty years after his death, his work is beginning to strike permanent roots." Johnson predicted, "Rockwell will be ranked among the Old Masters as he is already firmly wedged in humble hearts and minds." He continued, "Critics dismissed Rockwell for the usual trade union reasons. They have nothing to say about pictures which explain themselves. Rockwell gave them no intermediary function."[12]

Robert Hughes, in *American Visions: The Epic History of Art in America*, referred to Rockwell's "depthless narrative clarity."[13] Hughes memorialized Rockwell in his *Time* magazine obituary: "He never made an impression on the history of art and never will. But on the history of illustration and mass communication his mark was deep and will remain indelible."[14] Robert Rosenblum reveals with delight, "I, for one, am happy now to love Rockwell for his own sake."[15]

Norman Rockwell: Pictures for the American People features more than seventy of the artist's oil paintings and all 322 of his *Saturday Evening Post* covers.[16] A major initiative of The Norman Rockwell Museum, the show will introduce new and diverse audiences across the nation to Rockwell's legacy. Nine noted historians, art historians, and pop culturists have been invited to comment on Rockwell for this volume. Their essays reveal Rockwell as a keen observer of human nature, classically trained and knowledgeable in the traditions of Western art—in short, far more sophisticated than he is generally acknowledged to be. It is clear that Rockwell's impact on American culture far transcends any one movement, era, or message.

Painter of pictures for the American people. The people's artist. The audience always came first for Rockwell, and the audience still comes to see his work. Annually, two hundred thousand visitors journey to Stockbridge, a small town in the Berkshire Hills of western Massachusetts, to see the paintings and studio at The Norman Rockwell Museum, one of only a handful of museums in this country devoted to a single artist. The museum is dedicated to presenting the world's largest Rockwell collections in the context of the field of illustration; the museum celebrates illustration as an important contemporary art form.

Keenly aware of his audience, Rockwell let nothing come between them and the story he was telling. This was one of his credos: that a painting and an observer have a one-on-one relationship without the need of intermediaries. This belief is in direct conflict with much twentieth-century art. As modern art became more abstract, a world of intermediaries developed. This led to the idea that art was not important or serious if it was easily understood.

Mass culture today has blurred the line between high culture and low and has shaped contemporary visual expression. Without Rockwell's eyes, we might otherwise have lost a piece of our history. Rockwell's narrative imagery is a gift to the nation.

Rockwell's place in the critical canon of American art history continues to be debated. Rockwell himself commented through his painting *The Connoisseur* (page 86) on the dichotomy of his popular success and critical disdain. With his usual self-deprecating style and humor, he seems to say, "In the upside-down world of twentieth-century art, where do I fit in?"

In the end, it was people who mattered. The personal transformation and communication that occurs when one looks at a work of art is the artist's defining moment. Rockwell was a master at delivering that moment to his public. Norman Rockwell reminds us of our humor and humility, our happiness and humanity. These are not bad qualities to embrace.

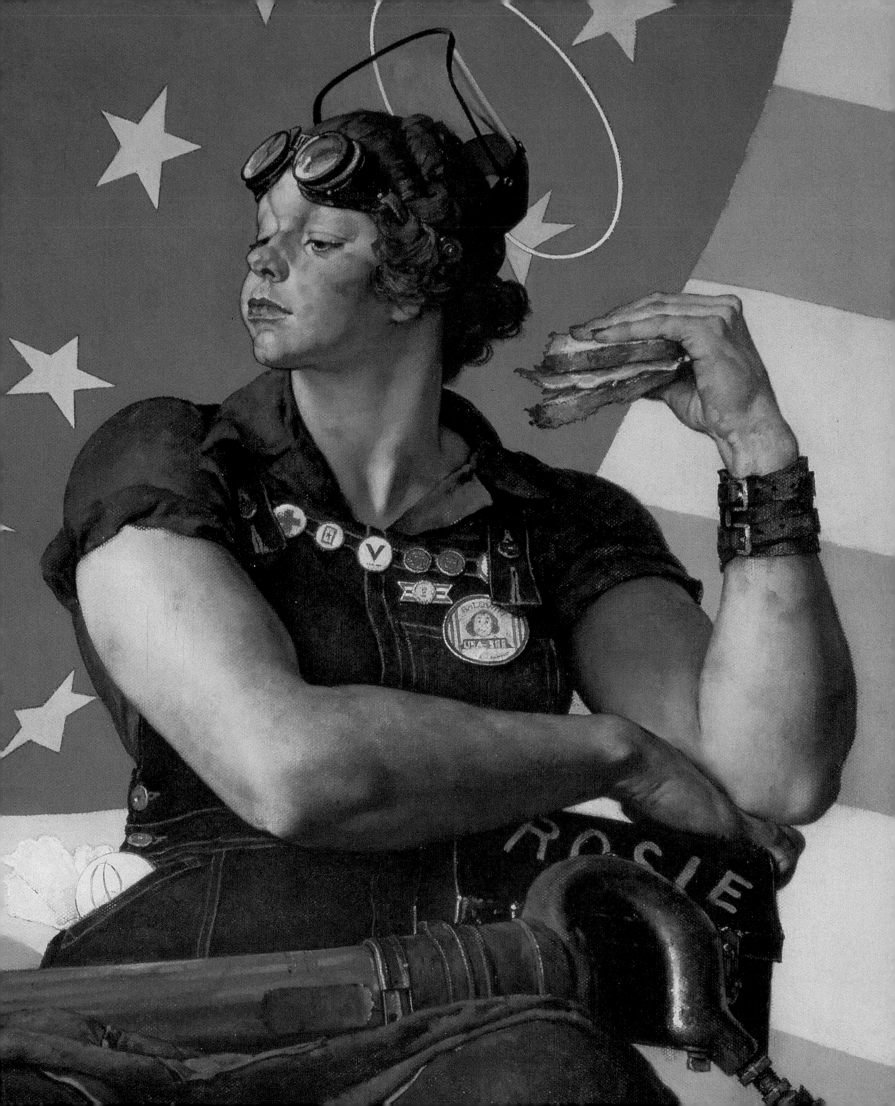

Thomas Hoving

The Great Art Communicator

Art history can be guilty of typecasting. Once an artist has been categorized, then that impression, no matter how superficial and misleading, is set in concrete, and art historians all too frequently stop looking. Of all the American artists of the twentieth century, few have been more miscast than Norman Rockwell. In most standard textbooks on American art, he's not even included. He is characterized almost universally as an illustrator, and as such he is largely ignored or reviled or, worse, snickered at. It is high time to look at Rockwell again and to place him in his authentic position in art. For he can be said to have taught many of us that distinguished art could be—and should be—an everyday experience.

Rockwell was more a commercial artist than an illustrator. His *Saturday Evening Post* covers and posters did not depict episodes from stories, but were penetratingly real images that, to him, summed up our country's history and spirit. These images stand firmly on their own as realistic works of art. We can understand them in a flash.

Rockwell's images are more universal than most people give them credit for. We can date them, but they are not dated. The paintings characterize people living and working at times that can be determined from their clothing and other details, but these characters never look like captives in some bygone and faded moment. The startling aspect of Rockwell's best works is that no matter what year he created them, they still possess a compelling fascination.

Art history for snobbish reasons has always been suspicious of artists considered to be popularizers—especially successful artists. Few in American history have been more popular—even loved—than Norman Rockwell. In his heyday, lines of people at newsstands would await the next issue of *The Saturday Evening Post*. His covers were constantly chattered about. Rockwell's paintings were as appealing to the majority of Americans as the cartoons in the old *New Yorker* magazine were to sophisticates. His fans hungered to see what he had to say next.

Part of Rockwell's importance in art is that he was one of the most successful visual mass communicators of the century. His work bridged the gap between high and low art. He savored the flavor of his

Rosie the Riveter (detail), 1943

29

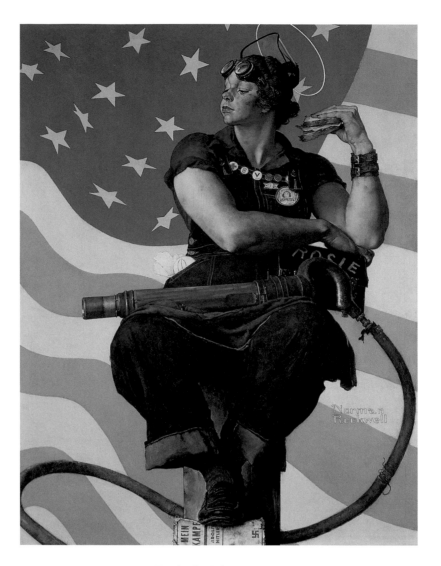

Rosie the Riveter, 1943

times and presented it in diverse and dynamic ways— funny, poignant, reflective, haunting, and never hokey or saccharine. He turned untold legions of Americans into art appreciators, many of whom went on to explore the whole world of art. He enhanced the inherent power of popular visual expression in TV and films.

One reason for Rockwell's success may be that he was strongly linked to the art form that was sweeping the world in the war years and just afterward. Like a movie director, he blocked out the moves of his "actors" according to a script and then "shot" them for posterity. Of course Rockwell's American Movies were highly selective. He once told a family in Burlington, Vermont, "This is where I can find America the way I want it." There are few scenes of degradation or poverty in Rockwell's epics, but what he offered was genu-

ine as well as unforgettable, and was usually presented with a sly sense of humor.

Unlike other illustrators from the 1930s through the sixties, Rockwell didn't sugarcoat. Nor were his creations mired in nostalgia or the mud of the advertising pitch. Although denounced in his lifetime by critics for a subject matter that was invented and all-too-perfect, one can now see that what he chronicled did exist.

His works were—and to a degree still are—so gripping that some have become visual codes for familiar American events. Come Thanksgiving, there's the famous Rockwell image *Freedom from Want* (page 98). With references to American life at home during World War II, there's often a Rockwell image— whether Rosie the Riveter (above) or a patriotic G. I.

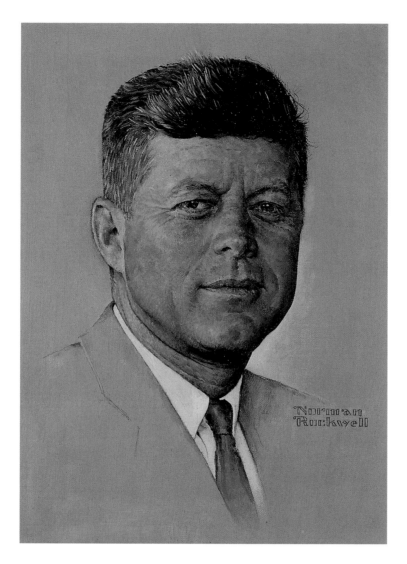

Portrait of John F. Kennedy, 1960

Joe—to depict the flavor of the times. Rockwell's name alone has the power to express some commonly held values. Rockwell's lasting power was even evoked to clean up O. J. Simpson's image during his criminal trial, when Simpson's defense team hung prominently in his house, for the jury to see, a print of *The Problem We All Live With* (pages 106–107), the memorable scene of the little girl being escorted to school by U.S. marshals.

In the field of portraiture, Rockwell excelled most American artists. The people in his works are, contrary to the stereotyped viewpoint, seldom idealized. His portraits are spare, subdued in color, and gritty as only the naked truth is. One is astonished when one sees photographs of his subjects at how beautifully Rockwell captured not only their likenesses but also their essential auras. Gnarled hands ache with decades of work, and facial lines tell of pain and character. Youth is never prettified, and below the surface of even his most charming children lie the anxieties and fears of the future. Women are not transformed into sirens. Men never display spurious machismo. Some of his portraits are exceptionally fine. His John F. Kennedy is among the best painted of that president, preserving his charisma, his dazzling youth, his romantic essence, and a hint of his jadedness (above).

In American art, there has rarely been a creator of such influence as Norman Rockwell. These days, now that the obsession for abstraction has cooled, his achievements are being discovered by scholars. Rockwell is more and more identified—correctly—as a cultural phenomenon, one who made a sea change in the perception of art in this nation.

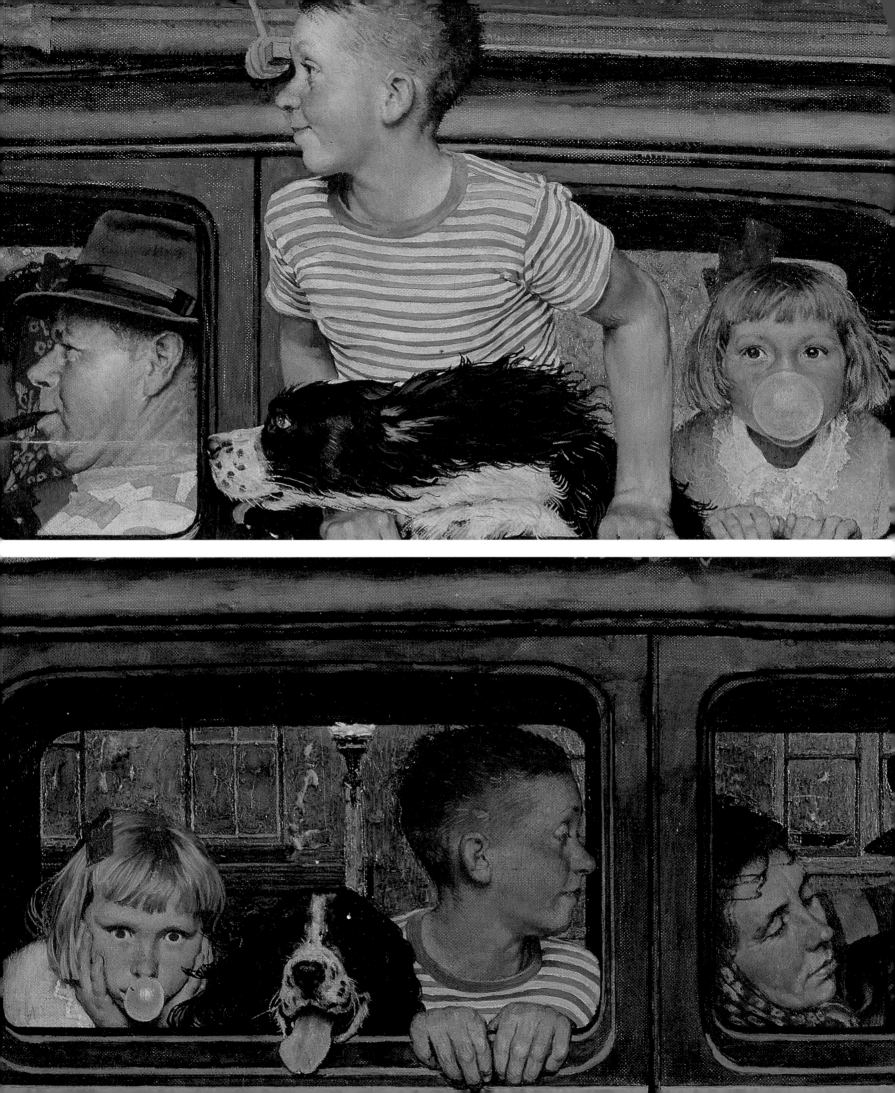

Judy L. Larson and Maureen Hart Hennessey

Norman Rockwell: A New Viewpoint

Commonplaces never become tiresome. It is we who become tired when we cease to be curious and appreciative. . . . [We] find that it is not a new scene which is needed, but a new viewpoint.[1]
—Norman Rockwell

In 1923, having launched a successful illustration career with dozens of *Saturday Evening Post* covers to his credit, Norman Rockwell experienced a crisis of confidence. He traveled to Paris thinking he would polish his artistic skills and find a new perspective, but he was quickly disappointed by his lack of progress and his inability to find meaningful subject matter. Recalling those frustrating times in a 1936 article, Rockwell described a moment of self-discovery. "I know now that all I need in my work is at hand. . . . The commonplaces of America are to me the richest subjects in art. Boys batting flies on vacant lots; little girls playing jacks on the front steps; old men plodding home at twilight, umbrellas in hand—all of these things arouse feeling in me," wrote Rockwell.[2] These were the richest subjects for the artist/illustrator; it was his mission to celebrate the ordinary, "the things we have seen all our lives, and overlooked."[3]

Norman Rockwell was born on February 3, 1894, to a family of modest means living in what he later described as a shabby brownstone at 103rd Street and Amsterdam Avenue in New York City. His father worked in the Manhattan office of a textile firm; his mother was a self-proclaimed invalid. In Rockwell's autobiography, which he dictated to his son Tom, he described distant familial relationships and only a few positive childhood memories. One was the joy of creating art. As a skinny, clumsy young boy, Rockwell had discovered his natural ability for drawing. His high school in Mamaroneck, New York, allowed him release time to attend the Chase School of Fine and Applied Arts in New York. Rockwell took pride in his accomplishments in art school, and at a young age he determined that he would become a famous illustrator.

Rockwell's other pleasant childhood memories were of summer trips to the country; he wrote of milking cows, fishing, swimming,

Going and Coming (detail), 1947

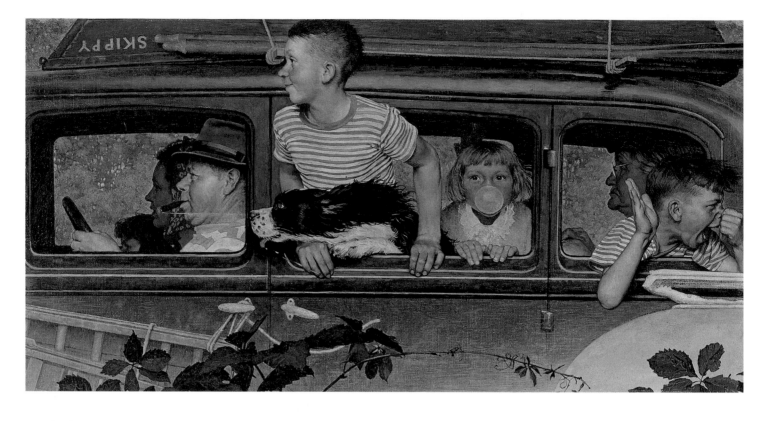

Going and Coming, 1947

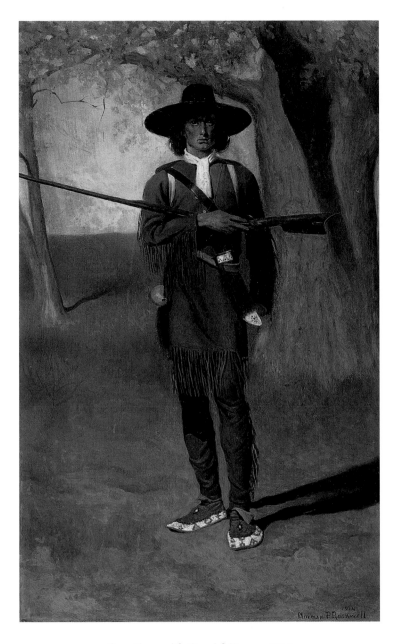

Scouting with Daniel Boone, 1914

trapping turtles and snakes, and riding horses. "I guess," wrote Rockwell, "I have a bad case of the American nostalgia for the clean, simple country life as opposed to the complicated world of the city."[4] Rockwell's yearning for the seemingly carefree life of the country would become a theme of his long career.

Rockwell idolized the great artists of the golden age of illustration at the turn of the century—Howard Pyle, E. A. Abbey, Howard Chandler Christy, A. B. Frost, and J. C. Leyendecker—and he was determined to join their ranks. He was accepted at the Art Students League in 1910, when the prestige of illustration

was waning in favor of urban realism and the modernist avant-garde. Yet Rockwell remained true to his goal. He enrolled in classes taught by George Bridgman and the well-established illustrator Thomas Fogarty. From Fogarty, Rockwell learned the practical skills of illustration, and from Bridgman, he heard details of the lives of great "old-time" illustrators, particularly Howard Pyle.

Although still a teenager, with Fogarty's help Rockwell secured his first job as an illustrator, and in 1913 he was offered a position as art editor for *Boys' Life*, the new magazine of the Boy Scouts of America.

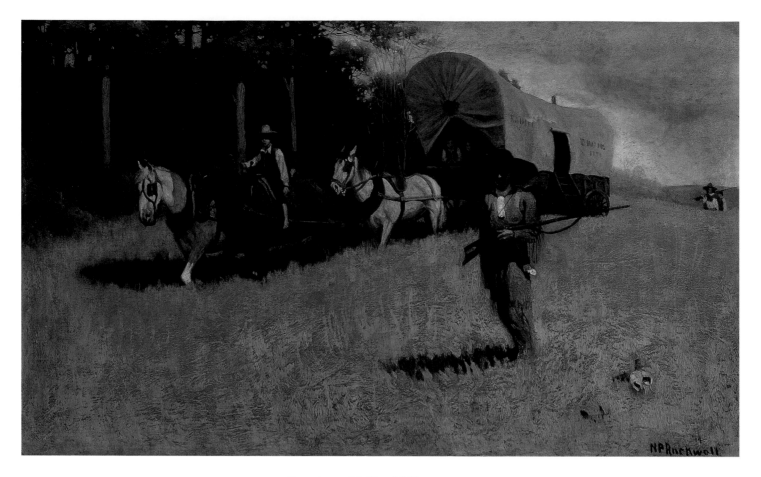

Scouting with Daniel Boone, 1914

It was the beginning of a lifelong association with scouting that would include fifty years of illustrating Boy Scout calendars, beginning in 1925. Rockwell also regularly contributed illustrations to several other children's magazines. But "in those days," Rockwell wrote, "the cover of the *Post* was the greatest show window in America for an illustrator. If you did a cover for the *Post* you had arrived."[5] A timid Rockwell presented his ideas to George Horace Lorimer, the editor of the Philadelphia-based *Post* from 1899 to 1936, and much to the artist's delight, his first *Post* cover was published on May 20, 1916 (page 38). It is a humorous piece showing an unhappy babysitter in his Sunday best pushing a carriage while two boys dressed for baseball tease him. Comic narratives made popular covers for the *Post*, and Rockwell demonstrated a flair for them. Although he tried his hand at pretty-girl pictures, he quickly realized that his forte was the world of ordinary folks and little kids. Rockwell would illustrate 322 *Post* covers over forty-seven years.

Bolstered by his successes at the *Post*, Rockwell proposed to Irene O'Connor, a schoolteacher, but their marriage ended in divorce in 1930. He was married again that same year to Mary Barstow, also a teacher, and that happy union produced three sons: Jarvis, Tom, and Peter. The 1930s was one of the richest decades of Rockwell's career. Although America remained in the depths of the Great Depression, Rockwell's work was in demand, and he suffered no financial hardship. With his new wife and young family, it was a time of personal contentment and happiness. Yet it was also one of the most troubled periods in his life as an illustrator. Rockwell had difficulty completing commissions, and he worried that his work was not good. He took his wife and infant son to Paris, hoping to find inspiration in the new European art movements. But after seven months abroad, he returned to New Rochelle and abandoned the idea of painting abstractions. Throughout, Rockwell continued working, completing *Post* covers, story illustrations, and calendar art for the Boy Scouts.

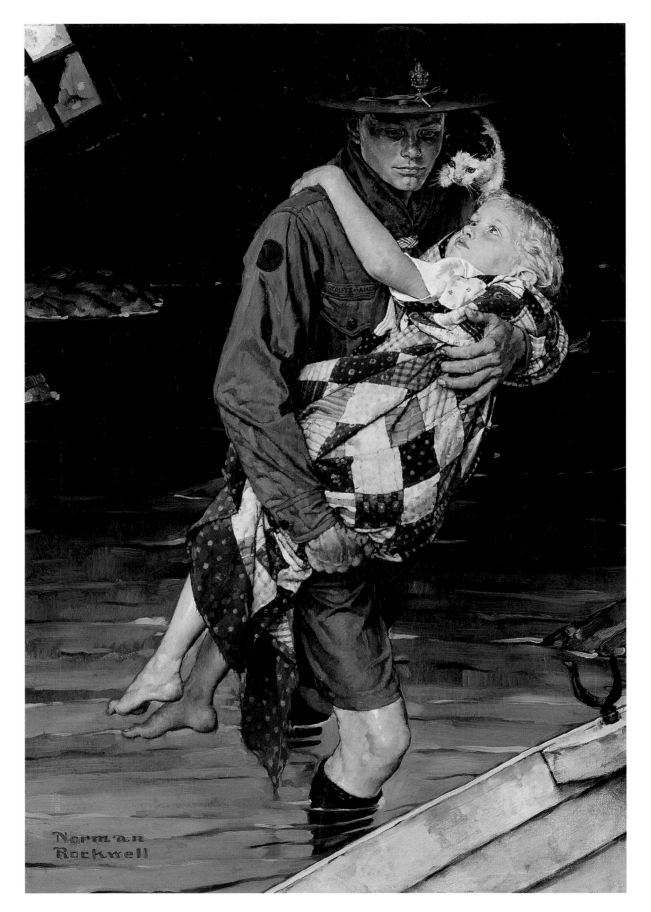

A Scout Is Helpful, 1941

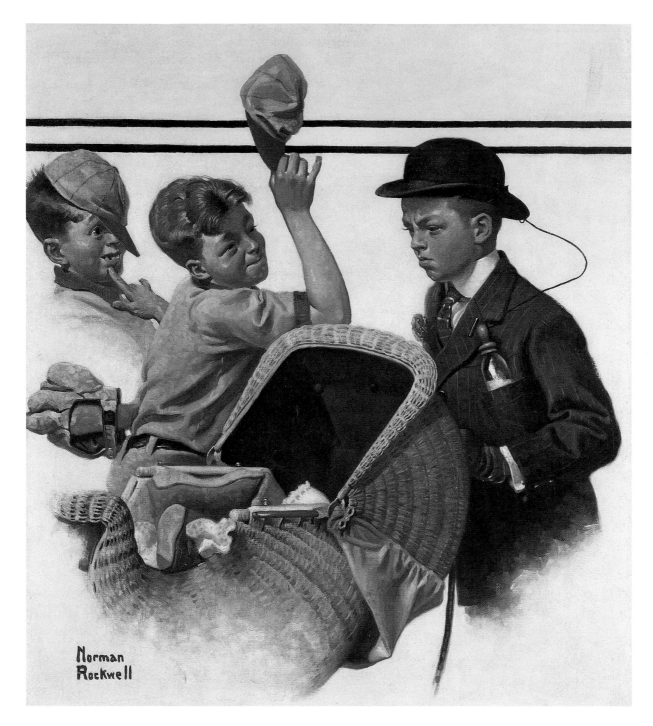

Boy with Baby Carriage, 1916

In 1935, Rockwell received the commission that revitalized his enthusiasm for his work. Heritage Press asked him to illustrate Mark Twain's *Adventures of Tom Sawyer* (page 72) and then *The Adventures of Huckleberry Finn.* Dedicated to making the most accurate illustrations possible, Rockwell did extensive research and was the first illustrator of those classics to visit Hannibal, Missouri, to set the proper scene. Two years later, when he illustrated a biography of Louisa May Alcott with scenes from *Little Women* (page 39), he became familiar with Alcott's hometown of Concord, Massachusetts. These commissions launched a period of remarkable activity in magazine-cover and story illustration. At the end of the thirties, Rockwell moved with his family to Arlington, Vermont, and quickly established friendships with other artists and illustrators

The Most Beloved American Writer, 1938

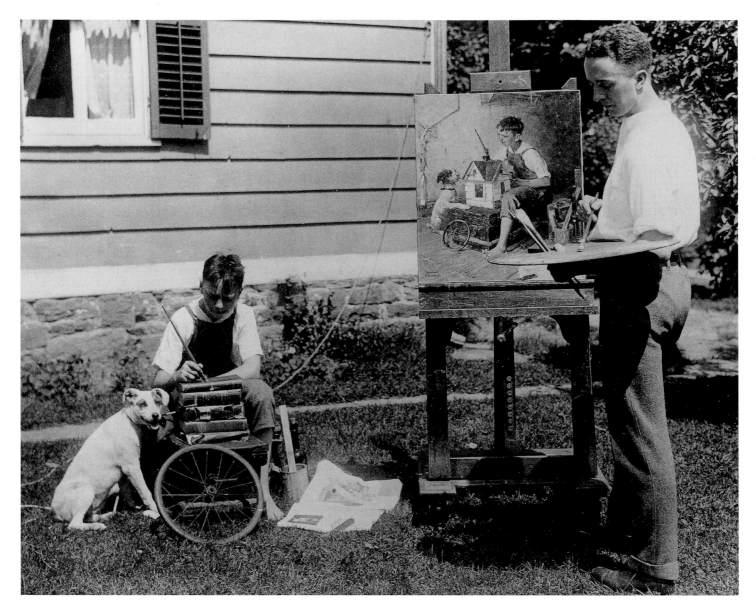

Norman Rockwell working on *Painting the Little House*, 1921

in the area. His work began to reflect small-town American life more consistently.

During World War II, Rockwell depicted life on the home front with illustrations of armchair generals and women war-workers. Willie Gillis, Rockwell's fictitious GI, made his first appearance in 1941 and was featured on eleven *Post* covers, including one in 1946 showing him at college, presumably on the GI Bill. Soldiers were shown on KP duty, at home on leave, and riding on troop trains. *The Four Freedoms* (pages 97–99, 101), completed in 1943, are Rockwell's most famous paintings of the period and were the centerpiece of the government's Second War Loan Drive.

Only one Rockwell image, a factory production poster, showed a bloodied soldier on the front lines, sitting at a machine gun that is almost out of ammunition (page 41).

In 1943, Rockwell's Arlington studio burned to the ground, destroying not only his artwork but also the valuable reference materials, art books, prints, historical costumes, and props (even his favorite pipes) that he had collected over three decades. Rockwell tried to put the best possible face on the disaster, creating a cartoon version of the event for the *Post* (page 42) and asserting that the fire had forcibly given him a fresh start. This prompted his close friend, illustrator

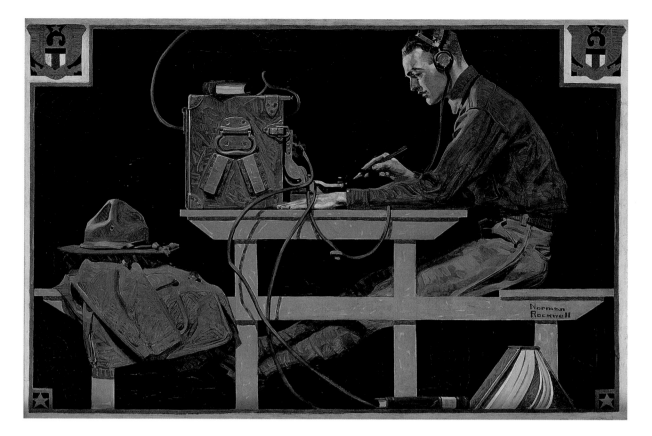

The U.S. Army Teaches Trades (Telegrapher), 1919

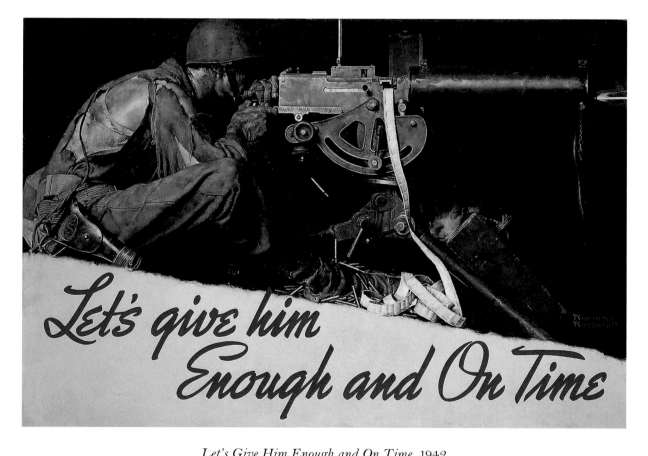

Let's Give Him Enough and On Time, 1942

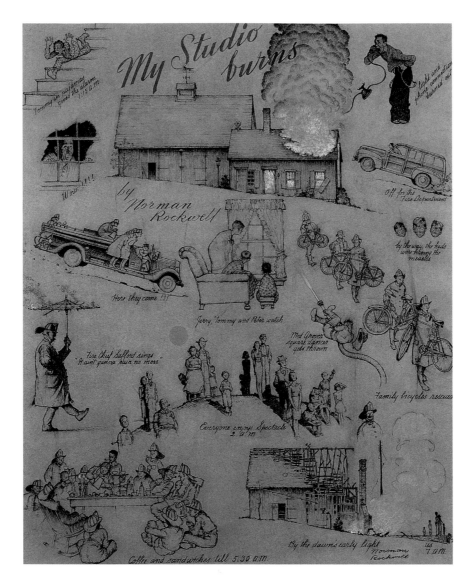

My Studio Burns, 1943

Mead Schaeffer, to joke, "He was so damned convincing that for several weeks I was on the point of burning down my own studio."[6]

Rockwell continued to chronicle American life on the cover of *The Saturday Evening Post*, and his covers from the postwar period are among his best-known illustrations. In addition, he produced a large number of advertising and commercial works, a lucrative and lesser-known aspect of Rockwell's work that had begun in earnest during the 1920s. Over eight hundred images were commissioned by more than 150 companies, including some of the largest and most successful American corporations, such as Ford Motor Company, Edison Mazda (now General Electric), Sun-Maid Raisins (page 43), and Hallmark Cards. A Rockwell adver-

tising image held a double meaning: the picture itself carried the corporate message, and Rockwell's signature conveyed the tacit endorsement of one of America's most celebrated figures.

In 1953, the Rockwells moved to Stockbridge, Massachusetts. Mary was battling depression and alcoholism, and Rockwell encouraged her to enroll in a treatment center there. Rockwell, who had suffered from bouts of depression all his life, also began therapy. In 1959, shortly after Rockwell finished dictating his autobiography to his son Tom, Mary died unexpectedly from a heart attack. Rockwell kept busy with commissions, but his life was more difficult alone.

The sixties proved a decade of change for Rockwell and for the nation as a whole. He joined a local art

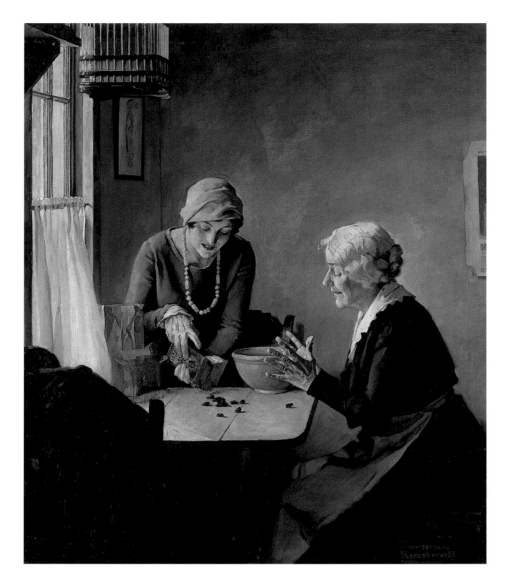

Fruit of the Vine, ca. 1930

class, where he tried new techniques and materials and returned to painting from the live model. Lonely after the death of his wife, he took a poetry-writing class in which he met Mary (Molly) Punderson, a retired schoolteacher, whom he married in 1961. Two years later, he terminated his longstanding relationship with the *Post*. Exactly how the break occurred is unclear. The *Post* was the quintessential modern consumer's magazine, and a new editorial team focused on updating the magazine's look, including fewer illustrated covers and more photography. Rockwell was unhappy with his last assignments for the *Post*, almost all portraits. His last *Post* cover appeared in December 1963, the only Rockwell cover to be used twice. Symbolizing the end of an era, it was a portrait of John F. Kennedy,

completed during the 1960 campaign and now used as a memorial (page 31).

Rockwell's next assignments represented a radical change. His commissions from *Look* magazine suggest both a turning point for Rockwell and changes in American society and visual culture. Although largely apolitical, Rockwell had a longstanding interest in civil rights; as early as 1946, he had supported the integration of a sorority at the University of Vermont and had corresponded with the Bronx Interracial Conference regarding race relations.[7] Yet the *Post*'s policy had been clear: "George Horace Lorimer, who was a very liberal man, told me never to show colored people [on a cover] except as servants."[8]

In the radical sixties, Rockwell wanted to approach

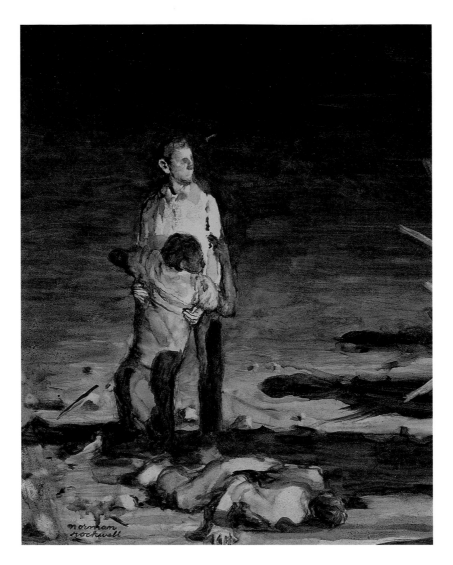

Southern Justice (Murder in Mississippi) (study), 1965

more liberal subjects in his work, and *Look* welcomed images such as *The Problem We All Live With* (pages 106–107), published in January 1964. Far from being scolding or incendiary, Rockwell showed himself in this picture to be a sensitive storyteller focusing on the individual; few viewers could resist the emotionally charged scene of an innocent and trusting little girl, vulnerable yet impervious to a nation in crisis. While the picture drew letters of praise from some viewers, others wrote accusing Rockwell and the editors of hypocrisy; one particularly nasty letter attacked the "vicious lying propaganda being used for the crime of racial integration."[9] Rockwell sustained his focus in other difficult images such as *Southern Justice* (page 45), which depicts a painful civil rights tragedy in Mississippi. *New Kids in the Neighborhood* (pages 46–47) is a thoughtful look at community integration. Rockwell also celebrated the Peace Corps and the accomplishments of the United States space program (pages 65, 53). Yet he declined a commission for a recruiting poster for the Marines at the height of the Vietnam War, asking an interviewer, "I don't think we're helping the Vietnamese people lead better lives, do you?"[10]

During the last decade of his life, Rockwell was still hard at work, but frail health kept him from producing much art. He set up a trust, leaving many paintings as well as his studio and personal archives to what would become The Norman Rockwell Museum at Stockbridge. In 1977, Gerald R. Ford awarded him the Presidential Medal of Freedom "for his vivid and affectionate portraits of our country." Rockwell

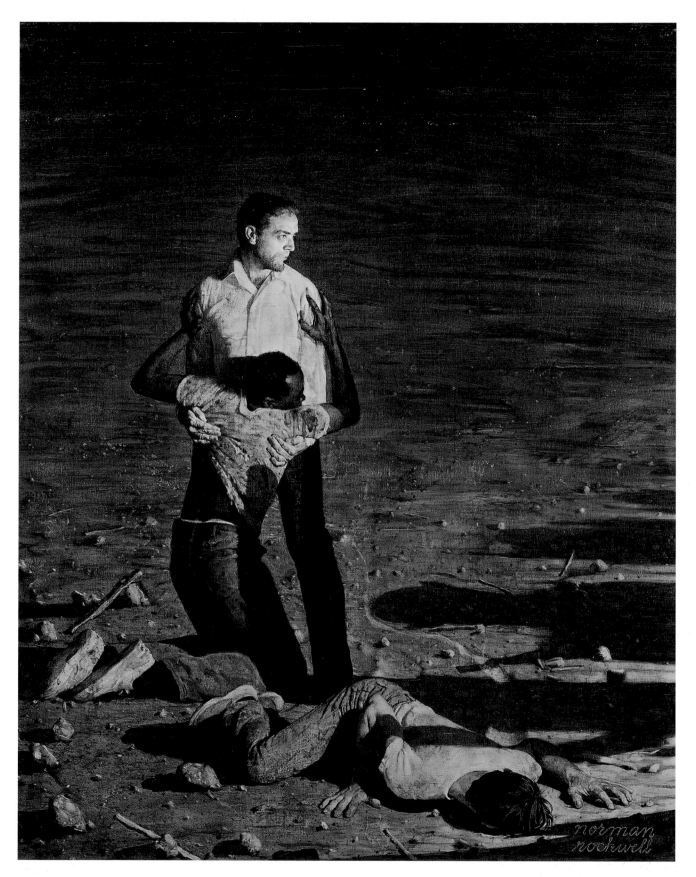

Southern Justice (Murder in Mississippi), 1965

died in Stockbridge in the fall of 1978 at the age of eighty-four.

Themes in Rockwell's Work

Norman Rockwell had an extraordinary ability to create narrative imagery, virtually inventing a visual vocabulary that gave shape and definition to the ideas, social needs, and aspirations of twentieth-century American culture. He never claimed to portray reality, but declared that he depicted "life as I would like it to be." He purposefully avoided "the agonizing crises and tangles of life" and painted a world where sadnesses were often pleasant and problems humorous.[11] His work is highly naturalistic, painted with painstaking precision, with every detail carefully articulated so the viewer feels that Rockwell is "reporting" an actual story, rather than "creating" one. Caught up in the visual lure of Rockwell's reality, we are willing to accept these idealized subjects as perfectly natural. Yet as Rockwell's son Peter observed, any form of realism is still a manipulation of reality.[12] Rockwell, in effect, became a master at representing American ideologies.

Anyone can relate a tale, but a good storyteller is rare. He or she knows when to linger over details and when to gloss over them quickly; the pauses in a great story can be as meaningful as the words, and an unexpected crescendo or a surprise ending will hold one's attention. All these talents were Rockwell's; he simply used paint instead of words to create his narratives. Although he drew attention to details, no one part of his images dominates the whole. Nothing is incidental; every brushstroke serves the narrative. In a world that is far from perfect, Norman Rockwell

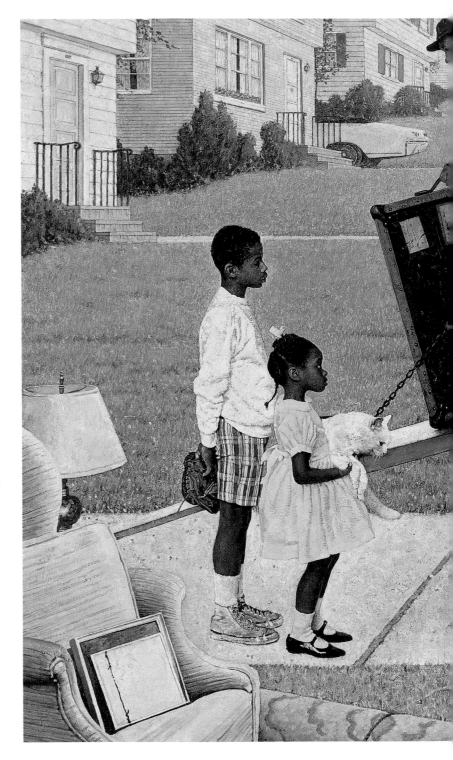

New Kids in the Neighborhood, 1967

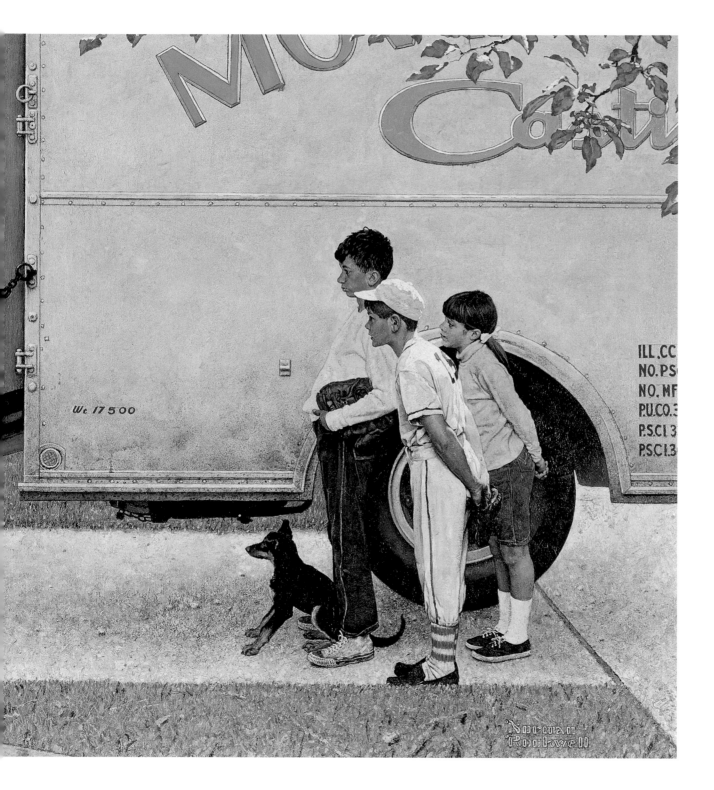

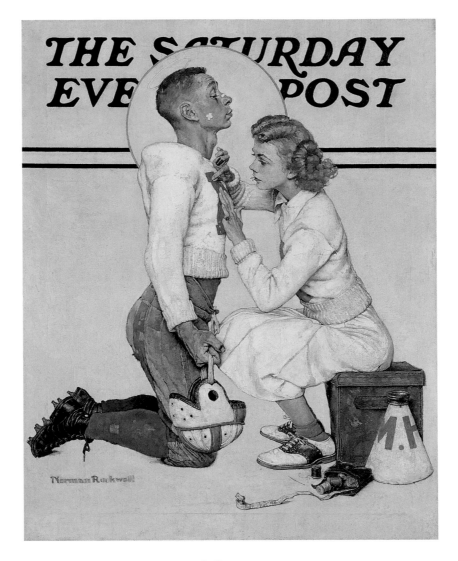

Football Hero, 1938

found exemplary moments in the ordinary and told his stories to an eager American audience.

It is this talent for storytelling, for seeing the deeper meaning in the everyday as well as in the extraordinary, combined with his abilities as an artist that make Norman Rockwell the consummate cover artist. A magazine cover must evoke a response in the instant it catches the viewer's eye. There are no captions, no explanations, no opportunities for lingering analysis. In cover after cover, Rockwell was able to produce an immediacy of communication. He pondered and struggled over his subjects, paring away the excess until he had the perfect story.

The narratives offer a wide range of characters and situations, but Norman Rockwell's American stories are dominated by four themes. The first is his fondness for celebrating the ordinary. While other illustrators might choose the high points and milestones of life, Rockwell focused on the elusive commonplace moments. He chose mundane experiences and elevated them to levels of great significance. He avoided the wedding ceremony, for example, in favor of the couple applying for a marriage license (page 49); he did not paint the football hero scoring the winning touchdown, but the proud moment when he receives a letter from an adoring cheerleader (above). In *No Swimming* (page 13), Rockwell focused on the aftermath of a forbidden swim and was thus able to capture the universal in the scene: the feeling of mischievous children caught in the act. The black outline framing the picture cuts off two of the figures, while the third extends above it, emphasizing the impression of

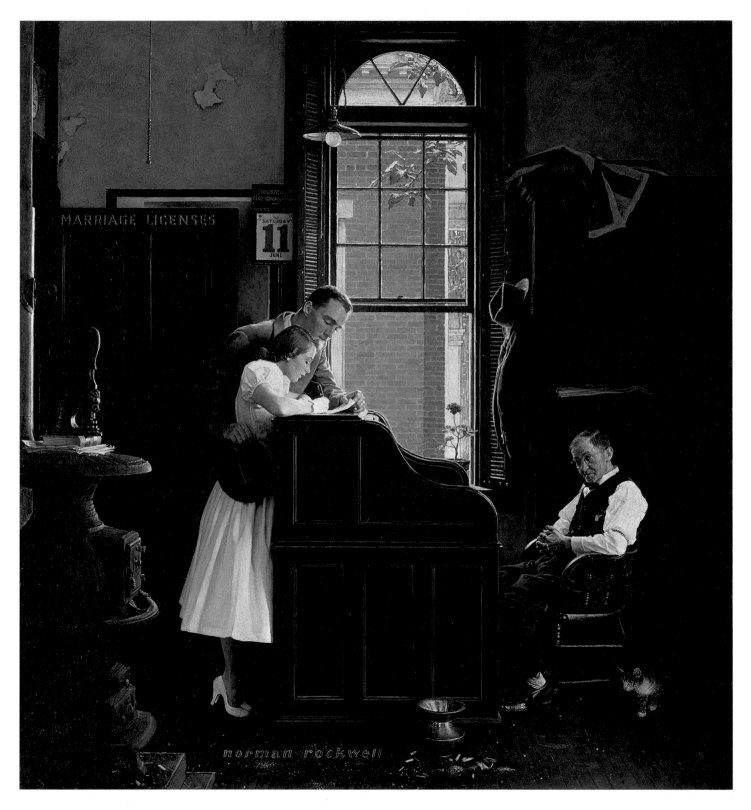

The Marriage License, 1955

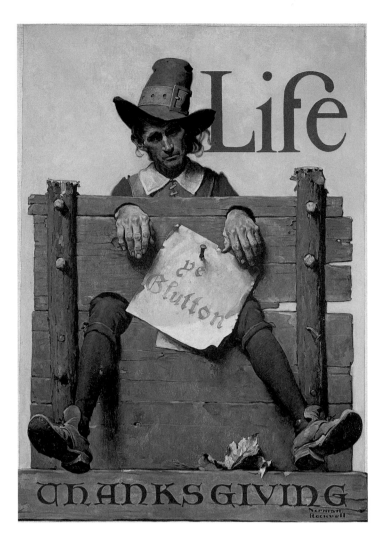

Thanksgiving—Ye Glutton, 1923

haste and adding to an overall sense of urgency. These are the moments that most people miss; Rockwell found them and presented candid shots from all of our lives.

As America moved forward with its twentieth-century agenda, it also looked backward, drawing on the past to justify its newfound world leadership. In remembering history, Americans discovered patterns and systems that could be reoriented to serve current purposes. Rockwell's pictures played a role in shaping this sense of the past, a second dominant theme of his work. In some cases, he borrowed directly from his favorite British storyteller, Charles Dickens, inventing classic characters who sing, dance, and make merry against the backdrop of nineteenth-century England, America's mother country. Rockwell also found subjects in America's colonial past that demonstrate Yan-

kee common sense and integrity. In some images, such as his many renditions of Abraham Lincoln (page 51), Rockwell sought the ideal or the heroic; in others he used humor to gently poke fun at the unfortunate pilgrim in the stockade for overindulgence (above), or at Ichabod Crane before his encounter with the Headless Horseman (page 51). Common to these historic images is nostalgia—a feeling of comfort in the longing for times past, where the accuracy of memory is subordinated to the mythologizing of history.[13]

"Inventing" America is another theme of Rockwell's work. The twentieth century was the American century—a time of social change, new political and economic relationships, shifting gender and race relations, and constant industrial and technological advances. Part of Norman Rockwell's role was to make the new seem familiar. A television antenna being

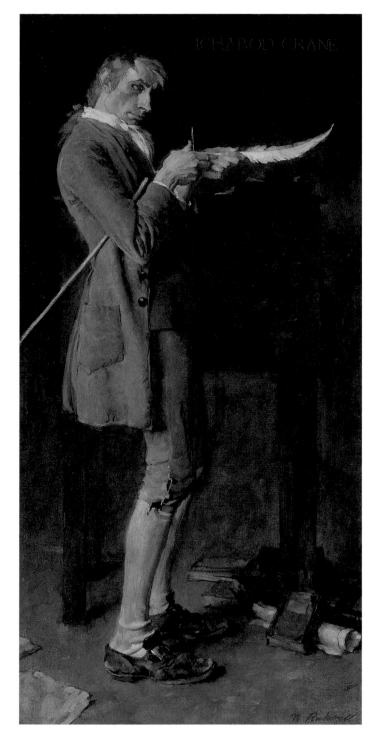

Ichabod Crane, 1937

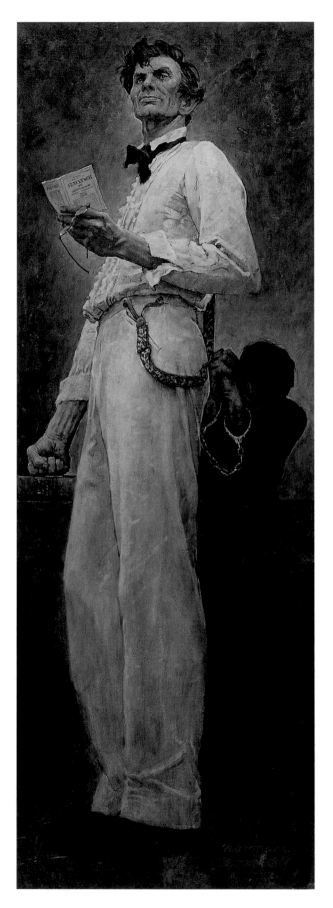

Lincoln for the Defense, 1962

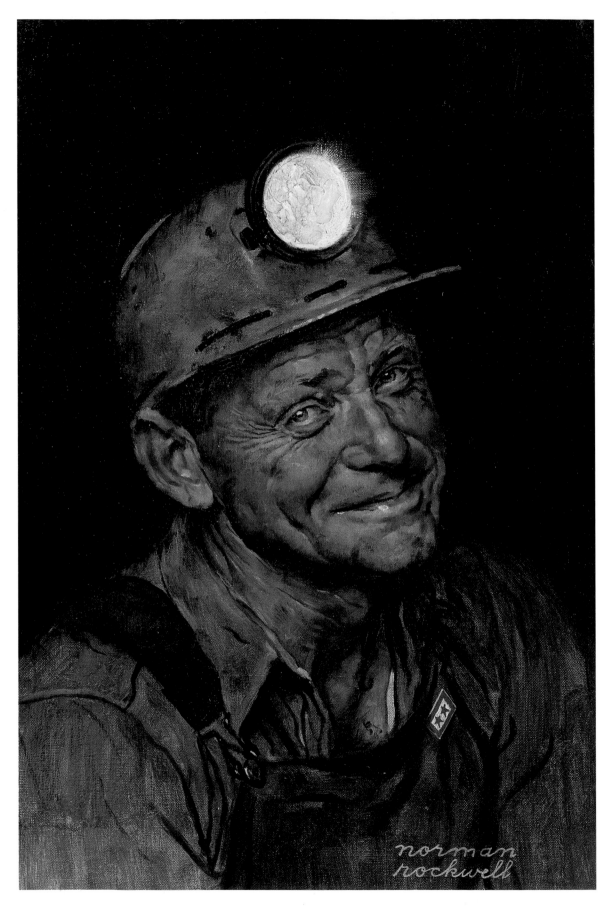

Mine America's Coal (Portrait of a Coal Miner), 1943

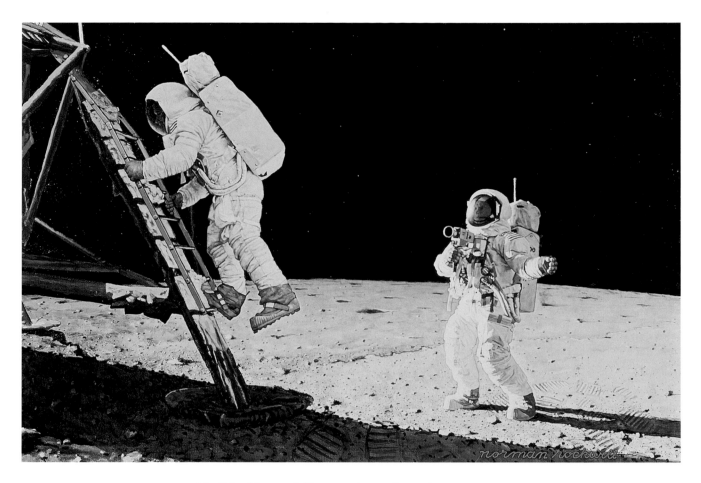

The Final Impossibility: Man's Tracks on the Moon, 1969

attached to the top of a Victorian house offers one example of how past meets present (page 148). From family vacations in station wagons (page 34) to walks on the moon (above), the twentieth century offered countless opportunities for creating new American imagery. Rockwell's art reassured the nation that cherished values would not disappear, for the nation needed them to meet its new challenges.

Finally, Rockwell's pictures often honored the American spirit. Particularly during times of crisis, Rockwell created images that communicated patriotism and unquestioned allegiance to the United States. Rockwell's stories promoted American values such as industriousness, fair play, and decency. The young clerk studying his law books under a portrait of Lincoln (page 146), for example, is no less a hero than the World War I recruit who learns a new skill (page 41) or the Pennsylvania miner, whose Blue Star pin indicates two sons at war, featured on a coal production poster during World War II (page 52). It can be

difficult for contemporary audiences to appreciate Rockwell's patriotic imagery. These pictures may seem sentimental and overwrought today, but in times of war and economic depression, they were reassuring. The images served to build consensus and to boost American confidence in a period of rapid growth and changing mores.

Rockwell's Process

Rockwell's illustration career was different from those of the famous illustrators who preceded him. Most illustrators of the nineteenth century worked in response to a written text, but Rockwell's cover illustrations started from independent ideas—usually his own. He translated his ideas into small conceptual sketches, often only two or three inches square, which he shared with editors and art directors for approval. He claimed that the best ideas came from his own experiences, although he was always prowling for new subjects and kept a folder of ideas. He mulled over

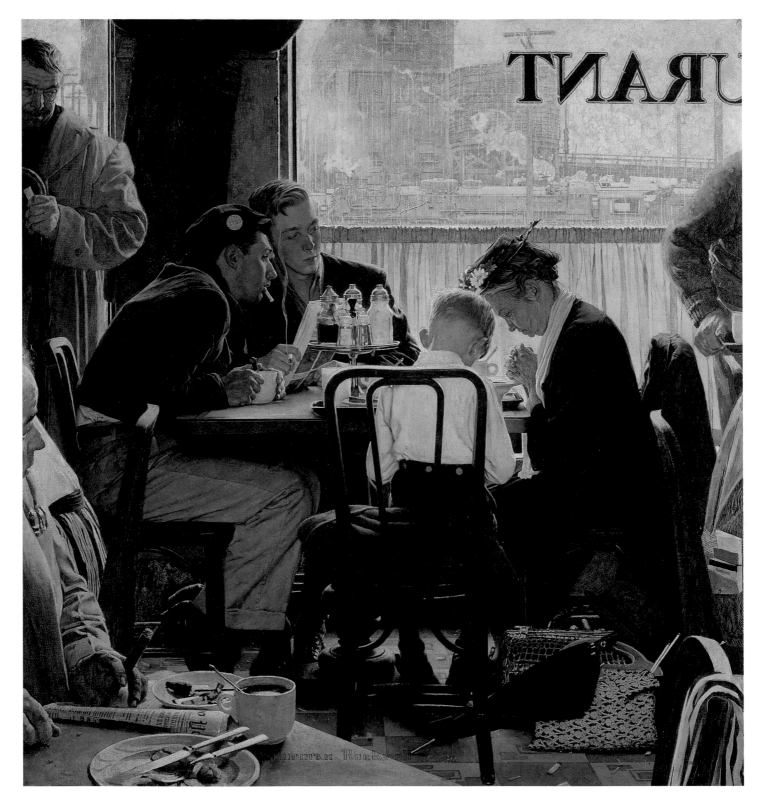

Saying Grace, 1951

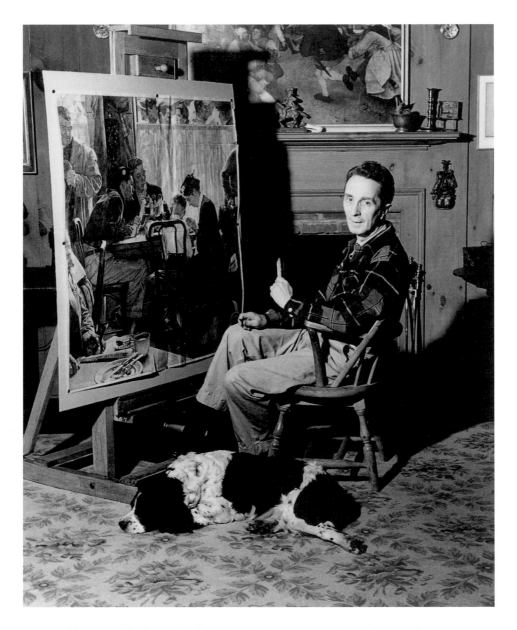

Norman Rockwell in his West Arlington studio with a study for
Saying Grace, 1951

The Gossips (page 171) for more than twenty years before finally figuring out the humorous ending, in which the "scandalous tidbit" is communicated to the surprised subject. Readers often sent suggestions, but Rockwell maintained that he used only four in forty-three years. One was for the popular *Post* cover *Saying Grace* (page 54). A reader wrote about seeing a Menno-nite family in an automat, and Rockwell liked the idea so much that he adapted it to a scene of a pious grand-mother and her grandson saying a blessing over their dinner in an inner-city café. The composition is spa-tially complex, yet every element directs the viewer's attention to the main characters. The accents of red serve as exclamation points and also keep us focused on the centerpiece of the narrative. Rockwell's master-ful still-life of dirty dinner dishes in the foreground anchors the realism of the scene, making us feel that we, too, are in the diner, the slightly embarrassed ob-servers of a pious grandmother and child.

Conscious that his works would largely be seen as photomechanical reproductions, Rockwell concen-trated on making strong compositions that would re-tain their impact when reduced to magazine-cover size. These straightforward, seamless presentations

Cousin Reginald Spells Peloponnesus (Spelling Bee), 1918

were the result of weeks of work to achieve the most compelling effect. Close observation, attention to detail, and scrupulous accuracy are hallmarks of Rockwell's work.

Rockwell was keenly aware of the power of composition in telling a story, and his best paintings draw the viewer in. Rockwell's mentor, Howard Pyle, had preached about the importance of helping the viewer "jump into a picture," and Rockwell heeded his advice by, for example, showing scenes over a character's

shoulder or reflected in a mirror. In some instances, Rockwell carved out an imaginary space for the viewer. Many Americans might imagine the Thanksgiving in *Freedom from Want* (page 98) as the ideal, in part because of the welcoming face turned toward the viewer.

Pyle had been a perfectionist in his illustration, agonizing over the right prop for every period piece. Eager to follow in Pyle's footsteps, Rockwell assiduously collected props and costumes, and would even buy a piece of clothing from a stranger if it had the

well-worn look he wanted. Rockwell's eye was absolutely literal: if a model wore a green sweater, he had difficulty painting it red. Rockwell at first resisted using photography as a tool in composition and continued to work with live models. In the mid-1930s, however, he learned to use photography to enhance his vision and memory, although he maintained that photography could not substitute for sound technique and good concepts. Once an idea sketch had been approved, however, photography enhanced the development of a picture. If an illustration was set in a restaurant, for example, Rockwell would find just the right one to photograph; if he had worked only from memory, he said, he would have missed important details.

Photography also allowed Rockwell to use non-professional models. Previously, artists had depended on professional models who could hold a pose for hours at a time. Photography made it possible for Rockwell to choose models based on their physical characteristics, since the time they spent posing was minimal. Consequently, friends and neighbors were always eager to volunteer, although Rockwell insisted on paying them, knowing that posing would be more of a task for them than a treat. Most important, photography gave Rockwell the freedom to leave the New York area, with its supply of professional models, and move to rural New England, where he used his family and neighbors as models.

Having selected just the right models, props, and setting, Rockwell would engage a photographer to take dozens of shots while he assumed the role of director, staging the scene. Each painting required fifty to one hundred photographs, as Rockwell carefully documented details such as the fold of a cuff on a man's trousers, or a hand grasping the back of a chair. If it were an action shot, Rockwell would use blocks or books to support a model's foot at just the right angle for running or walking.[14] When all the photographs had been developed, Rockwell would spread them out on his studio floor and begin the task of selecting the best to use in composing his illustration.

Rockwell would next undertake a charcoal drawing of approximately the same size as the projected painting so that he could clearly see all elements of the picture except color. From his early experience in composing black-and-white illustrations, Rockwell understood the importance of contrasting tones and relative values. He would frequently erase sections of his meticulous charcoal drawings, and if he wore a hole in the paper he would simply cut out the worn area and make a paper insert.

In contrast to the charcoal drawing, the color study was small—the size of the final cover—to give Rockwell a sense of how the image would look on a newsstand. Rockwell would often have a photograph of the charcoal study printed the same size as the magazine cover, and he would paint directly on the photograph. He painted the color study in a loose, impressionistic way and sometimes added an acetate overlay to test the effect of color in selected areas.

Literally surrounding himself with his preliminary work, as well as any art books or prints he had referred to, Rockwell would finally begin the oil painting. With the aid of carbon paper and a gallery assistant, the charcoal study was traced onto a stretched canvas where it served as a foundation for underpainting, a monochromatic layer on which to build the final painting. Rockwell liked to use mars violet as underpaint because the color lent warmth to the finished surface.

In each step of the technical process, Rockwell was critical. He might change models or completely alter a scene—whatever it took to create the strongest possible composition. He admitted that he "fussed" over canvases. Even with pressing deadlines, Rockwell did not hesitate to experiment until he was satisfied.

For the popular *Post* cover titled *Art Critic* (page 61) Rockwell's studies show that he was initially inspired by Frans Hals's dour Dutch matrons (pages 58–60). Using his wife Mary as the model, Rockwell began a lengthy process of photography and sketching. Over time, as the character evolved, Hals gave way to Rubens, and the hausfrau became a flirt. In at least two photography sessions, Rockwell teased out Mary's most evocative expressions, photographing each facial characteristic until the visual humor had exactly the tone he desired. In all, he developed twenty preparatory drawings and oil sketches for the portrait of the lady before he was satisfied that he had captured the subtle humor of her expression.

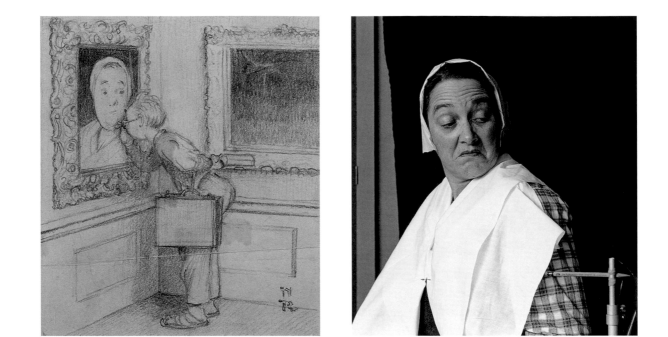

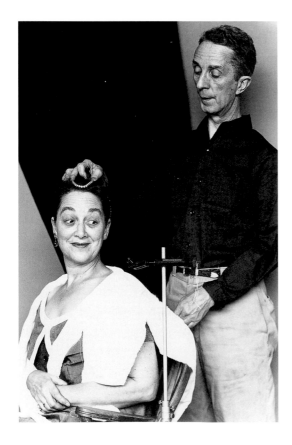

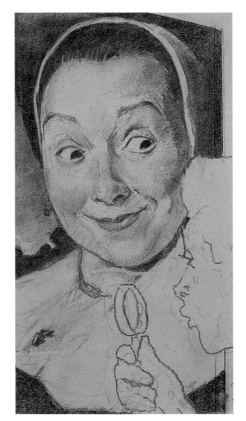

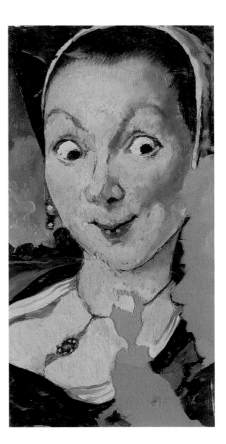

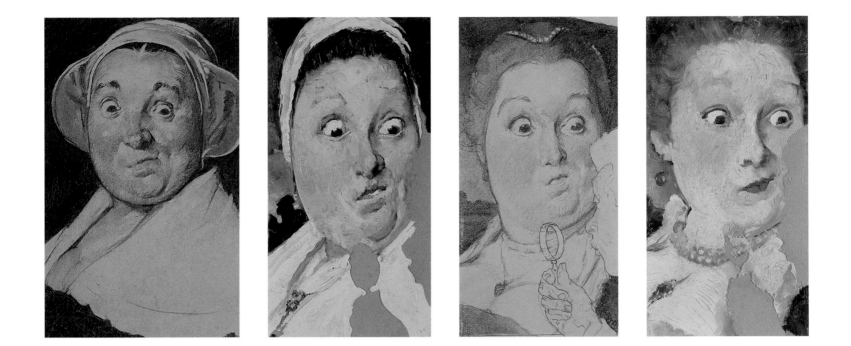

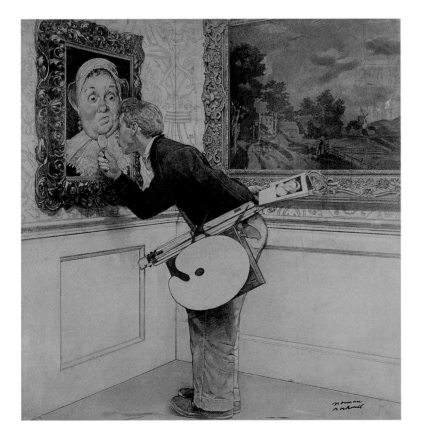

Studies and photographs for *Art Critic*, 1955

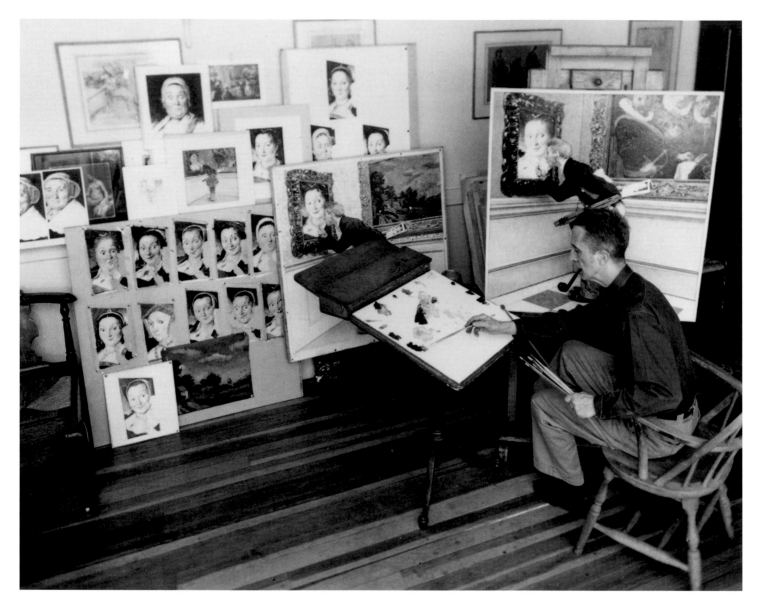

Norman Rockwell painting *Art Critic*, 1955

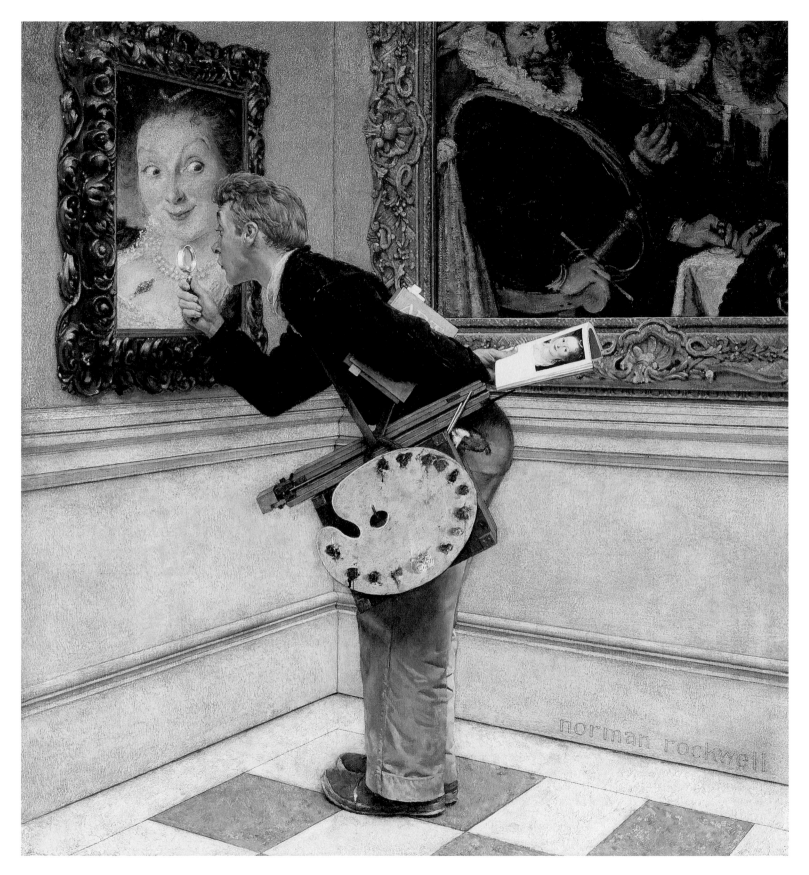

Art Critic, 1955

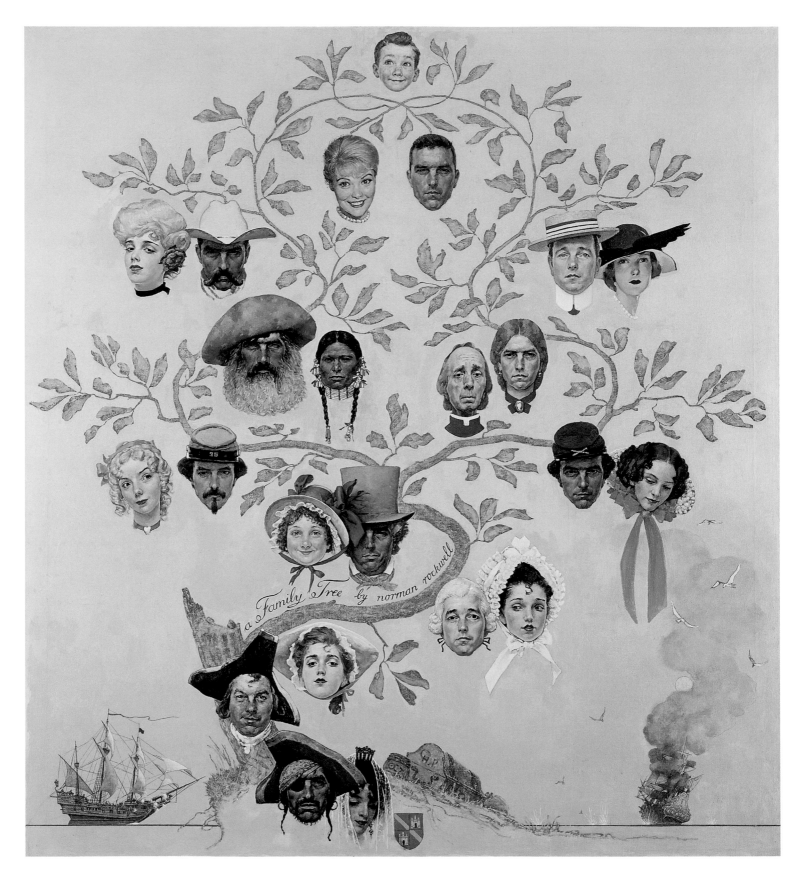

Family Tree, 1959

Rockwell would try just about anything to achieve a desired effect. He thought *Family Tree* (page 62) should look weathered and old, so he rubbed dirt from the garden onto the canvas. When it still appeared "too painted," as he put it, he sandpapered the surface. Satisfied, Rockwell commented that "the dirt treatment worked. It gave the background a beautiful texture."[15] He also achieved remarkable textures through painting, scraping, and repainting. Built-up layers of paint were Rockwell's favorite texture upon which to work. Late in his career, he discovered latex paint and experimented with using it as a ground layer. (We now know that oil over latex is an unstable combination, and this has created conservation problems for some of his paintings.)

Rockwell always sent his final paintings to the publisher framed, even if the canvas was still wet and unvarnished. He felt that a frame completed a work, even when the frame itself was minimal and inexpensive. Once the art editor had the finished painting, he might call and ask Rockwell to change some detail. Rockwell once had the unpleasant experience of having the *Post* paint out a horse without his permission, but such extreme changes were rare.

The final disposition of the original painting or drawing depended on the commission. Most commercial work was retained by the corporation; Rockwell's arrangement with the *Post*, however, allowed him to retain the original while the *Post* held the copyright. In many cases, particularly during the first decades of his career, originals were not returned to Rockwell, and their whereabouts remain unknown. Rockwell was generous with the art he owned, often giving studies, drawings, or even finished paintings to his friends and fans.

Once a painting was approved by the art editor, it was sent to be photographed in color. The primary colors—red, yellow, blue—were separated onto gridded screens; a "key screen" defined the blacks. Printing matrixes were then made from the various screens and run through the press one color at a time. Scrutinizing any photomechanical reproduction with a magnifying glass reveals that it is composed of tiny dots of color. The finer the screen, the better the reproduction. Once a good color reproduction was achieved, the art editor would overlay titles and other printed matter.

━━

Rockwell followed the tradition of nineteenth-century American genre painting established by such masters as George Caleb Bingham, Winslow Homer, and Eastman Johnson, who created scenes of everyday American life. A century ago, there was no clear distinction between commercial and fine art. Bingham coveted the prestige of having his paintings reproduced in engravings by the American Art Union. Homer published engravings of his best paintings in *Harper's Weekly* and other magazines. Johnson permitted commercial chromolithographic firms to make mediocre copies of his paintings for the mass market. Rockwell felt the effect of a changing art world in which fine art and commercial art became separate.

As modern art became less accessible to the general public, Rockwell's antiquated style was a haven for those who felt excluded from the avant-garde. In the 1950s and 1960s, critics began to position Rockwell's work as a foil to modernism. He was popular, commercial, and conservative—all the qualities contrary to the avant-garde. Rockwell's son Peter, defending his father, speaks of stacks of letters from an adoring public who wrote, "I don't know anything about art, but I like your paintings."[16] Rockwell represented the democratization of American art in an era when critics prized highly sophisticated, introspective expressions. Rockwell's critics have found him lacking in profundity, and if by that they mean that he used no enigmatic imagery, difficult themes, or erudite messages, they are right. To be profound, however, is also to be wise, heartfelt, acute, and intense—and Rockwell was all of these. Dozens of illustrators worked for the *Post* and *Look*, yet Rockwell's is the name that survives in the popular canon.

In the twentieth century, visual imagery permeated American culture, ultimately becoming the primary means of communication. Rockwell's images have become part of a collective American memory. We remember selected bits and pieces of information and often reassemble them in ways that mingle fantasy with reality. We formulate memory to serve our own

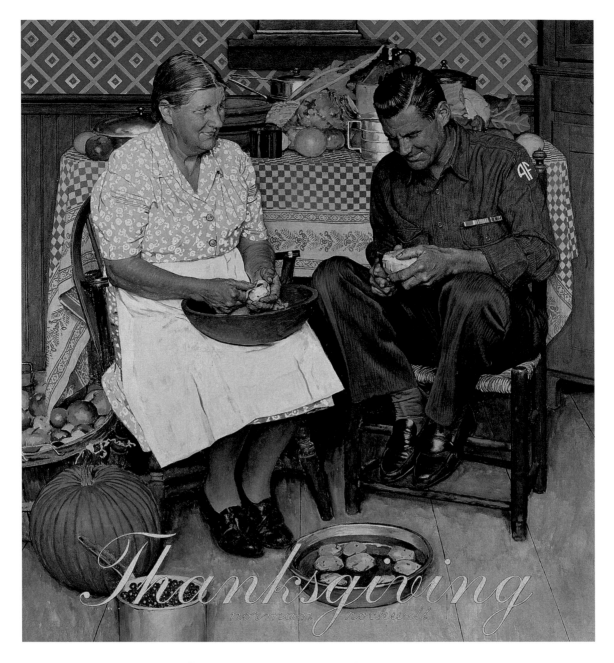

Thanksgiving: Mother and Son Peeling Potatoes, 1945

needs and purposes. Rockwell knew this instinctively: "Everything I have ever seen or done has gone into my pictures in one way or another. . . . Memory doesn't lie, though it may distort a bit here and there."[17]

Norman Rockwell is among the best-known American artists of the century. He painted portraits of presidents and other political leaders. He formulated advertising art for products ranging from Jell-O to Crest toothpaste. He created classic characters of American lore such as Willie Gillis and Rosie the Riveter. Although many people associate his work with the values of hearth and home, Rockwell also tackled contemporary and often controversial issues such as civil rights, school integration, the Peace Corps, and moon walks. Rockwell found hidden fragments of beauty in the chaos of life and helped us recognize moments of common grace. In a century of rapid social change, economic disparity, international wars, and technological advances, Rockwell's pictures helped Americans feel connected to a cultural homeland. They did so by reminding us of the details of life that are often overlooked.

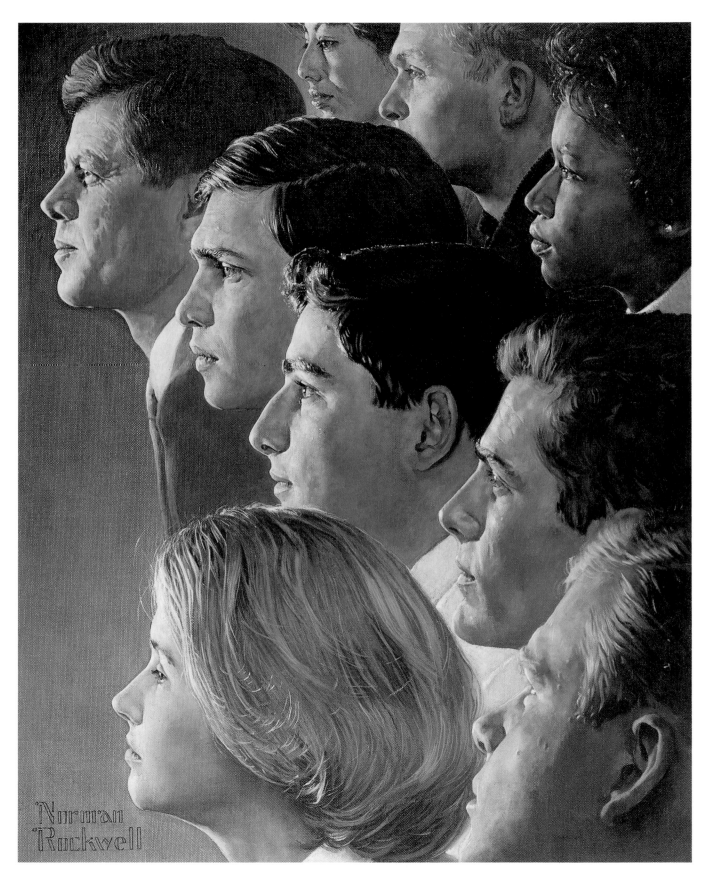

The Peace Corps (J. F. K.'s Bold Legacy), 1966

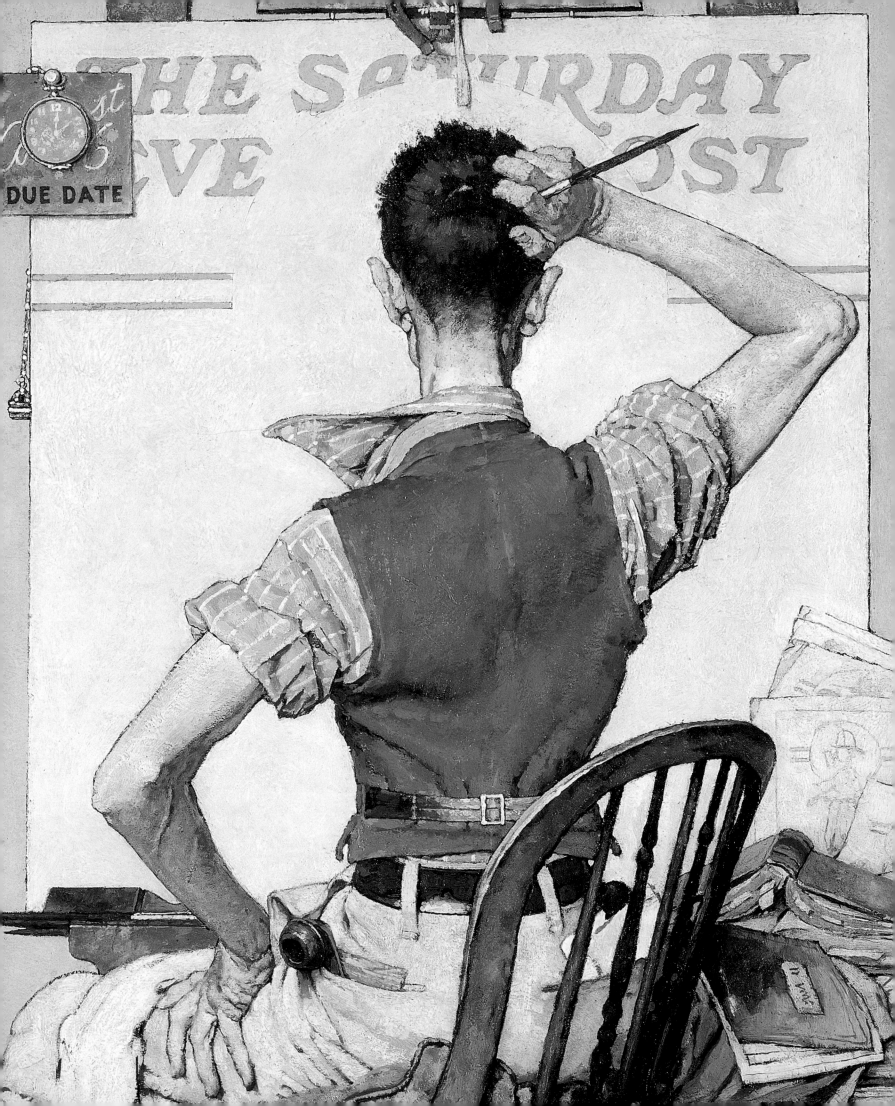

Peter Rockwell

Some Comments from the Boy in a Dining Car

My father was a closet intellectual. Behind the folksy exterior, the happy storyteller, was a sophisticated technician with a knowledgeable interest in the history of Western painting and a frequently tortured relationship to his own art. None of these intellectual characteristics could be allowed free expression in his painting, however, because he believed they would have damaged the message he wanted to convey and the relationship he wanted to maintain with his audience. In order to tell a story, a storyteller must always create a self-image that produces in the audience a state of willing, believing listening. The images that a folksy, pleasant, one-of-us pipe-smoker puts before us may be the same as those of an intense, dirty, angry, long-haired pot-smoker, but the story we hear will be different. The story and the storyteller are one. You cannot change one without changing the other.

Norman Rockwell the storyteller knew this as well as he knew how to paint. No matter how much he knew, cared, and thought about the history and art of painting, that could not get in the way of the story he was telling. Yet he felt and thought enough about these subjects that he could not resist inserting them into his pictures, so that sometimes he was telling stories about painting. These stories had to fit his image, so they were always framed in humor. A case in point is the 1938 *Post* cover self-portrait *Artist Facing Blank Canvas (Deadline)* (page 68).[1] One of the classic horrors of a painter's existence is facing a blank canvas without any idea of what to put there. But instead of anguish, the painter scratches his head in befuddlement. We can appreciate the problem because the painter looks just like we feel when we cannot see exactly what to do next.

One of the deeper amusements of this painting is that the artist has turned the problem into its own resolution: "I cannot think of what to paint, so I will turn that into my painting." At one and the same time he states the problem, involves the audience with the problem, and resolves the problem. The artist must feel an intimacy with

Artist Facing Blank Canvas (Deadline)
(detail), 1938

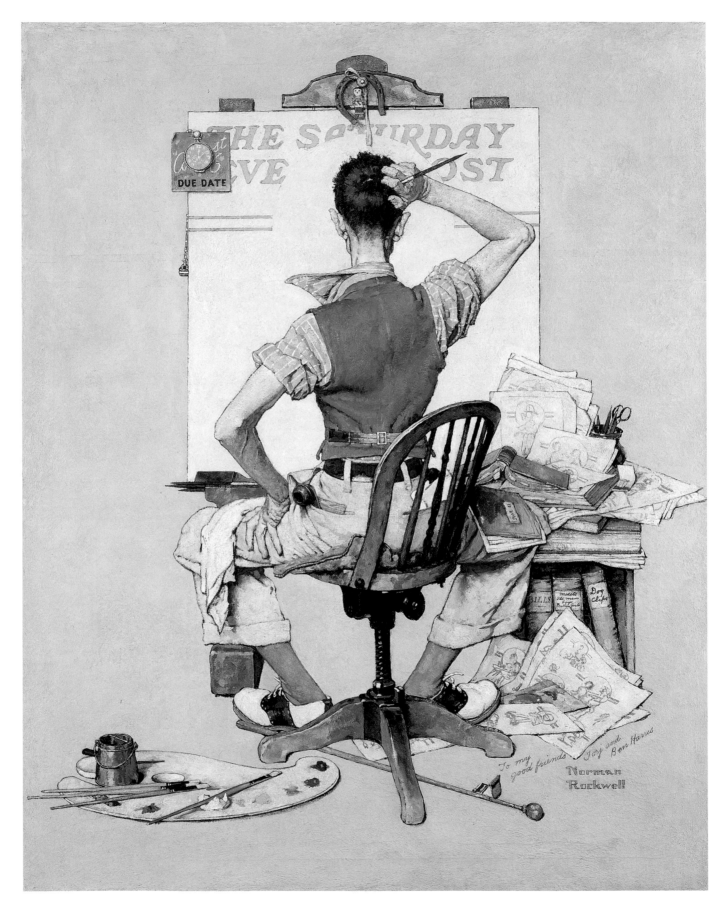

Artist Facing Blank Canvas (Deadline), 1938

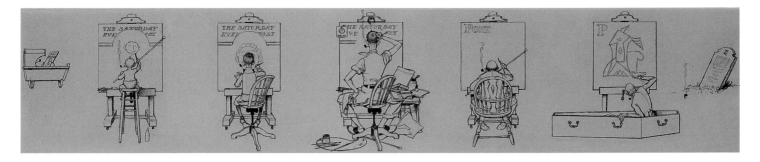

Norman Rockwell Illustrator (NR from the Cradle to the Grave), 1946

his audience, otherwise he could not admit to this problem and make himself the butt of his own joke. But also, on a more intellectual level, there is a form of playing with the nature of realistic painting here. The job of the illustrator is divided into two parts: the generator of ideas and the painter. Concept and execution are separated so that the block in the creative process can be identified; it is in finding the concept. Execution is not the problem, as is made manifest by the detail-filled image. Realistic painting is realistically analyzing itself. Hiding behind the joke is a statement of some seriousness: the problem with painting is the concept.

During the late 1920s and early 1930s, my father went through a period of turmoil in both his personal and his artistic life. He divorced and remarried. His painting became a source of dissatisfaction. A son was born, and then he picked up the family and went to live and paint in Paris. At that time, Paris was the center of modern painting. French painting, beginning with Impressionism, was the avant-garde. American artists went to Paris to escape the provincialism that they often felt in their own country and to find a source of renewal for their art. Norman Rockwell was conscious of what went on in the world of painting, and apparently he felt stuck in a rut. Perhaps the way out was to follow the lead of the avant-garde.

One of the directions of modern painting was toward minimizing the process of developing a picture through preparatory sketches. The traditional method was to slowly develop a composition through increasingly refined drawings. An artist planning to paint a landscape would make sketches outdoors but then develop them in the studio into the final composition, which was often an idealization that combined the most interesting parts of a number of real places. The Impressionists, in contrast, took their easels and canvases outdoors and painted the scenes that were directly in front of them. Later abstract painters did not paint outdoors, but they did follow the Impressionists in rejecting preparatory sketches. Picasso and Matisse carried out their compositional work directly on the canvas: concept and execution were simultaneous. My father's technique was always one of careful preparation. He posed models only after their positions had been worked out as part of the overall composition, and he usually made a careful charcoal drawing before he began the actual painting. In Paris in 1931–32, he was questioning his own technique.

Seen in this light, the 1938 *Post* cover seems like an act of affirmation. The concept and the execution are divided. The painter cannot begin until he has an idea worked out, even if this idea turns out to be his inability to find an idea. He scratches his head before the blank canvas because he cannot work that way. He must have a prepared concept before the act of painting begins. The painting is then a form of credo: "This is what I believe about painting." At the age of forty-four, after seriously questioning his own methods for several years, the artist reaffirmed before his public his faith in his traditional technique.

In one other painting—a *Post* cover, like all his paintings that are statements about painting—Norman Rockwell confronted contemporary painting, which, in 1962, was taking a road very different from his own. This is *The Connoisseur* (page 86). A man

Fireman, 1944

stands with his back to us—just as the 1938 self-portrait shows the artist with his back to us—gazing at an action painting. There is nothing else to be seen but the painting and the observer. The painting is in the style of Jackson Pollock. The observer is dressed in a conspicuously formal and old-fashioned way: gray suit, gloves, an umbrella, and a hat. It is not the dress (then or now) that one would associate with either museum- or gallery-going. It is not the dress of a businessman or an art critic. In fact, it is notable for the way it makes the person unusual. No man in 1962 dressed that way unless he wished to stand out as conspicuously old-fashioned.

Another aspect of the painting is its complete absence of judgment. The man, his back to us, shows no emotion other than interest in the painting. The painting looks back unemotionally and certainly unjudgmentally.[2] It may seem strange to say that a painting is unjudgmental, but since my father had already painted three *Post* covers in the forties and fifties in which paintings are looking judgmentally at something or someone, it needs to be noted. *Fireman* (above), *Framed* (page 71), and *Art Critic* (page 61) all depict figures in paintings looking out from their frames at things or people in a disapproving or amused way. Paintings are alive, these pictures say, and they react to what goes on around them. (This is not a surprising thing for an artist-storyteller to communicate.) The fact that the abstraction is so detached from the viewer makes it stand out in the context of my

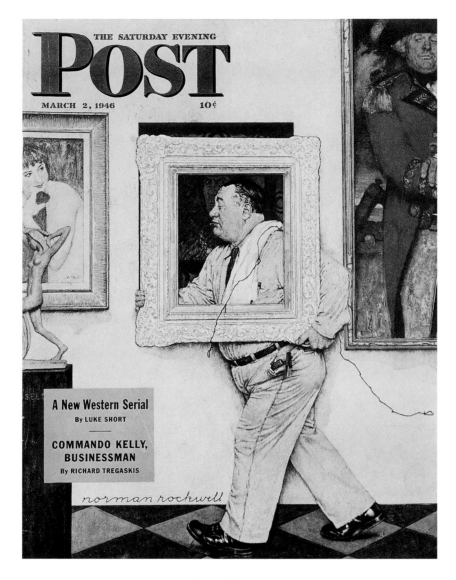

Framed, 1946

father's other paintings of paintings. That the viewer is both old-fashioned and nonjudgmental is equally noteworthy.

In the 1960s, people were judgmental about painting. Many looked upon abstractions as incomprehensible and possibly insulting and immoral. On the other side, many in the world of fine arts viewed realistic painting as not merely dated, but also reactionary and worthy only of contempt. My father, because of his way of painting and his popularity, was, in spite of himself, caught in the middle of the mutual bad-mouthing. People would write that he must hate Picasso and Pollock. I remember that a painter once came to visit just to tell my father that he was the last hope for world painting. My father, who tried never to disagree with

anyone to his face, commented after the man left how happy he was that we had served him a second-rate lunch. The other side accused him of contributing to a taste for bad painting. A fellow student once told me that my father's paintings were deplorable because they convinced American workers that they were happy when in fact they were not. In the middle of all this, Norman Rockwell painted his own way and frequently enjoyed the paintings of others. He was an admirer of Picasso, but was a bit befuddled by Abstract Expressionism.

To juxtapose without comment an abstract painting and a quaint observer is, in the context of its time, a statement in itself. Rockwell was judging himself, I think, to be a bit old-fashioned. The observer in the

Tom Sawyer (Whitewashing the Fence), 1936

painting shows the painter's view of his own style. The difference between the two, observer and observed, is a way of stating his acceptance of who he is and his unwillingness to change. The lack of judgment between the two and toward the two (for as the painting makes no judgment, we are not allowed to make one) says, "If there is a war, it does not exist between these two when they are alone together." They may not understand each other or agree, but any conflict lies outside the direct relationship between the two. This is also a credo: a painting and an observer have a one-on-one relationship without the need of intermediaries.

This belief is in conflict with attitudes about art in the twentieth century. As modern art has become more abstract and personal, a whole world of intermediaries has developed. On the one hand, art history lives in part from the belief that we cannot understand art without studying the context in which it was created. Criticism, on the other hand, takes its impetus from the idea that even the art of our own time requires interpretation in order to be appreciated. This can lead to the idea that art is not important or serious if it is easily understood. Rockwell acted in some ways as if he agreed with this, insisting with a slight touch of

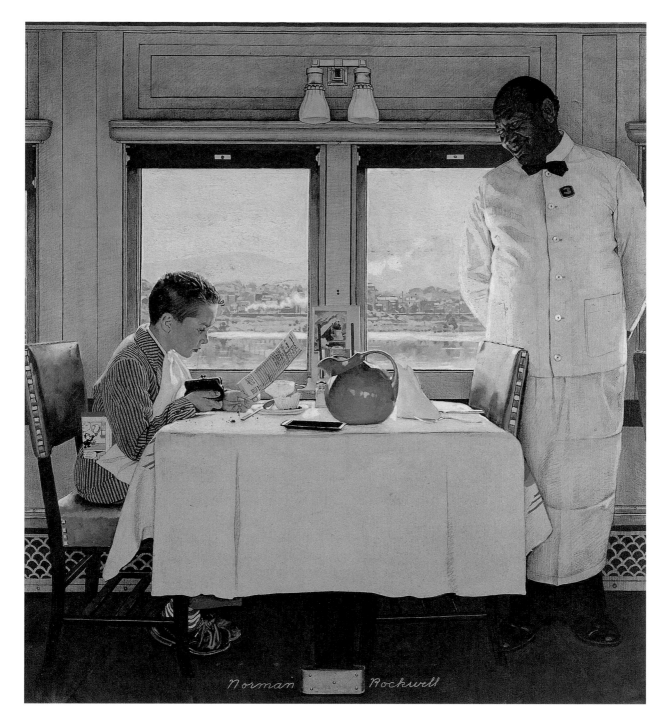

Boy in a Dining Car, 1946. Peter Rockwell was the model for the boy in this painting.

false modesty that he was merely an illustrator, a lesser sort of artist. At the same time, he did not budge from his position that what he did must encounter its public without the mediation of words or explanation. The story must be told without even a title, which *Post* covers never carried. Even in his book and story illustrations, such as for *Tom Sawyer* (page 72) and *Huckleberry Finn*, words do not stand between the picture and the audience. Rather, it is the picture that mediates between the words of the story and the reader by giving images to the tale. It is perhaps worth considering whether some of the opposition to Rockwell's work in critical circles may be because of its rejection of criticism's *raison d'être*. Seen in this light, *The Connoisseur* is a statement of aesthetic belief that stands out for its opposition to contemporary critical thinking.

The absolute realism of my father's pictures was the means he used to create the direct and unmediated relationship between picture and public. Everything was clearly and precisely depicted. He was a stickler for details, believing that every object in a picture had to be right. Every detail is shown with an equally precise realism. He never imagined a scene—a barbershop, or a stable, or a town clerk's office—but rather found a particular one to use as a model. Then he made sure that every detail was true to that place. Equally, there are no foggy corners or incomprehensible parts to confuse us. The pictures are so clear and detailed, so precisely and simply there in front of us, that they seem to present the story innocent of artifice. We can encounter the picture directly because it shows us a physical reality that we do not doubt.

The difficulty of this type of realism is that it takes a great deal of artifice to construct it. The painter uses perspective to create the semblance of three-dimensional space on a two-dimensional surface. Then there are all the problems of paint and color that must be mastered in order to create this artificial reality. Added to this is the fact that my father did not simply paint the setting directly; he used a real setting—Shuffleton's Barbershop in East Arlington, Vermont, for example (page 5)—as a shell into which he placed those details that told his story and from which he eliminated anything extraneous. I remember him troubling over whether he should have drops of water running down the window in order to make it clear that it was a window we were looking through. In the end, he rejected the idea as an unnecessary detail. The picture that looks out at the viewer with such an honest, open face is actually the product of planning, organizing, calculating, thinking, and finally, of all the technical ability that the artist can draw upon.

This contrast between the innocent image and the sophisticated technique that was at the heart of my father's pictures both fascinated and, I think, bothered him. To my mind, the single picture that most completely shows this fascination is the third of his three April Fool's Day *Post* covers (page 75). Through a drawn curtain, we see a young girl and an old man in a crowded room that is somewhere between a junk store and an antique shop. It is full of meticulously painted realistic details that are, for one reason or another, almost all wrong. This wrongness takes many forms: the girl is wearing two different shoes, the man has spurs on his shoes, she has a book slung from her arm instead of a purse, he has behind his ear something that is a pen on one end and a pencil on the other. This picture is, on first sight, a highly wrought version of the comic book drawings entitled "Find what is wrong in this picture." As we look at the painting, we see more and more ways that something can be painted absolutely realistically, yet be absolutely wrong. One way is the wrong detail—the girl's book-purse or the halo on the Mona Lisa. Another is realistic but unreal combinations, such as the animal at the girl's side, which has a dog's head on a cat's body with a raccoon's tail. Then there are those things that are impossible in this location: the birds flying through the room and the deer standing in the bookcase. The tropical bird on the left adds a different level to the unreality, because every other animal—deer, skunk, dog/cat/raccoon—implies a temperate climate. Then there are the almost surrealistic elements: the girl is repeated sitting in the shelf cuddling a skunk and as a sculpted bust behind the man's shoulder, and they both hold peculiar dolls. If you start to add together all these details, it is not simply a "what's wrong" picture, but a view through a curtain into a world of mysterious identity-switching that, as one looks at it more and more, becomes slightly disturbing. What is the meaning of the doll the girl holds, which is a combination of the old man's head, an antique dress, and deer hooves? The composition links the man's head to the two doll's head repetitions through the girl's arm to the skunk by way of a left-to-right diagonal. Does this have some meaning? The picture seems to be saying something about the relationship between childish innocence and old age, but what exactly?

I think that my father started this painting as another version of the April Fool's joke picture, a game played with realism in which each detail is painted with such innocent clarity that its veracity is accepted, temporarily blinding one to the ridiculous incongruities. The realistic painter in him could not resist demonstrating, as a joke that all could enjoy, what an artifice realism is. Somehow the joke seems to have

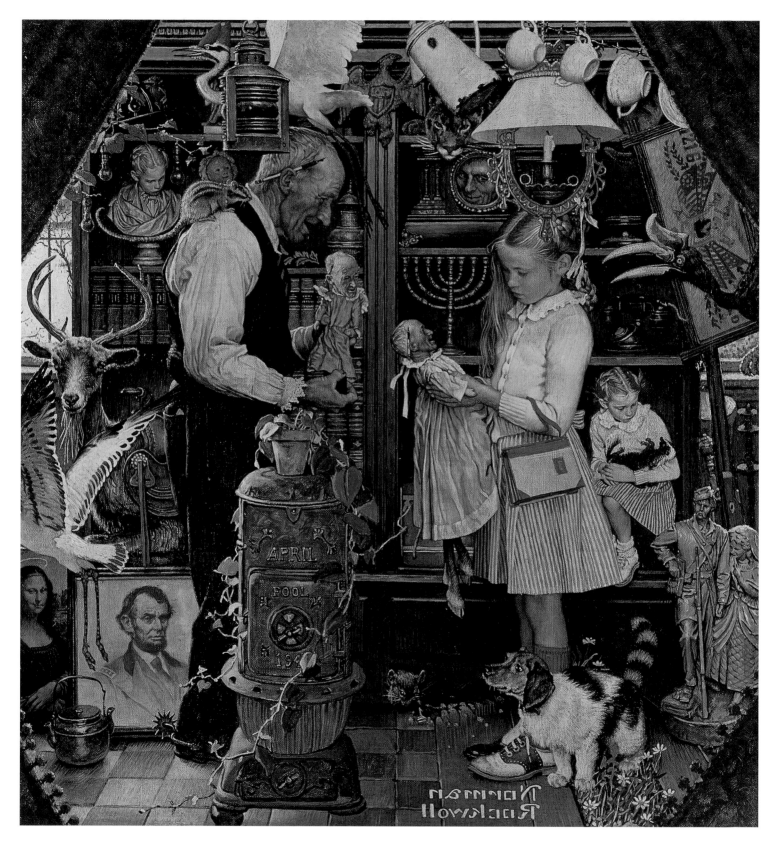

April Fool: Girl with Shopkeeper, 1948

sucked him in, so that combinations of the incongruous began to generate the possibility of mysterious meanings. It is as if realism is not just technique and artifice, but is also magic. Once entered, the world of magic can draw you in like a whirlpool until you find yourself in unexpected places. This picture is vaguely disturbing in part because it does precisely what Rockwell rejects in every other painting: it creates areas of uncertainty and asks difficult-to-answer questions, which open up a space for interpretation between the image and the observer. His fascination with the game-playing that realism requires of the artist led him to a type of painting in which the games are the subject. As the game became more complicated, the artist became more involved with it and less conscious of his relationship to his viewer. He seems to have been in danger of being sucked into another world by the very realism of which he was such a master.

My father did not, to my knowledge, ever again paint a mysterious painting. He returned several times to the painting's relationship to the observer, but he never again used the magic of realism to create a world contrary to our own. He did, however, paint a picture in which he tried to clearly describe his own technique of realism. This is *Triple Self-Portrait* (page 77), something of a misnomer since it contains more than three self-portraits. The painting was done as a cover for the *Post* issue that featured the first installment of his autobiography on February 13, 1960. Thus the painter is introducing his life story, composed with the help of his writer-son (my brother Tom), with a painted image of himself. He seems to be saying that he cannot paint his life story, but he can paint who he is now.

This picture is not a simple self-portrait in front of a mirror. Rather, it is an image of the artist in the process of painting a self-portrait. He expresses his pleasure in multiple images by showing himself looking into a mirror and painting. We have three major images: the artist with his back to us; the face seen in the mirror; and the black-and-white drawing on the canvas he is about to begin painting. Each of these presents a different attitude: the slightly awkward figure almost crouched in front of the painting with a touch of the comic; the intensely serious face looking in the mirror with eyes obscured by the reflection of light on

his glasses; and the outgoing, confident, and friendly face of the drawing on the canvas. Which, one is inclined to ask, is the real Norman Rockwell? Or is the real one too complex to contain in one image? Whatever the answer might be, we are not allowed to see the artist in one simple image, but fractured into a sequence of figure, mirror image, and slightly artificial self-image.

The sense of a sequence is heightened by the drawing tacked to the upper left corner of the canvas. This shows four different versions of his face as well as a sketch of his hand holding a pipe. It tells us, among other things, that the image on the canvas is the product of a process of trying out various poses. We thus have two sequences: the major one of figure, mirror image, and composed self-image, and the smaller one shown by the sketches. All of this is, of course, within the larger context of the total self-portrait, which is the painting as a whole. This picture, which at first sight is a simple one of the artist at work, has become a treatise on the art of composing a self-portrait.

Why is the face in the mirror so serious and intense when the one he is painting is so different? On one level, this repeats the message of the 1938 self-portrait, that there is a distinct difference between the act of composition and the act of painting. Through the sketches, the artist has arrived at his composition. Only after the composition is worked out will he return to reality for assistance in creating the finished painting. Reality is secondary to composition. On another level, the painter is allowed to have his cake and eat it too: he can show us both his belief in composition and his ability to paint realistically. On a strictly visual level, the larger size of the drawing is balanced by the color of the mirror image. So the painting, while indicating that composition precedes reality in the sequence of creation, gives reality an equal importance.

Who is the figure between the faces? Obviously it is the painter. This faceless figure is created with body language. He is neither the intense realist nor the optimistic composer, but rather a slightly awkward worker moving between the two. This figure shows a bit of the same quality of caricature that we see in the figure in the 1938 self-portrait, but it is only a suggestion. His position seated on a stool was obviously

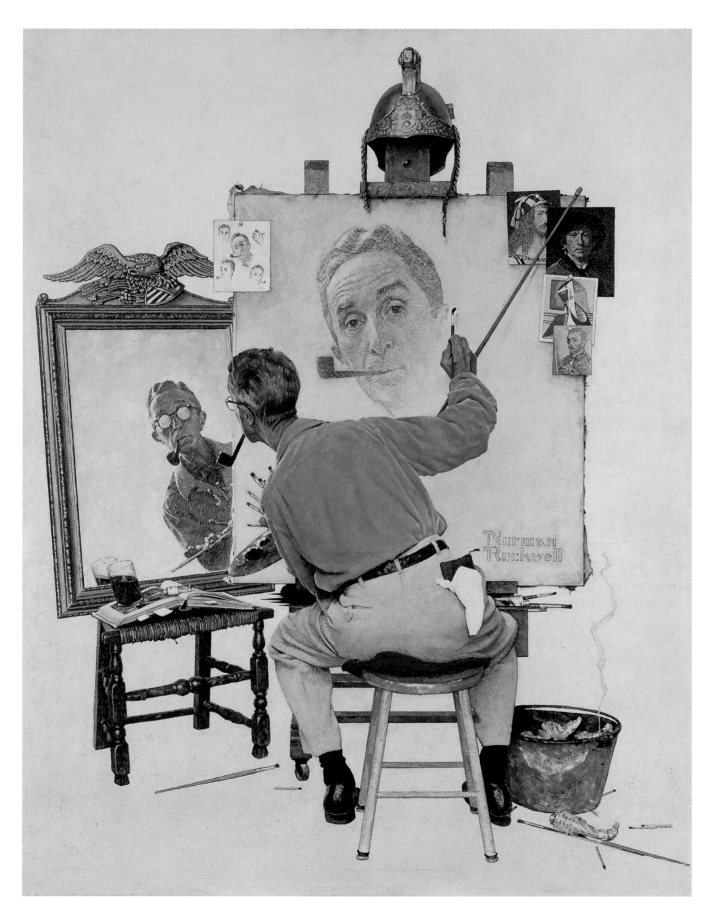

Triple Self-Portrait, 1960

important. As far as I know, Rockwell never painted sitting on a low stool. The chair in the 1938 painting is an accurate depiction of his furniture. So the awkwardness of the painter, the largest self-depiction in the painting, is important to the self-portrait as a whole. The intense realist and the optimistic composer are both mediated between and controlled by a slightly caricatured, faceless figure.

There are other details in the picture that refer to Rockwell's life and work: the American eagle; the Paris fireman's helmet; the smoke coming from the trash can (something that no amount of intensity in painting would have led him to neglect, given that he had caused his own studio to burn down in 1943 by carelessly knocking out his pipe on a seat cushion); and the reproductions of self-portraits of famous painters. These show us other aspects of the way the painter thinks, works, and feels. The painting in front of us is a multiplicity of images. The painter is playing a game, in effect asking us to construct his self-portrait from the images. The importance we give to any one area will make the interpretation of the painting in part our own creation.

My father believed that the picture and the observer should encounter each other directly without interference from words or interpretation. To my mind, *Triple Self-Portrait* is both the most complete and the most complex statement of this belief. We are given a variety of images and told, in effect, to construct the meaning for ourselves. There is, however, another side to this. The artist has not told us who he believes he is. He has given us the material to construct an image and by doing so has avoided committing to any one image of himself. By leaving it up to us, has the artist opted

out of the implied purpose of a self-portrait—to tell us who he really is?

My father held seemingly contradictory views about his own painting. On the one hand, the picture is straightforward, showing the artist painting in his studio. On the other hand, the painting is a careful construct made up of a gradually developed idea followed by meticulous execution. As we can see in the relationship between mirror image, the various sketches, and the face on the canvas, reality is secondary to concept. The final picture is the result of a long process of thinking. Although we encounter the painting directly, the painter is in careful control of what we see. It seems to me important that when we look at a Norman Rockwell picture and think about the painter, we bear in mind this contrast between openness and distance. We may not know the painter as well as we think we do.

Girl Running with Wet Canvas (Wet Paint), 1930

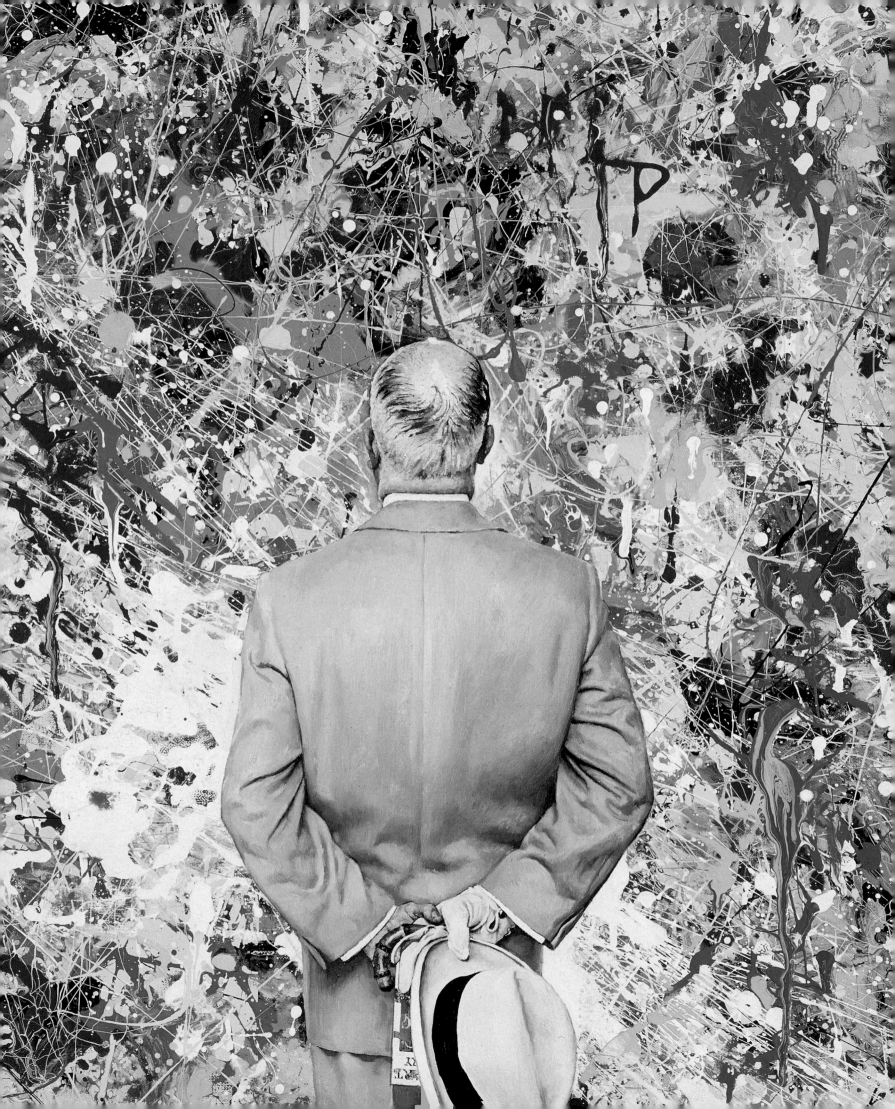

Wanda M. Corn

Ways of Seeing

Norman Rockwell cared about the history of art and often put paintings by old and new masters in his paintings. He particularly enjoyed depicting humorous interactions he imagined transpiring between museum visitors and paintings on the walls. Take *Art Critic* (page 61), a painting about the intense looking that goes on in museums. A young art student in baggy pants and torn sneakers is absorbed in the act of looking. With the aid of a magnifying glass, he studies a piece of jewelry adorning the chest of a woman in an imaginary Rubens portrait. That he is a copyist soon to begin his work Rockwell tells us through the young man's tools. Off a shoulder strap hangs his paint box, a portable easel, and a palette loaded with juicy globs of color rendered so literally that they invite touching to determine whether they are mere illusions or actual peaks of paint. (In Rockwell's oil painting for the illustration, they are in high relief.) Art magazines are tucked under the young man's left arm. Most importantly, in the hand held behind his back, he has a book illustrating the painting in front of him. Therein begins the joke, for in the reproduction, the woman looks straight out at the viewer as she would in an actual portrait. In the Rubens *à la* Rockwell, the woman gazes down upon the young copyist, conveying considerable interest in her young admirer. The respectable burghers in the seventeenth-century Dutch painting on the other wall also react with their eyes. They look disapprovingly upon what is transpiring between painter and painting. As our own eyes flit from detail to detail, joining all the other eyes at work, we quickly grasp that Rockwell's humor is about who is looking at whom. While this is easy humor to grasp, it rests upon a fundamental understanding of the nature of the art museum experience. Rockwell understood that museums are about seeing, about viewers using their eyes exclusively to interrogate the works of art in front of them. The humor comes when the figures in the paintings unexpectedly react to and return the viewer's gaze.

But where is the humor in another "looking-at-art" painting by Rockwell, the one called *The Connoisseur* (page 86)?[1] One's first impression is that little is going on. Rockwell set his stage with a cast of

The Connoisseur (detail), 1962

81

only two: the Painting and the Beholder. The Painting we see head-on; the Beholder, we see squarely from behind. We watch him beholding but are not privy to his reactions, for we cannot see his face. In addition there is one small but important walk-on role in this drama played by the Floor, whose diamonds direct our eyes into the painting and whose ordered forms create a base for the equally ordered Beholder. Given Rockwell's fondness for detail and for faces, the "defaced" viewer and the minimalist composition are the work's most startling features. Let's look carefully at these components as they appear in the original painting, where there is considerable texture and vivid illusionism, qualities diluted in the mass-produced and smaller printed version on the cover of *The Saturday Evening Post* (page 85).

When Rockwell rendered old-master paintings such as the Rubens portrait and the Frans Hals–like group in *Art Critic*, he imitated the loose brushwork and impasto on a much-reduced scale. Like those who make exquisite small-scale furniture for dollhouses, Rockwell had the ability to miniaturize the style of other painters. His deftness at imitation is particularly impressive in *The Connoisseur*, where he replicated Jackson Pollock's famous drip painting, a non-representational style completely at odds with Rockwell's own meticulous realism. From photographs and a couple of abstractions that the artist gave to friends, we know that Rockwell practiced his mock-Pollock style well in advance of the final painting.[2] He even had some studio fun, having himself photographed as he performed Pollock's characteristic gestures, imitating the famous and much-circulated photographs that Hans Namuth had made of "Jack the Dripper," as *Time* magazine described him (page 83).[3] Instead of the cigarette that hung from Pollock's mouth in many of Namuth's photographs, Rockwell clenched his pipe between his teeth.

In the final composition, Rockwell created a drip painting that appears to be approximately six feet square, reduced in the painting to one-third this size. It is just a little taller and wider than the height of the Beholder. Recalling Pollock's classic drip paintings of 1947–50 (page 84), Rockwell's Painting is a tour-de-force of illusionism. One can only marvel at how well he pulled it off. When Pollock created his large canvases, he laid them flat on the ground and walked around them, using the full swing of his arm to create arcs and drips of paint. The size and character of his forms, in other words, bore a direct relationship to the scale of his own body. To replicate such effects in miniature, Rockwell had to give the *illusion* of full arm swings of paint but in fact work up close with smaller instruments. He had to make the reduction without losing the proper relationship of the skeins of paint to the whole.

Even though the surface is not as airy and lacy as an original Pollock, Rockwell got something of the texture and energy right. His drips are appropriately thin, created by something more like a toothbrush than the trowel, knives, paint cans, and sticks that Pollock used, and the larger constellations of paint are proportionately in scale. Magically, the drips lie upon the surface of the canvas and retain their substance as paint. Some of the heavily painted areas have dried and shriveled, just as in Pollock's paintings.

While the painting easily satisfies viewers who know something of Pollock's style but have not been

Norman Rockwell painting *The Connoisseur*, 1961

Jackson Pollock painting *Autumn Rhythm*, 1950

Jackson Pollock, *Number 3 1949: Tiger*, 1949

trained in its intricacies, Pollock connoisseurs who have had intimate encounters with the real thing might blanch. For them, the forms would appear too mechanical and cold, the colors too bright, and the surface too densely worked over with the artist's characteristic forms.[4] Furthermore, Pollock's preferred format was not square, but vertical and tall or horizontal and long. "Apocalyptic wallpaper," Pollock critics might well call Rockwell's imitation, using Harold Rosenberg's pungent description of "decorative" action paintings whose forms and surfaces failed to have any existential urgency. Such works "lack the dialectical tension of a genuine act, associated with risk and will," Rosenberg wrote. The artist's "gesture completes itself without arousing either an opposing movement within itself nor his own desire to make the act more fully his own. . . . The result is an apocalyptic wallpaper."[5]

But if we characterize Rockwell as a mimic rather than as a poor abstract painter or Pollock wannabe, then we cannot help but be impressed by the way he used his realist skills to approximate (or illustrate) Pollock's drip style. He even buried a conceit of his

own within the Pollockesque swirls. To the right of the man's head, there is an unmistakable P for Pollock in bright red paint; with a little imagination one can also find a much larger (and bloodier) J to the left of the P. The stem of the J is crossed by a horizontal stroke, making not only a second, smaller J but also the shape of the cross. It was well known that Pollock had died in a car crash in 1956, five years before Rockwell conceived this work. On the wall below the Painting, in the same vertical register as the agitated JP, Rockwell signed his own name in sturdy, clean-cut block letters.

This deliberate juxtaposition of Pollock's non-representational artiness with Rockwell's own down-home illustrative skills happens again in the illusionistic body of the Beholder, which so bullishly interrupts the abstract Painting. In meticulous detail and clean realism, the Beholder is classic Rockwell; his body shape, clothes, and the things held in his hands identify his character type. He is conservatively attired, immaculately outfitted in a gray suit that is so perfectly fitted that nary a wrinkle appears across his broad shoulders. His costume not only speaks of his urbanity

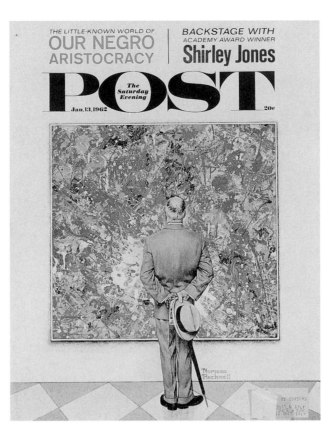

The Connoisseur, 1962

but also alludes to the male dandy whose aesthetic dress customarily included elegant gloves, an exquisite hat, and a walking stick, represented here by a surrogate umbrella. The soft gray gloves, in particular, give Rockwell's Beholder an air of preciousness and affectation, especially as one is worn while the other is not, a combination that has a long tradition in visual and literary representations of dandies. That our Beholder is a perfectionist in dress is also exemplified by his highly polished black shoes and his starched white shirt peeping above his suit collar and so tightly fitted that his neck bulges slightly out over it. This bit of fleshiness and the thinning gray hair suggest that the Beholder is in the prime of life. His dress evokes professional success (banking or law, perhaps), expensive tastes, and a touch of the esthete. He holds an Art Gallery Guide in his hands, signaling that he frequents galleries.

Exactly where is the Rockwellian humor in this confrontation between city man and abstract painting? *The Connoisseur*, unlike most *Post* covers by Rockwell, is exceedingly deadpan, giving us few directions as to how to react. Indeed, it is so open-ended that viewers read it from a variety of angles.[6] The three letters to the editor of *The Saturday Evening Post* that appeared in the February 17, 1962, issue are a case in point. M. R. Daugherty of Anaheim, California, wondered indignantly why Rockwell wasted his effort on "such junk! The word 'art' has been discounted as much as Uncle Sam's dollar in applying the word to such stuff." Joe F. Akins of Ruston, Louisiana, made his own joke of the cover by reading the Beholder as bewildered and suggesting that it was easy to understand why: for the painting "is obviously hanging upside down." A third writer, Robert J. Handy of Seattle, Washington, complimented Rockwell's modern abstraction—not bad for "just an illustrator"—and praised his sense of humor, a "quality sorely needed in modern art."[7]

The first two of these writers perceived the Painting as the kind of art they did not like or appreciate. The third found it funny, but did not say exactly where he found the humor. All of them implicitly acknowledged the primacy of abstract art in post–World War II American culture. By 1961, when Rockwell created

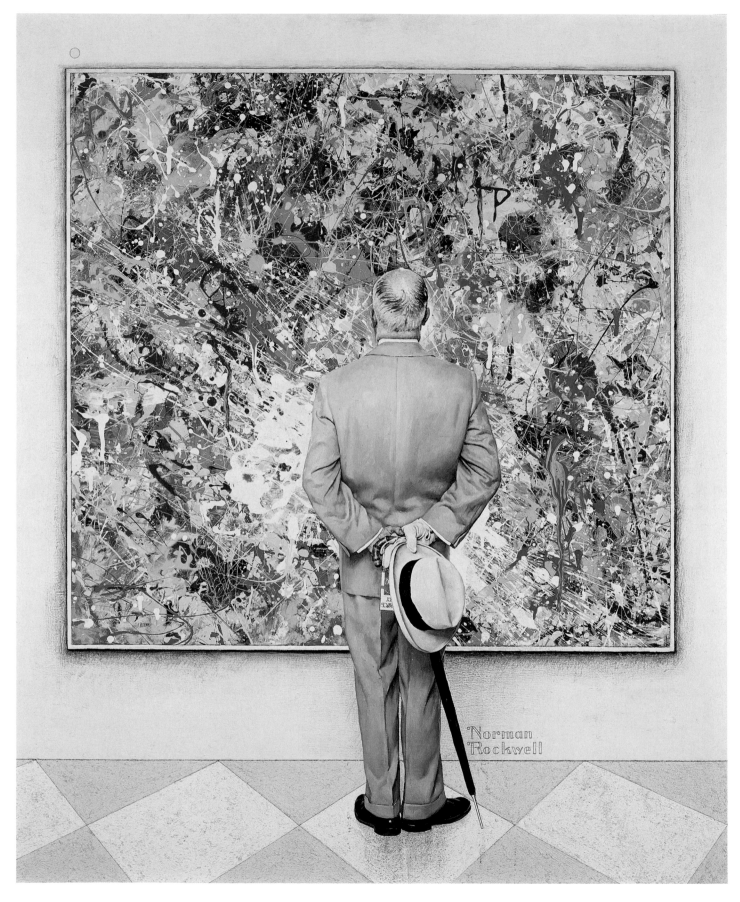

The Connoisseur, 1962

The Connoisseur, Abstract Expressionist art had been well covered in the popular press for nearly fifteen years; by the mid-1950s, it had successfully attracted collectors whose passion for this kind of difficult art was itself often newsworthy.[8] All this attention had helped fuel jokes and clichés about abstract paintings: that they could be hung with any side up or be produced by children or monkeys. In such a climate, Rockwell surely intuited that an encounter between a city gentleman and an abstract painting could amuse those for whom modern art was not a regular or necessary part of their universe. But he left the confrontation open to interpretation. *The Saturday Evening Post* readers might easily have found it funny because the world that the contemporary connoisseur occupied was so far removed from the realities of their own lives, or because they believed Rockwell shared their rejection of abstract art. Or they might project onto the male viewer their own bewilderment and anxieties as beholders of paintings whose forms of address they did not understand or find engaging. They might also have found the finely dressed art appreciator a comic figure, he being a type far removed from the middle-brow suburbanites who ordinarily populated the covers of *The Saturday Evening Post*.

There is good slapstick humor, too, in the collision of the chaos and disorderliness of the mock Pollock painting with the tidiness and fastidiousness of the Beholder, whose ordered world extends into the diamond-patterned Floor beneath his feet. The Painting is aggressive and assaulting; the Beholder, rooted to an earthbound tile, is passive and receiving. They are not natural partners but aliens confronting one another. However one wishes to describe it—chaos versus order, color versus line, Baroque versus classical, youth versus age, imagination versus rationality, left brain versus right, female versus male, immateriality versus material—Rockwell vested his illustration of a gentleman's encounter with an abstract painting with some of the grandest and most elementary conflicts in the universe. This is what makes me smile. The Painting is so random and chaotic and the Beholder so balanced and symmetrical. The middle seam in his suit jacket divides his body exactly in half, as does the thin space between his legs. Both arms are pulled behind his back at the same angle and even the folds in his sleeves and pant legs seems to echo one another. Furthermore, his weight is evenly distributed, and his feet are planted like a tree in the middle of the central white diamond on the floor. But then, within all this rigor, there are subtle asymmetries that Rockwell used to animate his stolid composition: the two feet pointing away from the body at slightly different angles and the Beholder's body placed just right of center.

There are also smaller amusements. A little twist of hair that has managed to escape from the Beholder's tidy pate curls into his bald spot like a Pollock swirl of paint; harder to see, there is also a little white tuft at the front center of the Beholder's head that simultaneously belongs both to the hair on the man's head and to the painting's surface. That the Beholder's body remains at attention in the middle of an explosion of white paint is another hilarious passage. How calm and contained he stands in the ejaculatory crossfire of luminous paint!

Given that the miniature Pollock painting is rendered so carefully, even respectfully, what can we

Unknown artist, *The Auction*, 1770

deduce, if anything, about Rockwell's personal appreciation of abstract art? If the Beholder is taken as Rockwell's surrogate, then it is all the more significant that the artist did not reveal the one body part we most want to see: the Beholder's face. This is a crucially missing element, since nothing about the Beholder, other than his containment and orderliness, registers any sure reaction to what he is seeing. Because faces are central vehicles for pictorial storytellers—certainly they were for Rockwell—the absence of the man's face warrants further consideration.

To assess the anomaly of Rockwell's faceless Beholder, let us compare him with other representations of connoisseurs looking at works of art. This is an old subject in the history of art, and traditionally the connoisseur's face is vital to the artist's narrative. When the subject first became popular in mid- to late-eighteenth-century England, connoisseurs were often the butt of visual jokes, and their faces carried the comic message. By distending the eyes and noses and exaggerating the wigs of their subjects, satirists such as William Hogarth and James Gillray mocked the pretense and greed of English gentlemen and women who formed private collections not because of a passion for art but for status and prestige. In an anonymous print made in London at this time, a group of upper-class connoisseurs, both men and women, stare at a landscape painting being offered for sale, not one of them seeming to notice that the canvas is upside-down (above). They are grotesquely malformed creatures, analogous to animals who consume everything in sight. They have hooked or pointed noses, barnyard mouths, and intense eyes aimed like arrows at works of art, but seeing nothing. They are acquisitive possessors who do not see.

Alongside this tradition of the connoisseur as blind and foolish, another depicted him as thoughtful and cultured. For artists such as Johann Zoffany in

Honoré Daumier, *Le Connoisseur*, 1860–65

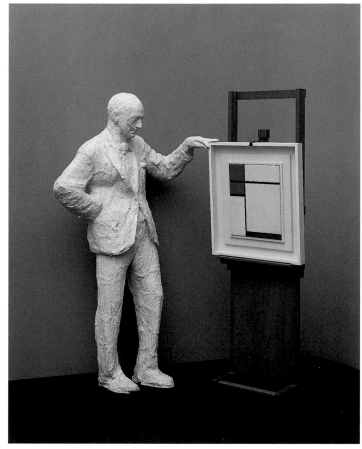

George Segal, *Portrait of Sidney Janis with Mondrian Painting*, 1967

England and, later, Honoré Daumier in France, the act of looking that transpires between a collector and a work of art was a favorite subject. In *Le Connoisseur* (above), Daumier's relaxed collector is seated in the privacy of his home, surrounded by works in his collection. He looks intently upon a small statue of the Venus de Milo standing on a nearby table, his absorption so total that we feel that we are intruding upon his private space.[9] The collector's face, turned to the object under scrutiny, registers appreciation and contentment. The pleasures of beholding, as well as possessing, are visualized further by the beam of light that Daumier uses to bring together the body of the connoisseur with the art he admires as well as the few prints at his side and on the table. Putting everything else in shadow, Daumier literally illuminates the satisfactions that concentrated looking can extract from works of art.

In his connoisseurial portrait of Sidney Janis (above), George Segal renders the same kind of genial looker who expresses his ownership of art—in this case a 1933 Mondrian painting—by gently touching its frame. In the 1950s and 1960s, Janis was a well-known contemporary art dealer in New York; he handled the work of European modernists such as Picasso and Mondrian and also contemporary American artists such as the Abstract Expressionists and Pop artists. By then he had also formed an important collection of modern art that in 1968 went to New York's Museum of Modern Art.[10] When he sat (or stood, in this case) for his portrait by Segal, he allowed one of the Mondrian paintings in his collection to be worked into the composition. Segal represents him looking kindly and reflectively at the abstract painting on the easel, as if it were a lover. Together the collector and painting form a couple on intimate terms.

In that Rockwell's Beholder is in a public space—most likely a commercial art gallery, given the guide

"*I wish this bench was in front of something I understood.*"

Barney Tobey, "*I wish this bench was in front of something I understood.*" *The New Yorker*, December 31, 1955

and umbrella in his hand—we must consider yet one more set of representations: cartoons about people in museums and galleries struggling to fathom—and articulate—the meaning of works of modern art. *The New Yorker* magazine specialized in cartoons of this genre and ran them so often that they conditioned audiences to expect humor whenever city viewers were pictured confronting difficult art. These cartoons poked fun both at the befuddled New Yorkers trying to understand abstract art and at the art itself.[11] In one such cartoon, a woman in a gallery of abstract sculpture stands in front of a golf club bent into an abstract shape and calls over to her perplexed husband looking at another work: "Here's one you'll understand." In another cartoon, two well-dressed women sit on a bench in front of a row of abstract paintings, and one says to the other "I wish this bench was in front of something I understood" (above). In these examples, viewers confess their inability to find meaning in abstract works of art, despite their effort. In a Peter Arno example that *The New Yorker* ran in 1961, two city gentlemen of the same type as Rockwell's Be-

holder study a Pollock painting and render a discriminating if pretentious connoisseurial judgment. One says to the other, "His spatter is masterful, but his dribbles lack conviction" (page 91).

Cartoons such as these had long been in circulation when Rockwell painted *The Connoisseur*. And his image has all the elements of these cartoons, except that it lacks a punch line. Rockwell does not tell us in words whether his Beholder is bewildered or delighted by what he is seeing; we don't even know if his eyes are open.

So what may we finally conclude about the silent Beholder's encounter with an Abstract Expressionist painting? Did Rockwell's faceless viewer-surrogate express the artist's own indecisiveness about modern art? Was the artist poking fun at connoisseurs of modern art by insinuating that they were dandified and effete? Was Rockwell angered, even threatened, by the popularity of New York School abstraction, expressing it by a joke: a miniature painting executed so well that Rockwell's talents as an illustrator dwarf Pollock's as a fine artist? Or was Rockwell's imitation the

Peter Arno, *"His spatter is masterful, but his dribbles lack conviction." The New Yorker*, September 23, 1961

sincerest form of flattery, conveying admiration for the abstractionist?[12]

There is some truth, I suspect, to each of these lines of argument, especially if we recall that Rockwell was working in a climate where he and other figurative painters such as Andrew Wyeth were roundly criticized for their storytelling. He had cause to defend himself against his detractors and have a little fun with the pieties surrounding abstract art. In the 1950s, the art world feverishly debated the relative merits of abstract art, realist art, and art illustration, and Rockwell, because he was popular, was frequently caught in the crossfire. Clement Greenberg, one of the most vocal critics of the period and a champion of Pollock and other New York School artists, set the terms of the debate. He argued for the aesthetic complexities and challenges of abstract art while protesting the cheapened kitsch culture that he felt dominated America. In Greenberg's lexicon, Rockwell's illustrations were kitsch—that is, popular and commercial artworks that appealed to the masses. His realism was easy, sentimental, and undemanding. When such popular forms

become the dominant taste, Greenberg warned, the high arts find it hard to flourish or even survive, and enlightened culture collapses; this was a great danger, he felt, in a society as populist and commercial as the United States.[13]

In 1949, Russell Lynes, a writer about contemporary culture, observed how pervasive the debates about the value of modern art, especially abstraction, had become. Even a popular magazine like *Life* was reporting on abstract painters and had sponsored a serious conference on the nature of modern art.[14] In a long and amusing essay, Lynes suggested that American culture was now divided along lines of taste rather than class. "It isn't wealth or family that makes prestige these days. It's high thinking," he suggested.[15] The country was now broken into three taste groups: highbrow, middlebrow, and lowbrow. Lynes described highbrows as individuals who were challenged by the complexities and intellectuality of modern art, while lowbrows did not care about what was in or out of fashion in art; they just liked what they liked. Middlebrows, on the other hand, took high culture seriously

IN CLOTHES CHARACTERISTIC OF THEIR CULTURAL STATIONS, A HIGH-BROW (LEFT), LOW-BROW AND MIDDLE-BROW (RIGHT) LOOK AT THE PICTURES THEY PREFER

HIGH-BROW, LOW-BROW, MIDDLE-BROW

Herbert Gehr, *Highbrow, Lowbrow, Middlebrow, Life*, April 11, 1949

but did not make the fine distinctions of the high-brows. They put reproductions on their walls rather than works of art, and in many respects they had ordinary and eclectic tastes. When it came to modern art, middlebrows could be philistines, lashing out at what they could not easily understand.

The editors of *Life* magazine liked Lynes's *Harper's Weekly* article so much that they digested it for their readers, creating two pictorial charts to categorize the new taste lines.[16] In one of these, they depicted three men standing in front of three pictures (above). Just as in Rockwell's *The Connoisseur*, we see the men completely from behind and judge their types by their clothes and body postures. To the left, the highbrow man in a suit has his hands drawn comfortably behind his back, his body relaxed as he looks upon a Picasso portrait. In the center, the lowbrow wears a baggy shirt with suspenders; he is short, a bit overweight, and lounges onto one leg. Working class in type, he

stares at a pin-up on a calendar. The third man, the middlebrow, stands with tension running throughout his suited body. His hands are drawn in front of him, his shoulders are square, his body type athletic and alert. He looks with assurance at Grant Wood's painting *American Gothic*. He might just as well have been admiring one by Rockwell.

Such postwar arguments set the parameters by which Rockwell was judged by modernist art critics at the time and by art historians today. The latter still are likely to see in the illustrator's work a pandering to philistine audiences, whose antimodern tastes they assume Rockwell shared and nurtured. *The Connoisseur* offers a brilliant corrective to such knee-jerk presumptions. In it, Rockwell makes clear that he knows something about abstract art, and he details for his audience the differences between his very literal style and the abstract one of a modern artist. He found a way to illustrate for a popular audience the different demands

that Abstract Expressionist canvases and the covers of *The Saturday Evening Post* made on their viewers. He used *The Connoisseur* to illustrate the theory of looking advocated by the New York School of abstraction and to demonstrate how different it was from the mode of looking embodied within his own illustrations.

A Rockwell painting addresses its viewers directly, relying on many details that are relatively easy to synthesize into a story. The canvases of abstract artists, especially those of the New York School, asked beholders to take time to experience pure form and color. The ideal viewer for Abstract Expressionist work was meditative, someone who slowed down, relinquished external concerns, and put himself into that suspended state Michael Fried has called "absorbed beholding."[17] As Pollock once told an interviewer, he thought viewers should look "passively" at his paintings "and try to receive what the painting has to offer and not bring a subject matter or preconceived idea of what they are looking for."[18] Through such acts of intense looking, the viewer might so psychologically merge with the painting that he would lose consciousness of his physical self (replacing eye-sight with I-site, we might say). Such a theory of transcendence lay behind the New York School's production of very large canvases, so large that they become painted environments, engulfing viewers who engage them from a close vantage point. Customarily, these canvases were hung low and far apart so that viewers would experience each one completely on its own, standing so close that they would have no peripheral vision outside the canvas. They were meant to be completely immersed by large fields of color and painted line.[19]

This, I would submit, is the kind of beholder experience Rockwell illustrated, revealing himself to be far more learned and experienced in abstract art than one might generally suppose. *The Connoisseur* illustrates the relationship between Beholder and Painting that abstract artists imagined and desired. Following this line of argument, let's look one last time at *The Connoisseur*.

Like the Pollock abstractions it imitates, the Painting is very large and was the first thing Rockwell painted. (One can see the vestigial outline of drips under the figure and under the white of the wall at the edges of the canvas.) He then painted the body of the Beholder over the painting so that two thirds of his body was embraced by the abstraction.[20] By tilting the diamond tiles of the Floor upward, Rockwell exaggerated what he had undoubtedly read about painters such as Pollock and Mark Rothko, whose ideal viewers engaged abstract paintings at close hand. He intensified that engagement by adding subtle shadows at all four edges of the canvas, making the Painting appear suspended in front of the gallery wall and pushing into the Beholder's space. Because the Painting is so colorful and dynamic, and so much more aggressive than the Beholder, it threatens to wrap the Beholder in its web. As if a counter force, the modeled body of the Beholder pushes back into the abstract canvas, creating a playful push-pull dynamic that cleverly mimics one of the formalist ideals of the Abstract Expressionist painters.

Locking his two protagonists into an intense pictorial relationship, Rockwell played upon the cliché that opposites attract. In its lock on the Beholder, the abstract Painting also signifies the attacks the New York School made on illustrators like Rockwell, whose gray-suited surrogate—so very realistic in style—stands his ground. But Rockwell's most subtle and sophisticated humor resides in the way he dramatized the nature of looking that Abstract Expressionist canvases invited and depended upon. This was not the kind of looking at details through a magnifying glass that Rockwell depicted in *Art Critic*, an old-master variant of seeing that he practiced as his own. It was rather a contemporary style of absorbed looking that promised transcendence and the experience of bodily loss. Rockwell's down-home emblem of that loss, and of this manner of beholding, is the missing face. The marvel is that Rockwell found a popular and accessible means to illustrate this difficult and innovative style of beholding while remaining true to his own audience's more traditional ways of seeing.[21]

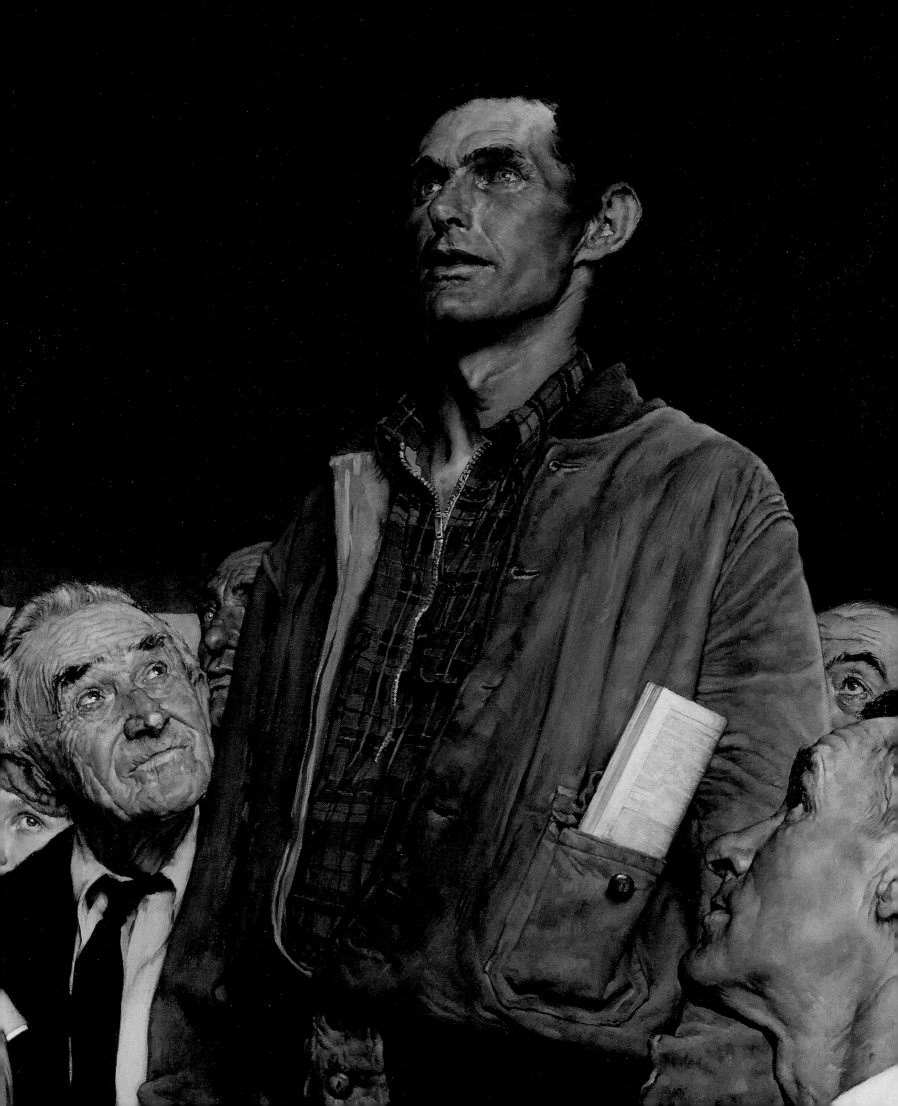

The Four Freedoms

The Four Freedoms are perhaps Norman Rockwell's best-known images. The four freedoms were outlined by Franklin Delano Roosevelt in his 1941 State of the Union address, and Rockwell completed his paintings of them during World War II as his contribution to the war effort. An immediate success from their first appearance in *The Saturday Evening Post* in 1943, *The Four Freedoms* have achieved the status of icons in American visual culture.

In his 1941 address, Roosevelt identified four basic human rights —freedom of speech, freedom to worship, freedom from want, and freedom from fear—that should be guaranteed "everywhere in the world." Roosevelt was both identifying the objectives of the war and revealing his hopeful view of the postwar world. Roosevelt's worldview could not be legislated into reality. Freedom from fear (by which Roosevelt meant a global reduction in armaments) and freedom from want were viewed as liberal politics, and congressional conservatives fought many of Roosevelt's war initiatives, which they saw as an extension of his New Deal.[1] For the Roosevelt administration, however, the four freedoms were always a critical component in understanding why we were fighting.

The Office of Facts and Figures (OFF), one of three government agencies responsible for war information—along with the Division of Information of the Office of Emergency Management (OEM) and the Office of Government Reports (OGR)—commissioned artwork, including murals, photographs, paintings, and woodcuts, that would present the freedoms to the public. Many works featured such symbols as a cornucopia or house of worship, while others depicted simian Japanese soldiers battling the Allies, or caricatures of the Axis dictators. The OFF also assembled a corps of writers, led by Librarian of Congress Archibald MacLeish, to communicate the idea of the four freedoms. Despite pamphlets, posters, displays, and other public outreach, by the summer of 1942, an Office of War Information survey reported that "only about one-third of the American public has any knowledge of the Four Freedoms as such, [and] no more than two per cent were able to identify all four of them correctly."[2] The four

Freedom of Speech (detail), 1943

freedoms had not yet penetrated the minds, much less the hearts, of Americans.

The summer of 1942 was also proving difficult for Norman Rockwell. He was concerned about the war effort and eager to do his part but unable to determine a course of action. In both his autobiography and a 1945 *New Yorker* article, Rockwell told the story of *The Four Freedoms* commission with a dramatic flair. Both versions tell of a 3 A.M. epiphany, when he realized that he should create a series of posters based on the four freedoms using his Vermont neighbors as models. There followed three days of frantic work on huge charcoal drawings and a disheartening trip to Washington, D.C., with his good friend and fellow illustrator Mead Schaeffer. Although the *New Yorker* article suggests benign neglect on the part of the federal bureaucracy,[3] Rockwell tells in his autobiography of outright hostility from the Office of War Information. "'The last war you illustrators did the posters,' he [the man in charge of posters] said. 'This war we're going to use fine arts men, real artists.'"[4]

Both versions of the story feature the same hero—Ben Hibbs, editor of *The Saturday Evening Post*—whom the dejected Rockwell and Schaeffer saw in Philadelphia on their return trip. Hibbs, on hearing Rockwell's idea, immediately jumped at the chance to publish the images, telling Rockwell to stop work on all other projects and finish the *Freedoms* for the *Post*. In both versions, the huge government bureaucracy fails to recognize the golden opportunity being offered, while the *Post*, a private enterprise, sees its chance and takes it.

The accuracy of this story becomes suspect, however, on the basis of one letter to Norman Rockwell from the Assistant Chief of the Graphics Division, Office of War Information. The letter, dated April 23, 1943, was written by Thomas D. Mabry after *The Four Freedoms* were published in the *Post*.[5] Before the war, Mabry held several positions at The Museum of Modern Art, New York, including Executive Director, and he came to his government post with an impeccable background in the art world.[6]

I have been wanting to write you for sometime to tell you how successful I think your Four Freedoms paintings are. I recall last spring, when you came to see me at the Office of Facts and Figures, *I said at that time that one of our most urgent needs and one that was most difficult to fill was a series of posters on the four freedoms.* Your paintings, which we are fortunately able to use as posters, will go a long way toward filling that need. I hope we will be able to work together in the future on other projects as the government greatly needs to call upon you (emphasis added).

Mabry enclosed a set of advance copies of the posters.

Why would Norman Rockwell have created a story of such melodrama surrounding his *Four Freedoms* if he had, in fact, met with federal representatives about such a commission? Why would Mabry have written so cordially about meeting with Rockwell the previous year if he had dismissed Rockwell's offer of work so coldly? No other letters have been found to shed additional light on the matter, although any earlier correspondence may have been destroyed when Rockwell's studio burned to the ground in May 1943.

The internecine wars within the agencies responsible for war information may hold the answer to this dilemma. The Writers' Division of the Domestic Branch, headed by MacLeish, was a division of the Office of Facts and Figures and was responsible for producing pamphlets that presented the government's position on issues relating to the war. Yet the three agencies responsible for war information—OFF, OEM, and OGR—were each autonomous. There was no single government entity controlling or even coordinating the flow of information.

By the spring of 1942, when Mabry wrote that he and Rockwell met, criticism of the government's information systems was high. On June 13, 1942, Roosevelt issued an Executive Order creating the Office of War Information (OWI), centralizing the OFF, OEM, and OGR.[7] The administration also brought film producers and advertising executives into the OWI to better coordinate public outreach. Explicitly criticizing the Writers' Division, one memo to MacLeish claimed, "We must state the truth in terms that will be

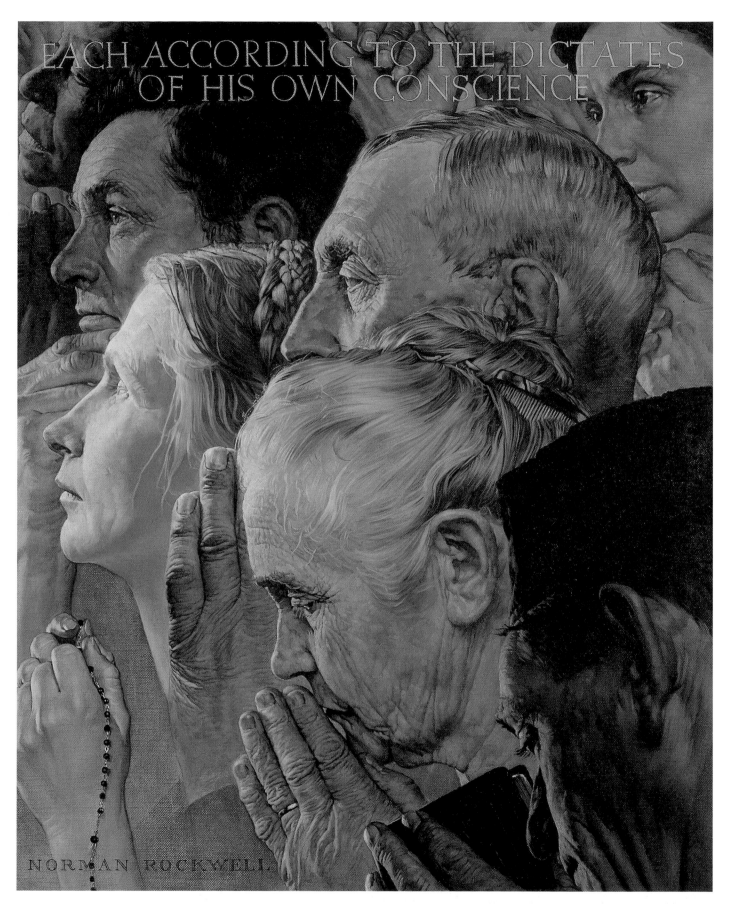

Freedom to Worship, 1943

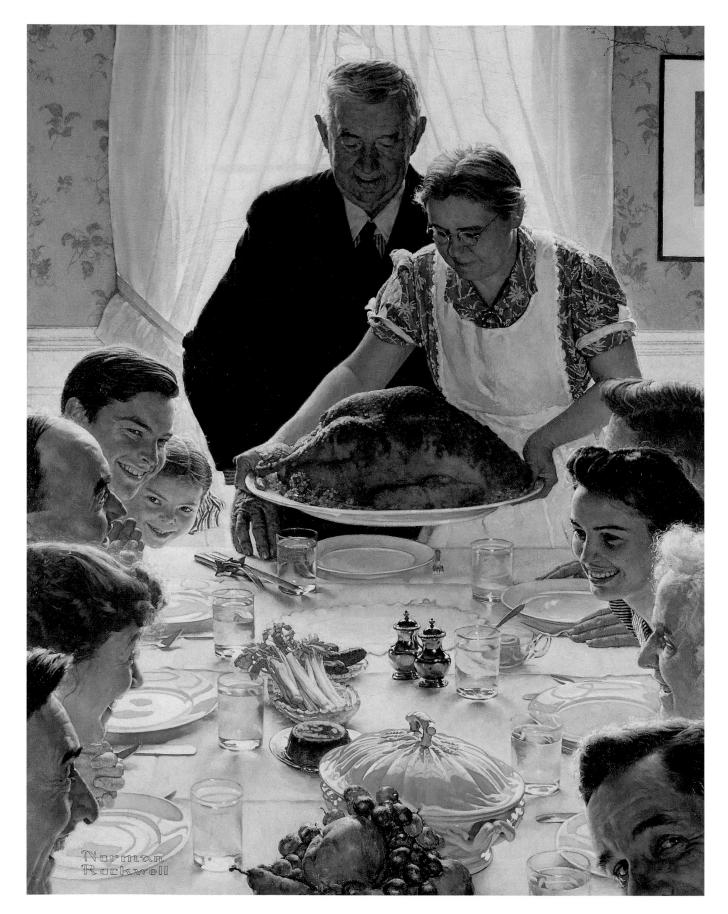

Freedom from Want, 1943

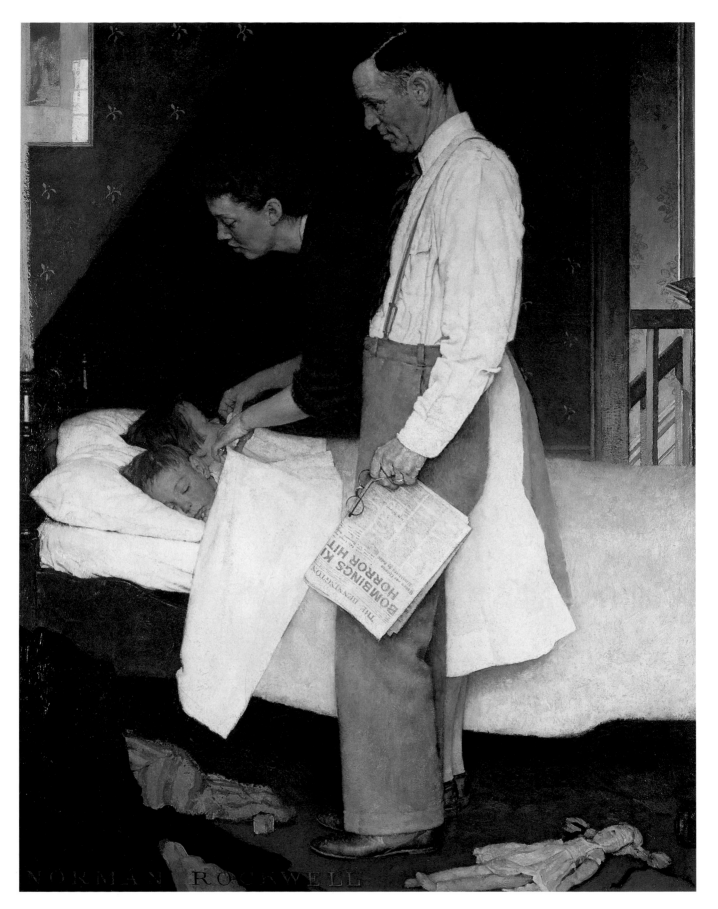

Freedom from Fear, 1943

understood by all levels of intelligence."[8] Image became all important. Pamphlets, the bailiwick of the Writers' Division, began to be seen as peripheral to getting the message out, and the liberal intellectuals of the Writers' Division became disenfranchised.[9]

The situation finally came to a head in the spring of 1943. Price Gilbert, a former vice president for Coca-Cola then working for the OWI, argued that posters portraying Nazi brutality by noted artist Ben Shahn were too unattractive for the general public. Gilbert expressed a preference for Norman Rockwell's visually appealing scenes.[10] The OWI decided to use Rockwell's *Four Freedoms* instead of Shahn's posters, widening the split between the "ad men" and the liberal intellectuals, who refused to concede that the general public might be more receptive to Rockwell's images than to Shahn's. Shahn and Francis Brennan— the former chief of the graphics bureau who "objected to treating the American people 'as if they were twelve years old,'"—created a poster with their interpretation of Gilbert's requirements for success. It showed the Statue of Liberty holding a bottle of Coca-Cola, with the caption "The War That Refreshes: The Four Delicious Freedoms."[11] In April 1943, when a pamphlet on American agriculture was cancelled because it was viewed as not being positive enough, the entire Writers' Division resigned en masse.[12]

It seems probable that Norman Rockwell was caught between these two factions in the spring and summer of 1942. Rockwell claims that he was moved by the Atlantic Charter (issued in the summer of 1941) to consider painting *The Four Freedoms;* it is likely that the suggestion came instead from Mabry or another official at the OFF. If a discussion did take place between Mabry and Rockwell in the spring of 1942, Rockwell probably would have returned to Arlington to begin work on the paintings. As the gulf widened within the OWI, Rockwell, unaware, may have returned to Washington in the summer of 1942 (having had his 3 A.M. brainstorm) to review his sketches, only to meet with derision (perhaps from Francis Brennan) and no commission to complete the works. By the spring of 1943, when Rockwell's paintings for the *Post* were completed, changes at the OWI created a warmer climate, at least in some quarters, for Rock-

well's work. The adoption of Rockwell's reassuring images for the Second War Loan Drive, while deepening the schism in the agency, showed the importance of using accessible words and images in getting the message of the four freedoms out at home as well as on the battlefield.

Once Rockwell had been commissioned by the *Post* to do *The Four Freedoms,* it took him six months to complete the job, "and it was a struggle."[13] *Freedom of Speech* (page 101) alone took four attempts. Rockwell's initial inspiration—a lone dissenter at a New England town meeting allowed to speak without argument or harassment—did not change, but composing the painting proved difficult. In one version, there are too many people in the picture and no single focus; in another, the viewer looks down on the speaker, who gazes ahead, close-mouthed. The final painting shows a strong central figure in the act of speaking, surrounded by his neighbors. The viewer is invited into the picture as a participant, seated in the bench and looking up at the solitary speaker, who stands out against a large blackboard, providing a background so dark that Rockwell's signature is almost invisible.

Freedom to Worship (page 97) caused more problems. Rockwell's first idea was to show a barbershop with men of different races and religions being shaved or waiting their turn, "laughing and getting on well together."[14] The situation struck Rockwell as ridiculous, and he found that everyone had a different view of how a particular religion or race should look. There were at least two more attempts before Rockwell decided to focus on heads and hands, close-up, in prayer. Unlike in *Freedom of Speech,* the viewer does not easily feel part of *Freedom to Worship.* Here, the scale of the heads and hands and the composition itself create a barrier for the viewer. While one figure in the lower right corner stands at a slight angle, the majority of the heads are in straight profile, an unwelcoming pose. One gets the idea that this is what Rockwell referred to as a "Big Picture," particularly with the phrase "Each according to the dictates of his own conscience" lettered across the top.

The final two images, *Freedom from Want* and *Freedom from Fear* (pages 98, 99), gave Rockwell little trouble. For an American, Thanksgiving dinner

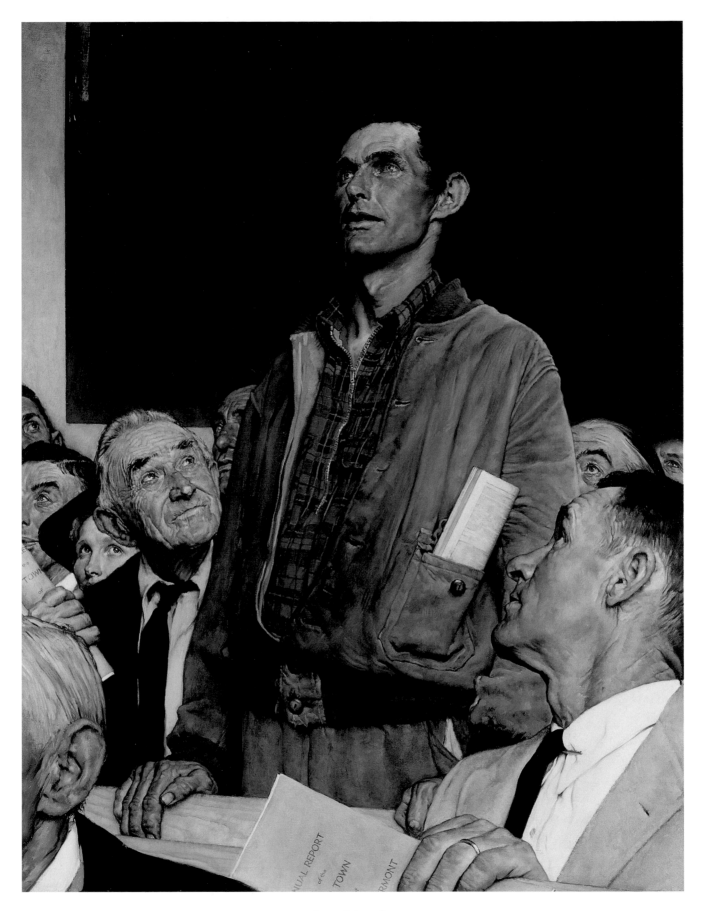

Freedom of Speech, 1943

seemed the ultimate fulfillment of freedom from want. Rockwell claimed to have painted the turkey on Thanksgiving Day, after which it became the family's holiday dinner.[15] Here a welcoming face in the lower right corner is turned toward the viewer. *Freedom from Want* is notable for Rockwell's virtuoso use of white on white, from china to table linens to water glasses and silverware.

The concept for *Freedom from Fear*, parents tucking their children into bed, was an unused *Post* cover idea from the Battle of Britain in 1940.[16] The angled chair in the lower left corner brings the viewer into the picture, but the scene is so intimate that some people may have felt more like voyeurs than participants. Rockwell's use of light within the darkened confines of the bedroom enhances that feeling of intimacy and emphasizes a sense of warmth and safety.

All four of the paintings share a muted palette. Rockwell's characteristic vermilion, which he often used to add interest to his works, is completely absent. Although often darkened or otherwise enhanced in reproduction, *Freedom to Worship* is composed of soft grays, beiges, and browns and is painted so thinly that the weave of the canvas is visible with no brushstrokes showing. Rockwell may have felt that these stylistic changes in *The Four Freedoms* were improvements to his regular painting style, reflecting his understanding of the importance of this commission and perhaps his anticipation of the public reaction to the works.

Rockwell believed that *Freedom of Speech* and *Freedom to Worship* were the most successful of the paintings. He wrote that *Freedom from Fear* was "based on a rather smug idea" that American children were safe in their beds as Europe burned. Rockwell also wrote that *Freedom from Want* was not popular overseas because of resentment of American overabundance. "Neither of them has any wallop," he said.[17] Yet *Freedom from Want* is now one of the best-known images in American visual culture. Popularly called "The Thanksgiving Picture," it has become a symbol of the November holiday. As a subject of parody and satire, it has been reproduced with Mickey and Minnie Mouse serving turkey to their cartoon family, in innumerable political cartoons, and as advertisement for frozen vegetables. While Rockwell may have felt the image lacked im-

pact, more than fifty years later, *Freedom from Want* has left an indelible impression on the nation's visual vocabulary.

Rockwell's assessment of *Freedom to Worship* as one of the most successful of the four is also questionable. Rockwell's success with *The Four Freedoms* was rooted in his fundamental ability to weave stories and create scenes in which many Americans could find something or someone to identify with, but *Freedom to Worship*, due to its monumental scale, is the least successful in this regard. Later, when he attempted to deal with other large topics from the Peace Corps (page 65) to the Golden Rule (page 103), Rockwell again used this focus on heads and faces, often in profile, sometimes with a phrase or caption lettered on the canvas. The effect seems too labored, as if to say, "This picture is important." Rockwell was usually able to achieve the same impact without being bombastic.

The Four Freedoms were launched on a nationwide tour in April 1943, during which over 1.2 million people viewed them and $132 million worth of war bonds were sold. Four million posters were printed during the war; with subsequent publications, *The Four Freedoms* are among the most reproduced works of all time. *The New Yorker* reported in 1945 that *The Four Freedoms* "were received by the public with more enthusiasm, perhaps, than any other paintings in the history of American art."[18]

Today, Norman Rockwell's *Four Freedoms* are all but divorced from Franklin Delano Roosevelt and the urgencies of wartime. Seen now in textbooks and newspapers, on plates and neckties, Rockwell's images still inspire enthusiasm. *The Four Freedoms* have become part of our public consciousness and collective memory.

Golden Rule, 1961

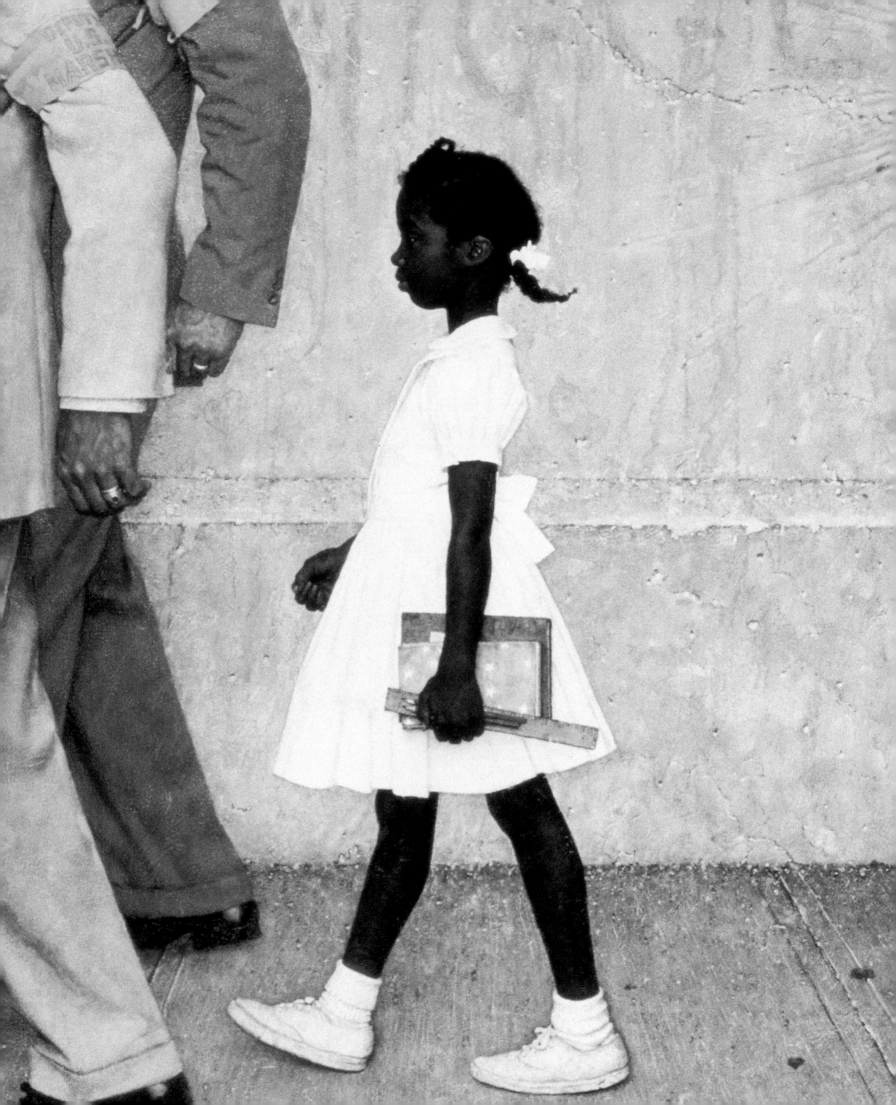

Robert Coles

Ruby Bridges and a Painting

A fateful coincidence changed my life in the fall of 1960—and gave me, eventually, an unforgettable acquaintance with a Norman Rockwell painting. I was on my way to a medical conference in New Orleans when suddenly a police barricade confronted me and others trying to make our way toward that cosmopolitan city. All of us were told that because a nearby school was being desegregated by federal court order, we were not going to be allowed further travel—a blockade had been established to give the police control over some of the city's neighborhoods. Suddenly, unexpectedly, I had a lot of time on my hands. I could have turned around and returned to Biloxi, Mississippi, where I then lived as an Air Force physician, in the military under the old doctors' draft law. Instead, I walked a few blocks, and soon enough I was in the presence of a large crowd of men, women, and children, who were not only milling around but occasionally uniting in a shouted refrain: "Two, four, six, eight, we don't want to integrate!"

Again and again I heard those words, directed at the yellow brick and cement building, the William Frantz School. Police were standing here and there, some of them, I noticed, joining in the screaming. I asked a middle-aged woman who seemed friendly what was happening. She told me right away—with words I'll never stop hearing in my head: "They're trying to bring a nigger kid into our school— it'll be over our dead bodies!" I was stunned—a well-dressed, fine-spoken woman who had descended into a panicky malice, who couldn't seem to help herself, who was ranting on a street corner to a Yankee stranger.

In about five minutes, just as I was about to walk away then drive away, I heard a hush, an almost audible spell of silence—as all eyes were directed toward several cars which, out of nowhere it seemed, had arrived in front of the school. Out of them, a number of men jumped quickly, warily, and out of one car, two men and a small girl dressed in white, with a white bow in her hair and a lunch box in her right hand. Suddenly, as the men and the child approached the school, walked up its steps, the crowd got back its collective voice and started the chant I'd already heard, kept repeating it, interrupted by cuss

The Problem We All Live With (detail), 1964

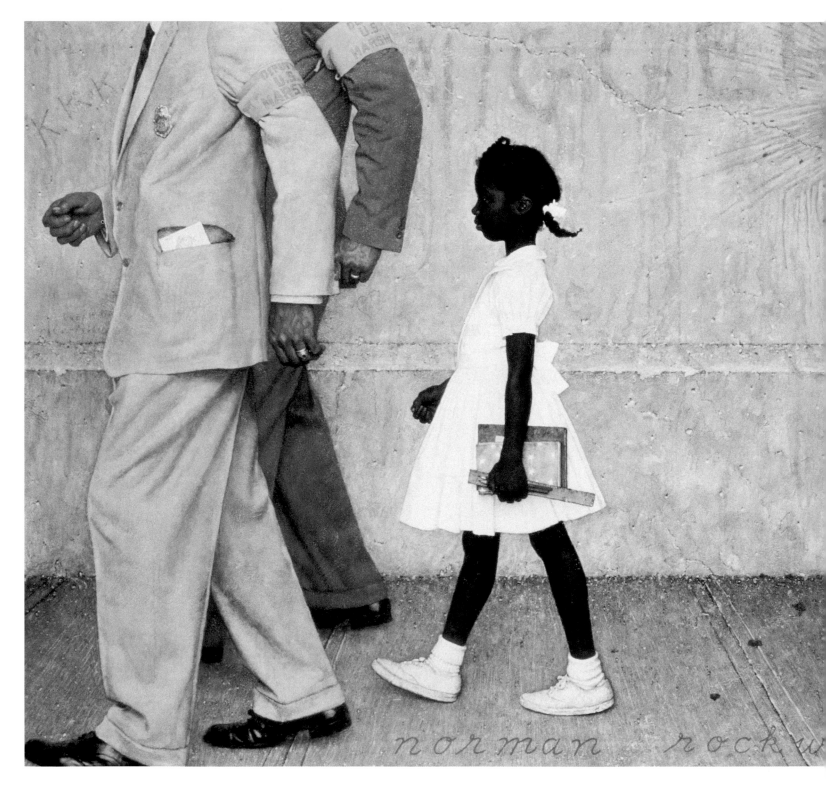

The Problem We All Live With, 1964

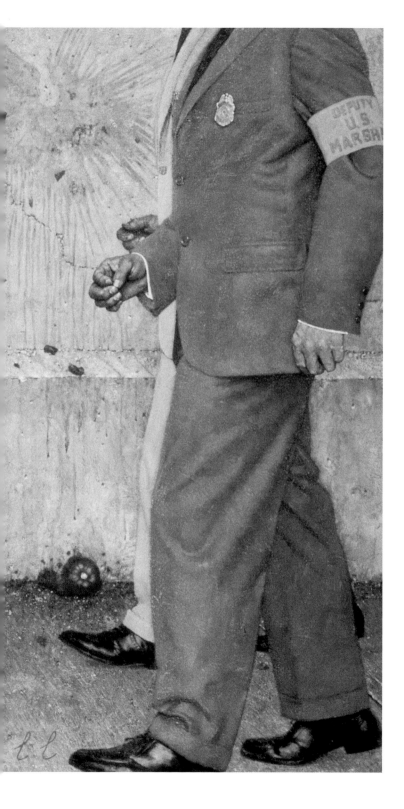

words, threats, terrible curses. The girl didn't look back; the men kept walking and, I noticed, were armed.

In no time, Ruby and her protectors (who were federal marshals mobilized by the Justice Department in Washington) had disappeared, though the mob was reluctant to follow suit. I left—drove away toward my home near Keesler Air Force Base, lost in melancholy thought. Not long afterward, in a way, my working life began: I determined it was my job to try to get to know Ruby Bridges, that girl I'd seen, and the three other girls, also aged six, who faced mobs standing outside another New Orleans school, McDonogh 19, and in the years following, a host of African American children who initiated school desegregation in city after city of the deep South during the early and middle 1960s.

Of all those children, Ruby was most familiar to me. For one thing, I knew her and her parents the longest—and then, her ordeal was literally singular: unlike others in New Orleans and elsewhere, she was all alone as she encountered those daily mobs, and the people on the street hurling epithets knew it, because they persisted far longer than those who shouted at the three girls who began attending the McDonogh school. I was often, as a white man wearing an Air Force officer's uniform, able to stand and listen to those people as they heckled Ruby, and in time I got to know some of them, interviewed them in their homes, even as I was meeting Ruby and her family in their home.

In a sense, it was Ruby's father who got me to do those interviews with the various white people I'd seen as I watched the drama in front of the Frantz School unfold. (A total boycott lasted months, so that Ruby had the school all to herself.) One day, Abon

Study for *The Problem We All Live With*, 1963

Bridges, while contemplating his daughter's school life (the struggles she experienced in order to arrive there and leave there, always in the company of federal marshals, and the experiences she had there as the sole student), offered these telling remarks: "You know, Ruby isn't learning only from her teacher at Frantz. She's learning from what's going on outside that building. She's learning all about people, human nature you could say—she's taking a *course* in human nature. What do I mean? I mean that this is a tough world, and people are always worrying about what's ahead, whether they'll keep their job, and be able to make ends meet—at least most people. You look at those folks on television, shouting at my little girl, and you can't help but wonder what they're really shouting about! I tell Ruby—you have to feel sorry for folks who can't help themselves: they leave their homes to come to the school, even in the heavy rain, just so they can tell this little girl that they hate her, and she'll 'get it,' and they hate the government, their own government, and it'll 'get it,' too. Now I ask you, isn't there something real sick about that—and what is it, what in the world is it that makes people get like that? Ruby has asked that so many times; she wants to know why, why, why—and I keep telling her that we should feel real sorry for people who behave like that, because

they're telling you something. When she asks me *what* they're telling us, I try to get her to stop and think. I say, honey, when someone's shouting at a little child they don't know, at a stranger trying to go to the first grade, then you can be sure there's someone else they want to shout at, or there's something on their mind that's upsetting them real, real, bad and they don't know how to get it out, how to say it, even to themselves—what's bothering them so bad—and then you come along, and they just go and use you, that's what they're doing: they're going after you, so they won't have to figure out what's wrong in their life, and what's wrong in the country."

As I heard such words, realized their import, I decided I ought try to learn more from the people whose predicament Mr. Bridges had so shrewdly evoked for his daughter, for me. In time, I came to know a family whose six-year-old daughter would have been Ruby's classmate, had not the following line of reasoning prevailed—relayed to me by a father almost the same age as Ruby's dad, and whom I had gotten to know reasonably well: "You probably wonder why we won't just ignore that kid, and let our own [children] return. [I had been asking him and his wife about their daughter's educational future, and that of her younger brother, when he became of school age, if the boycott

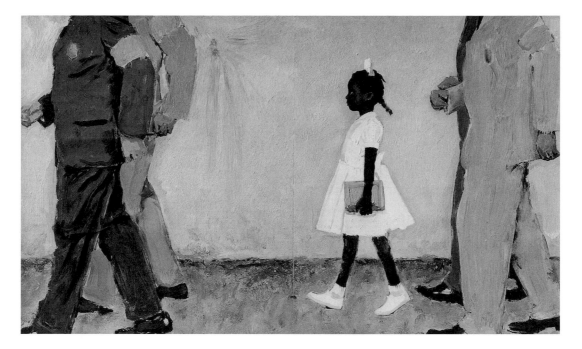

Study for *The Problem We All Live With*, 1963

persisted.] Well, let me tell you something: it's a matter of pride, that's how I'd put it to you. There's a lot of things that will happen to you in this life, there's all these problems that you have, and you've just got to learn to live with them, and it can be hard. I've lost my job twice in the past couple years, and I've had to go and find a new one each time; and my folks, they're getting old, and they're sick, and you have to pay the doctors and there's no money you have, so you borrow, and then there's big interest, and you feel everything is ready to crash in on you. Then, all of a sudden, some big-shot federal judge, on a big, life-time salary, comes and tells you that everything is going to change, that what is right and wrong is now going to be different, and *you're* the one to take the lead on all this, not the rich folks, living in the fancy neighborhoods, no sir: they got protection—[if] worse comes to worse, they'll send their kids to private schools. It's all unfair, and that's why there comes a time when you just have taken so much, and now it's all come here to roost right in your own neighborhood, and they're coming at your own child's life, *her* school, and giving it to someone else, just because someone up there in Washington, D.C., says it's got to happen, and someone down here, that judge, goes along."

The longer I listened to him and others like him,

the more I realized the truth of Abon Bridges's observations, a biblical truth, really: the scapegoat as an instrument of persecutory self-expression—the mob's anger, in this instance, deflected from its own social and economic vulnerability onto Ruby's situation, her presence and her jeopardy as a symbolic version of a day-to-day jeopardy experienced by her tormentors. Of course, it is one thing to know that, and quite another to be in Ruby's position, as even her dad, so intent on comprehending the world and explaining it to his daughter, well knew: "I try to help my little girl know what's going on, and why it's turned out like this. But there will be times when she looks at me, and she's clearly in trouble, because no matter what I tell her, she's got to listen to those folks saying their mean, mean words and she has every right to be upset. I'm telling her we've all got our problems, including those people screaming their heads off, and she's thinking that she's the one who has the biggest problem of all, what with the marshals the only white ones in New Orleans who are in any way looking out for her."

Ruby's father and the white father of a girl who was kept out of school for months because of a segregationist defiance of a federal judge's ruling both talked of their serious problems, and they shared those problems, which are in general to be found across the

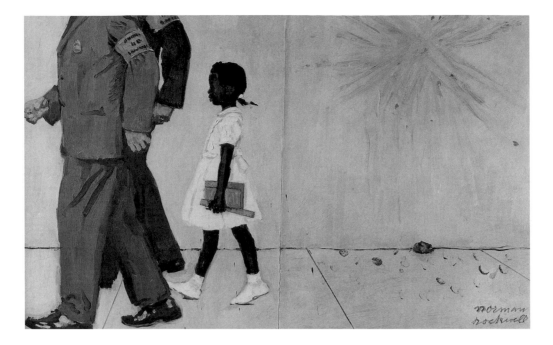

Study for *The Problem We All Live With*, 1963

color line. No wonder that in early 1964, when the centerfold of *Look* magazine showed Norman Rockwell's *The Problem We All Live With* (pages 106–107), there was an intense interest among both the white and the African American families I had come to know, and certainly an attentive, even aroused response from both fathers I have just quoted, not to mention from Ruby herself. Ruby was less expansively talkative, of course, than her dad, not to mention the white dad just summoned here. When she saw the picture of a "Negro child," as she heard herself described at the time by polite people, friendly people, as opposed to longtime hecklers, she looked carefully and for some time, but had no words to offer. She did, an hour or so later, ask her mother whether the picture was meant to be of her. In the mother's words: "She said, 'Mama, do you think that's supposed to be someone like me, maybe me?'" The mother said yes, that her experience had become well known to many people across the nation, hence that picture.

When I had a chance to sit with Ruby, we had a more extended discussion of the picture. Of course she had been drawing pictures of herself for me all along; and she had even tried to draw a picture not unlike, in subject matter, the one Norman Rockwell did for *Look*. (In child psychiatry we often ask children to draw, paint—and learn, thereby, what is on their minds, no

matter their not-rare reluctance to speak about the worries or fears besetting them.) As we looked at the Rockwell picture together and at her own pictures that dealt with the same theme (a girl escorted by grown-ups into a school in the face of evident or implied danger, a pioneer's lonely act on behalf of certain ideals), Ruby mused aloud about several matters: "I sure wish I could draw the way he does! He's got it down, what's happening, Daddy said, and he's right. I thought of the picture the other day, when I went to school, and I wondered what the men would say—if they saw the picture. [By then the marshals were not needed at the school.] I'll bet one of the marshals would say that his wife thought that if everyone in that crowd saw the picture, it might make a difference—they'd stop being so mean. (Daddy said that, and one of the marshals, maybe, would agree with him, and he'd mention his wife, because he always did.) But I'll bet the other marshal would say he wasn't sure [that would happen], because you've got a lot of angry people out there. That's what one marshal kept saying a lot—that there were a lot of angry people out there. If you look at the [Rockwell] picture in the magazine, you'll see things going all right, nice and quiet, but if you looked at the television, back then, it was real bad."

That was an extraordinary moment for me, listening to Ruby: in her own way, with the help of what

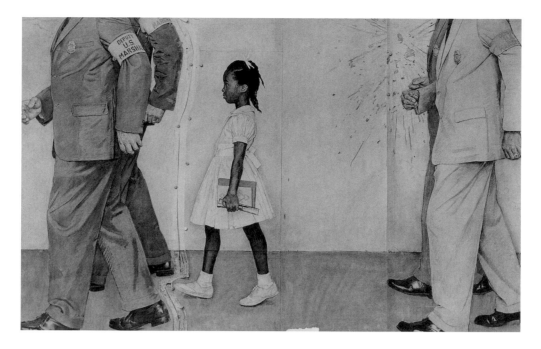

Study for *The Problem We All Live With*, 1963

she'd heard in the past from her dad and those marshals, she'd become a knowing social critic, and also an art critic. She had figured out the difference between television's documentary footage and the work of an artist—a painter's kindly but firm evocation of a moral moment in a nation's history, as contrasted to the first-hand, sometimes only thinly edited camera work that appeared on home screens. For Ruby, eventually, it came down to this: "That picture [by Rockwell] is about me, I guess—and what you see in the news is about the trouble on the street."

The white man who has been one of our witnesses here, and who surely caused some of the "trouble" Ruby rather tactfully mentioned, also got to see the Rockwell picture in *Look*, and had this to say: "That magazine tells you to 'look,' and I sure did; I thought 'there she is, the nigra kid.' You look at her and you begin to feel sorry for her—a lot of people will, I'm sure. It's not *her* we were against, you know. It's the interference in our life by those folks up North, that's what it was, that's what we were saying."

A shift in his language and his sentiment or ideology, so I noticed. For him, "nigra" was a less hostile or insulting or demeaning characterization—as opposed to the word "nigger" which, heretofore, he'd all the time used. Moreover, he was now (as never before was the case) letting Ruby herself off the hook, directing

his considerable ire at his nation's political life, at a region rather than a person. I couldn't help but feel then that a magazine's picture had somehow touched his heart, had given him some psychological if not moral pause. In a strange way, of course, Rockwell's picture, with its title of *The Problem We All Live With*, had brought together African American and white antagonists, each of whom (two fathers of six-year-old girls) had already said virtually the same thing: that there was indeed "a problem" or two with which they had to contend. The picture's quiet drama, its mix of affection and social candor, and its title worthy of a Trollope novel had somehow had an impact on a wide range, indeed, of those caught in such a difficult and scary and prolonged confrontation—all of which I had the pleasure and honor to tell Norman Rockwell in person when I got to know him in the late 1960s, as we worked together on a children's book, *Dead End School*, which I wrote and he illustrated. It was a book about school desegregation, only up north in Boston. How well I remember his interest in, as he put it, "the real Ruby," as opposed to the girl he gave to all of us—though I kept telling him that he, in fact, had caught and rendered for all of us some of the "real Ruby": after all, I had her word for it.

Study and working photographs
for *The Problem We All Live With*,
1963

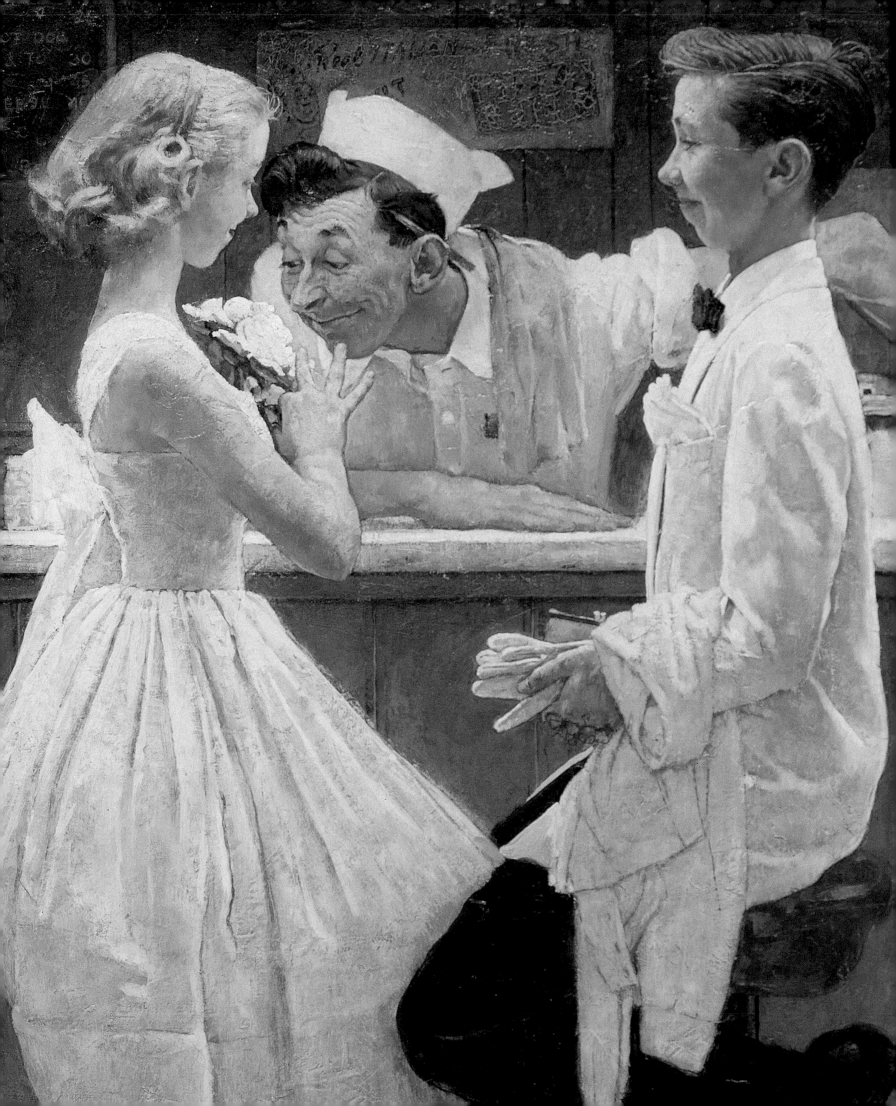

Dave Hickey

The Kids Are All Right: After the Prom

The icons of a living culture do not begin as canonical works preserved in books and museums and taught in university classrooms. They begin as treasures of living memory, and when official canonization is not forthcoming, they either fade from that memory or remain and survive there, as Norman Rockwell's *After the Prom* (page 117) has remained and survived in mine. I remember its first appearance on the cover of *The Saturday Evening Post* on May 25, 1957 (when I was as young as its young protagonists). Reconsidering it now, I find myself hard-pressed to come up with a better example of Rockwell's penchant for giving us, as John Updike put it, "a little more than the occasion strictly demands." With *After the Prom*, Rockwell has given us a great deal more than the occasion demands: a full-fledged, intricately constructed, deeply knowledgeable work that recruits the total resources of European narrative picture-making to tell the tiny tale of agape he has chosen to portray—all this for the cover of a weekly periodical whose pages will curl and melt before we have forgotten Rockwell's image.

 The *Post* version of *After the Prom* is a reproduction of a painting in oil pigments on an easel-sized, rectangular canvas that is about 13 percent taller than it is wide. In the narrative of the painting, Rockwell has positioned us so we are at once inside and outside the story. We have just entered a small drugstore in an American town on an evening in the spring and now stand facing a 1930s-era soda fountain bathed in golden light and populated by local citizens in 1950s-era clothing. Three customers are sitting on stools in front of the counter. A soda jerk is on duty behind it. In the right center of the picture, a blond young woman in a white formal dress and a brown-headed boy in a white dinner jacket and dark slacks sit facing one another on counter stools so that we see them in profile.

 The boy perches on the stool in an erect posture, holding the young woman's purse and gloves before him with her pale pink sweater draped across his forearm. He looks on proudly as the soda

After the Prom (detail), 1957

jerk leans across the counter to inhale the fragrance of the young woman's gardenia corsage. She lifts the flowers from her shoulder to present them to him. The third customer at the counter (partially cropped by the left-hand edge of the picture) sits on a stool with his back to us, holding a cup of coffee in his right hand. He glances over and smiles as the soda jerk sniffs the gardenia. A working man and almost certainly a war veteran, he wears a tattered bomber jacket, an Air Force cap with a visor, and khaki pants. A notebook and several pencils are stuffed into his back pocket. A ring of keys hangs from his belt.

The small-town consanguinity of the group is emphasized by the fact that all four figures in the painting bear a vague familial resemblance to one another. The boy and the soda jerk, who have the same nose, chin, and eyebrows, are almost certainly brothers. Everyone in the picture is smiling the same small smile, and we, as beholders at once inside and outside this cozy scene, are invited to smile as well. We are inside the store but not up at the counter—a part of the society but not a part of the community—but the open picture plane still welcomes us. It implies that even though it is best to be a part of the community, just being a part of the

society is not so bad, because even though we cannot smell the gardenia, we can inhale the atmosphere of the benign tableau arranged around it. The clustered burst of white in the center of Rockwell's painting, created by the young woman's dress, the boy's jacket, and the soda jerk's hat and shirt, constitute *our gardenia;* we stand in the same relationship to that white blossom of tactile paint as the soda jerk does to the young woman's corsage.

To compose this scene before us, Rockwell has divided the vertical rectangle of his picture in the traditional European manner, by laying the short side of the rectangle off against its long side, creating two overlapping squares whose intersecting diagonals create the picture's armature. The bottom line of the upper square runs along the tile line at the base of the stools; the top line of the lower square runs exactly through the boy's sight line (marking one of the horizon lines in the bent space of the painting). The whole action of the picture occurs within the overlapping area of the two squares—just at, or just below, our eye level. The counter, the kick rail, and the floor tile create a harmonic sequence of strong horizontals that intersect the regular verticals of the stools, the wood

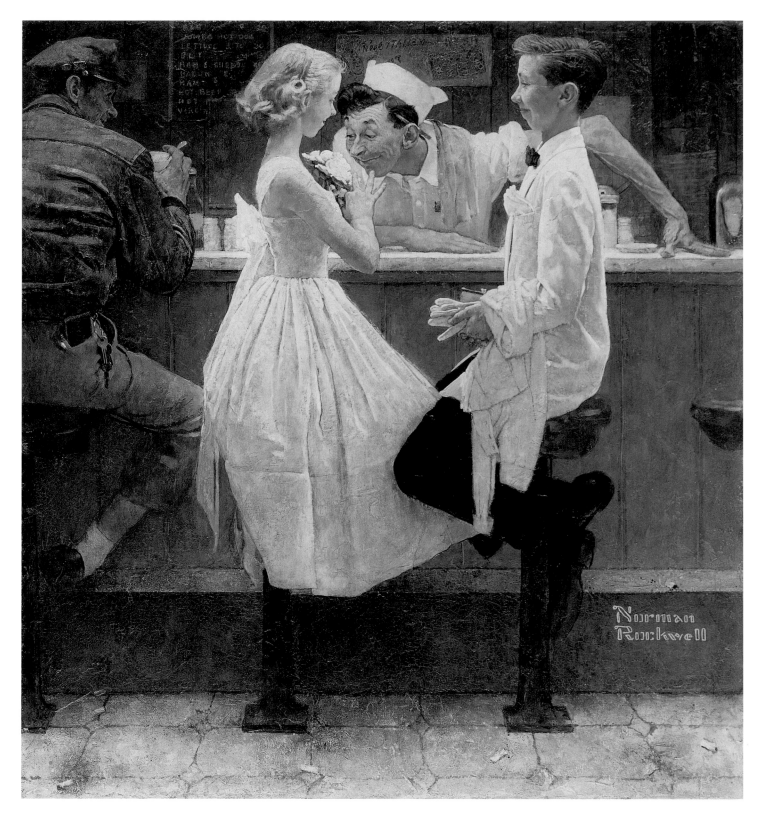

After the Prom, 1957

Jean-Honoré Fragonard, *The Swing*, 1767

paneling, and the signs on the wall behind the counter. This in turn creates an architectural grid into which the human figures are arranged in an intricate pattern of rhyming angles.

The forty-five-degree diagonals of the overlapping squares predominate. The front edge of the young woman's white dress, her upper arm, and the soda jerk's extended left forearm all lie on left-slanting forty-five-degree angles. The veteran's lower leg and the boy's upper leg lie on right-slanting forty-five-degree angles that reinforce the right-slanting forty-five-degree sight line of the soda jerk as he gazes at the gardenia. The boy's upper leg intersects the front of the young woman's dress at a right angle on the horizontal center line of the painting; this creates an inverted triangle that cradles the intimate action of the picture. The upper leg of the veteran and the boy's lower leg lie exactly on a falling thirty-degree line that traverses the picture, so their bent legs create two

symmetrically opposed seventy-degree angles, like arrows, pointing to the young woman, who is the center of all their attention. The pencil behind the soda jerk's ear also lies on a thirty-degree angle; it points out the young woman, as well.

In his most elegant formal maneuver, Rockwell takes the right-pointing triangle created by the working man's bent leg and the left edge of the canvas and rotates it ninety degrees to the right so it reappears as the upward-pointing triangle created by the soda jerk's bent left arm and the top of the counter. In this way, Rockwell acknowledges and accommodates for the fact that he has taken the static, symmetrical, face-to-face encounter between the boy and the young woman and invested it with dynamic balance by shifting its center of gravity about 13 percent upward and to the right, as indicated by the direction of the pointing triangles, to a point marked by the inverted triangle that cradles the central action. This device,

Jacques-Louis David, *Belasarius Receiving Alms*, 1781

combined with Rockwell's cropping of the counter on the left and right, creates a picture that, although it is harmonious and delicately balanced within itself, does not feel self-enclosed or claustrophobic. It still opens out; it still includes us.

To achieve this peculiar blend of inclusion and exclusion, Rockwell employs a pictorial strategy invented in late-eighteenth-century France and subtly alters it to his own purposes. As Michael Fried pointed out in *Absorption and Theatricality* (1988), one of the idiosyncratic inventions of eighteenth-century French painting was the practice of inserting a surrogate beholder into narrative pictures—a character within the painting's space whose response to the action we may take as a cue to our own responses and through whose eyes we are presumed to see the scene portrayed in its optimum configuration. This device is employed as a naughty joke in Jean-Honoré Fragonard's *The Swing* (page 118) where the surrogate beholder has a revealing view of the young lady in the swing that is not available to us. In Jacques-Louis David's *Belasarius Receiving Alms* (above), we see Justinian's great general, unfairly disgraced and blinded by the emperor, reduced to begging for alms in the street. One of Belasarius's

soldiers stands in the background of David's painting facing us, witnessing the scene we see from the opposite side. His horror and alarm cue our own responses, and his presence renders the action of the painting self-enclosed, as if we were seeing this drama from outside the moment and behind the proscenium.

In *After the Prom*, the soda jerk performs the function of Belasarius's soldier. He is our surrogate beholder (or inhaler, in this case). His response is clearly a cue to our own, but with a difference. Eighteenth-century paintings of this sort, such as Jean-Baptiste Siméon Chardin's *House of Cards* (page 120) or Fragonard's *Young Woman Reading*, insist on the *privacy* of the experience—of the young man building his house of cards or the young woman engrossed in her romantic novel. By extension, the private experience of absorbed beholder *inside* the painting is presumed to be analogous with that of the absorbed beholder *outside* the painting; both are presumed to be engaged in internal activities outside the realm of the social. In *After the Prom*, however, the soda jerk, who is our surrogate beholder (or inhaler), is not alone. He is *himself beheld* by the three other figures in the painting. He inhales the fragrance of the gardenia that is symbolic

Jean-Baptiste Siméon Chardin, *House of Cards*, 1736–37

of young love, and he visibly responds; the other figures in the painting respond to his response, and to one another. We respond to the totality of these responses, but we are not alone either. We are but one of many citizens glancing at their weekly issue of *The Saturday Evening Post*.

The innocent relationship between the two young people, symbolized by the gardenia corsage, then, is less the subject of than the occasion for Rockwell's picture. The generosity of the characters' responses, and of our own, is the painting's true, argumentative moral subject, and this was especially true in 1957 when Rockwell's prescient visual argument that "the kids are all right" was far from de rigueur. Having been a kid in 1957, I can testify to the welcome reassurance of Rockwell's benediction. It was exactly what was needed because, even though we all remember that American children rebelled against their parents in the 1960s, we tend to forget that American parents rebelled against their own children in the 1950s—that in the midst of the postwar boom, they began to regard their offspring with jealousy and suspicion, as spoiled, hedonistic delinquents who had not fought World War II or suffered through the Great Depression and were now reaping the unearned benefits of their parents' struggle. This attitude is the target of the reproach implied by the veteran's response to the action in *After the Prom*. His benign smile seems to say: "This is what I was fighting for—this is the true consequence of that great historical cataclysm—this moment with the kids and the gardenia corsage."

Rockwell's picture, then, opposes the comfortable, suspicious pessimism of the 1950s and proposes, in its place, a tolerance for and faith in the young as the ground-level condition of democracy. And, strangely enough, this celebration of the historical promise of youth is probably the single aspect of Rockwell's work that distinguishes him as a peculiarly American artist. In all other aspects of his practice, Rockwell was a profoundly European painter, a painter of the bourgeois social world in an American tradition that has almost no social painters and very few paintings that even portray *groups* of people, except at ceremonial occasions in faux-democratic "history paintings" or as figures in a landscape. The high tradition of American art is that of portraits, landscapes, and still-life painting. Rockwell painted mercantile *society*, in the tradition of Hals, Hogarth, Grueze, Boilly, and Frith, but

Nicolas Poussin, *Venus and Adonis*, 1628–29

being an American, he painted a society grounded not in the wisdom of its elders, but in the promise of its youth.

This, I think, accounts for the perfect inversion of European convention in *After the Prom*. First, Rockwell was not painting a bucolic genre idyll, like one of François Boucher's romantic encounters of shepherd and shepherdess. He was investing this small-town flirtation with the seriousness of historical romance. In a comparable European painting, however, we would see earthbound adult lovers (Nicolas Poussin's *Venus and Adonis*, above, or Giovanni Battista Tiepolo's *Anthony and Cleopatra*) surrounded and celebrated by floating or gamboling infants. In Rockwell's painting, we have floating youths surrounded and celebrated by earthbound adults. Thus, the two adults in *After the Prom* are invested with considerable weight. The soda jerk leans theatrically on the counter. The veteran sits heavily on his stool, leans against the counter, and rests his foot on the kick rail. The force of gravity is made further visible by the draped sweater on the boy's arm and the hanging keys on the veteran's belt, while the two young people, in their whiteness and brightness, float above the floor, sitting perfectly erect

on the pedestals of the counter stools—in one of the most complex, achieved emblems of agape, tolerance, and youthful promise ever painted.

——

Even as *After the Prom* was being painted, however, *The Saturday Evening Post* was in the midst of phasing out the kind of paintings that Norman Rockwell had created for its covers since 1916. These covers, of course, were justifiably famous and much beloved, but "the times they were a-changin'," and in the rush of things, Rockwell's vignettes of everyday life quickly succumbed to the rising vogue for celebrity icons among American media providers. As a consequence, the last great poet of American childhood, the Vermeer of this nation's domestic history, concluded his career as a glorified paparazzo. For more than forty years, Norman Rockwell beguiled American citizens with generous and felicitous representations of themselves; he ended up painting pseudo-heroic portraits of their public surrogates and illustrating moral platitudes.

Of the first 310 covers Rockwell painted for *The Saturday Evening Post* between May 1916 and

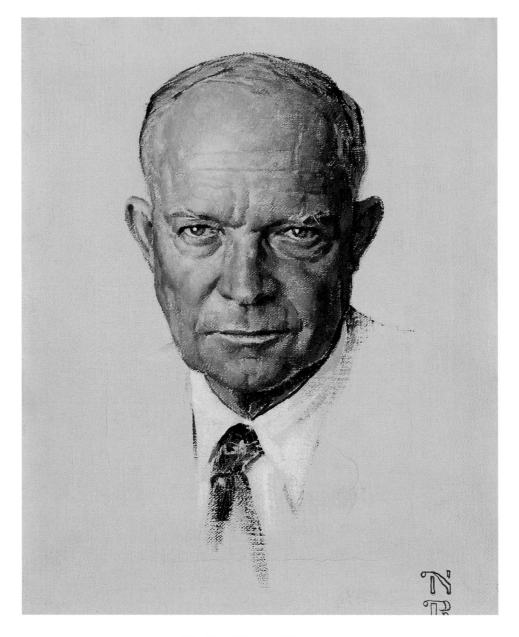

The Day I Painted Ike, 1952

September 1960, 306 portray ordinary Americans. Only *four* portray celebrities (Dwight Eisenhower twice, above, Adlai Stevenson, and Bob Hope). Of the last twelve Rockwell covers for the *Post*, between October 1960 and December 1963, *seven* portray celebrities. Three of these final covers are paintings of John F. Kennedy, and included among Rockwell's last "non-celebrity" covers is one of those egregious, moralizing Victorian tableaux of the sort once commissioned from Frederic Leighton: the "world's peoples" attired in ethnic regalia, across which, in golden Roman type, a text implores us to "DO UNTO OTHERS," et cetera (page 103).

Yet Rockwell's great social painting remains, and Norman Rockwell remains, as well, as a sustaining presence in the public consciousness—a more important artist than his modernist and post-modernist detractors will ever acknowledge, and a more complex artist than his traditionalist defenders are likely to admit. During his working career, his pictures were loved and respected not only by the American public but also by artistic spirits as dissimilar as Willem de Kooning and Andy Warhol. During the forty years since the zenith of Rockwell's career, the commercial illustrators with whom he competed for jobs have be-

Lunch Break with a Knight, 1962

come historical footnotes—as have 99 percent of the modern artists whose work was presumed to be infinitely superior to his—as, in fact, has modernism itself become a footnote.

Yet Norman Rockwell remains. During his public vogue, popular narratives in all media were routinely compared to Rockwell's way of looking at the world, and even today the vast preponderance of these popular narratives begin by evoking some version of Rockwell's domestic universe, then placing that cosmos in jeopardy through the machinations of criminals, bureaucrats, aliens, or asteroids. All of which suggests that the American vision Norman Rockwell invented and refined in paintings like *After the Prom*—which was supplanted by the rise of celebrity culture in the

1960s—was that which was *new*. In the history of art, Rockwell was the last, best practitioner of a tradition of social painting that began in the seventeenth century. In the history of America's democracy and popular culture, he was something brand new: the first visual artist who aspired to charm us all, and for more than half a century managed to do it.

Viewed from this perspective, the last anecdotal vignette Rockwell painted for the cover of *The Saturday Evening Post* (above) seems ominously prophetic. In this painting, the night guard at the Higgins Armory Museum in Worcester, Massachusetts, sits in semidarkness on the edge of a pedestal upon which a knight in full armor, astride his festooned and armored charger, presents a lance that disappears out of the top

of the picture, so both horse and rider seem suspended from it, as if on a merry-go-round. The museum guard is tucked into the lower-right-hand corner of the picture (the least dominant position in the rectangle). We hardly notice him at first, and when we do, it's clear that the little guy is tired and a little bored. He sits there with an open newspaper on his lap and pours himself a cup of coffee from his thermos. He seems prepared to wait out a long and tedious night amid his gleaming, posturing, heroic charges. At that moment, in the early 1960s, so were we all.

The painting of the night guard marks the end of what I consider to be the "real" (or at least the important) Norman Rockwell. The picture seems to be telling us that, and perhaps Rockwell knew it himself. Or perhaps he didn't. In any case, Rockwell eagerly participated in his own sanctification (or "maturation," as he would have called it). Having never had a proper "American childhood," Rockwell had always been, in his own perception, a child at heart and an instinctive outsider. During this period, as Rockwell underwent psychotherapy, he stopped thinking of himself like that (as a big kid making pictures to make friends) and began thinking of himself as a "mature artist"—as an *authority* on kids, like his two friends in Stockbridge, Massachusetts, Erik Erikson and Robert Coles.

Rockwell's friend and psychotherapist Erik Erikson had been a student of Anna Freud and was Boston's first child analyst. He was the author of *Childhood and Society* (1950), the book that introduced the terms "identity crisis" and "self loathing" into the lexicon of American childhood. Not long before Robert Coles became Rockwell's neighbor, he wrote *Children of Crisis* (1967). Coles's book dealt with the effects of the civil rights movement on children in the South, and he may have provided Rockwell with the story of Ruby Bridges as an inspiration for the young black girl whom Rockwell portrayed so powerfully in *The Problem We All Live With* (pages 106–107) walking to her newly integrated school in New Orleans, escorted by federal marshals. As strong and accomplished as this picture is, however, its cool, Davidian remoteness marks the end of Rockwell's instinctive identification with the citizens he painted and the beginning of his tenure as a member of the nation's new, therapeutic, power elite.

Rockwell, of course, would never gain any real access to Erikson's and Coles's peculiarly psychologized and Germanic vision of culture and childhood, but from this time forward, he would routinely mistake his friends' vocation for his own. He would generalize from particulars in the manner of a social scientist, rather than particularizing generalities as he had always done. Henceforth, like a painter king, he would paint his "subjects" rather than other citizens of the republic. He would illustrate "issues" rather than portraying other children of folly like himself. In his notes for a 1966 speech (although not in the lecture itself), Rockwell explained this shift. He began by announcing: "There was a change in the thought climate in America brought on by scientific advances, the atom bomb, two world wars, Mr. Freud and psychology." At the conclusion of his remarks, Rockwell responded optimistically to this daunting roll call by declaring himself to be "wildly excited about painting contemporary subjects . . . pictures about civil rights, astronauts . . . poverty programs. It's wonderful."

Today it's clear that these remarks marked a turn for the worse in Rockwell's career, but it would be a mistake to blame it all on science, psychotherapy, and Kennedyesque rhetoric. The truth is that, even though Rockwell was one of the great visual narrators of the twentieth century, he always thought of himself as an illustrator, and finally he became one. Throughout his career he was always casting about for the "big picture," for the "great subject" that would establish him as the important artist he correctly believed himself to be. In the end, sadly, he found the one and lost the other. His "big pictures" herald the twilight of his artistic importance. In his fatal misapprehension of his gifts, however, Rockwell was far from alone among American artists and writers. He was, in fact, no more the self-deluded Victorian than Mark Twain, who was similarly incapable of crediting his own comedic gifts —who thought *Huckleberry Finn* paled in its achievement beside his *Joan of Arc*, a novel which, in its platitudinous tedium, may be justly compared to Rockwell's *Four Freedoms* (pages 97–99, 101).

None of this diminishes either Twain's or Rockwell's startling achievement, however. And even though Rockwell himself concurred with the then-

fashionable assumption that his "old hat" domestic manner had somehow been superseded by the "new" glamour of issue-oriented, celebrity journalism, that does not make it so, since *nothing* in Western culture is older than issue-oriented, celebrity journalism. Homer invented the genre in *The Iliad*, and its return in the early sixties (courtesy, one suspects, of wily Joe Kennedy and his tame Harvardeers) signified nothing more than the last, vulgar recrudescence of the "great man" theory of history—the last dying swoon of an elitist idea that the virtue of a society resides in the concerns and personae of its leaders and heroes, rather than in those of its citizens.

In the history of Western art, this idea expresses itself in the traditional distinction between "history painting" and "genre painting." Genre painting, in this tradition, concerns itself with "low" subjects, with everyday people whose ordinary, inconsequent activities —eating, gambling, smoking, reading, singing, and playing the lute—are portrayed as evidence of human *vanitas*, as testaments to the perpetual evanescence of earthly desires. History painting, on the other hand, concerns itself with kings, heroes, gods, and saints and their *consequent* (which is to say *historical*) activities. Norman Rockwell's great achievement was in traducing this distinction and investing the everyday activities of ordinary people with a sense of historical consequence, and this acute micro-historical consciousness, I think, best explains Rockwell's survival as an artist of consequence.

To put it simply, Norman Rockwell invented Democratic History Painting—an artistic practice based on an informing vision of history as a complex, ongoing field of events that occurs at eye level—of history conceived and portrayed as the cumulative actions of millions of ordinary human beings, living in historical time, growing up and growing old. George Caleb Bingham is Rockwell's only American predecessor in this field, and his paintings are less historical narratives than provincial reportage, their emphasis falling more heavily on the place than on the times. Benjamin West's "democratized" history paintings simply substitute elected officials for crowned heads in the same pictorial universe. Rockwell's best pictures, on the other hand, treat each quotidian moment as a

distinct historical occasion. Moreover, Rockwell presumed that this moment would remain available to us in the continuity of tumultuous micro-histories that define democracy in progress. It is exactly this sense of history as tumult, however, that makes Rockwell a very poor candidate for the position of conservative icon for which he is regularly nominated. He does, indeed, portray a simpler past in loving detail, but this devotional aura derives less from his reactionary tendencies than from the fact that he invariably portrayed the *present* as a historical moment, as if it were the past—or moving rapidly in that direction.

For Rockwell, the world was ruthlessly tumbling forward, so he passionately captured the moment as it faded. Antique manners and traditional values, however, were never his true subject. Rockwell's most popular *Post* cover, *Saying Grace* (page 54), portrays a grandmother and her grandson praying before a meal in a crowded downtown restaurant. Because of this central narrative, the painting is routinely cited as evidence of Rockwell's commitment to "family values": it is presumed to be a celebration of familial obedience, adherence to established religion, and respect for tradition. In fact, as Rockwell himself insisted, *Saying Grace* no more advocates public prayer than *After the Prom* advocates teen dating. Its subject is the crowd of secular onlookers (our surrogate beholders) who respectfully tolerate citizens with values different from their own. *Their* behavior is being celebrated, because in a democracy where everyone is different and anything can happen, tolerance is the single, overriding social virtue.

Thus, those who look for traditional values in Norman Rockwell pictures will discover a virtual cornucopia of difference and disobedience, to which Rockwell invariably suggested that we respond with tolerance. Neither a scientific naturalist nor a conservative realist, Rockwell was always the democratic history painter, portraying a world in which the minimum conditions of democracy are made visible. His best paintings insist in a perceptible way that the atmosphere of benign tolerance, the tiny occasions of kindness, comedy, anxiety, and *tristesse* that he portrayed, far from being evidence of human vanity, are critical elements in the fate of the Republic, conditions

Day in the Life of a Little Girl, 1952

Girl with Black Eye, 1953

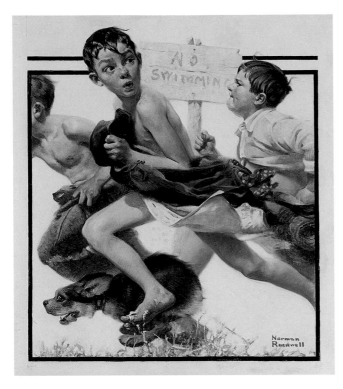

No Swimming, 1921

Two Old Men and Dog: No Swimming, 1956

that *must* exist if it is to survive in historical time. The characters in Rockwell's pictures may be "types," then, but they are types alive in time—never trapped in their particular historical instant but living through that moment on a specific historical trajectory.

The kids in Norman Rockwell's America always grow up. They are growing up before our eyes, in fact, and in Rockwell's pictures they always grow up free. In 1956, Rockwell reprised on a calendar his famous *No Swimming* cover from 1921 (above); he painted the same kids, thirty-five years later, fully grown but breaking the same rules with a new dog. That is the message: Democracy progresses in an untidy dance of disobedience and tolerance. So today I like to imagine the kids in Rockwell's pictures growing up as the kids who grew up looking at his pictures grew up. I imagine the kid with his bindle sitting at the soda fountain with the nice cop in *The Runaway* of 1958 (page 129) ten years later. He is standing by a highway with his backpack, thumbing a ride to San Francisco. Or he is bleeding and battered on the streets of Chicago, having encountered an altogether different sort of policeman. I imagine the *Girl with Black Eye* (page 127), who sits grinning outside the principal's office in 1953, ten

years later burning her bra. I imagine the kids in *After the Prom* sitting around the campfire in some commune in New Mexico trying to recapture the golden glow of that night at the soda fountain.

I do this because these things actually happened, and more. Because Jack Kerouac took Norman Rockwell on the road to portray a big, flat magical America full of kindness, comedy, and *tristesse*. Because Hugh Hefner took the grown-up kids from Rockwell's pictures into the bedroom and invented a new American iconography of girl-next-door domestic eros. Because all these kids showed up at Woodstock in search of that peculiar Rockwellian blend of tolerance and disobedience. They stood out there in the mud and waited for Roger Daltry to sing their anthem: *The Kids Are All Right*. They probably still are.

The Runaway, 1958

Neil Harris

The View from the City

For someone like me, growing up in the big city during the 1940s and 1950s, Norman Rockwell's art was a vaguely uncomfortable force. Uncomfortable may be too strong a word, for I can't say I actively disliked it or spent much time brooding over its cheerful messages. Instead, like many of my friends, I was dismissive, consigning the illustrations outside any circle of artistic or intellectual respectability. When I thought about his pictures at all, it was in the interest of marginalizing them, pushing them to the edges of consciousness. In view of Rockwell's semi-official status as the visual chronicler of American life, that may not have been the most natural thing to do. But given the usually adversarial relationship between youth and authority, it was also appealing, a safe act of symbolic revolt that would never be punished, and would probably go unnoticed, by my elders. It was far simpler than protesting the compulsory daily pledge of allegiance to the flag, which many of my schoolmates managed rather vigorously. Feeling superior to Norman Rockwell's exercises in Americana constituted an act of personal independence with few apparent consequences.

Revisiting these attitudes more than forty years later, I try to understand their basis. My condescension undoubtedly did not result from lack of familiarity. The Rockwell magazine covers and advertisements were as omnipresent in New York City as everywhere else in the United States; *The Saturday Evening Post* constituted a newsstand fixture, and the calendar art was displayed in offices, schools, and garages. Rockwell's urban following seemed large and enthusiastic.

Nor was my disdain built on any specific hostility to Norman Rockwell's views or values. It was clear that the artist stood alongside great liberal causes. The posters of Franklin Delano Roosevelt's celebrated four freedoms, the attacks on racial bigotry, and the good-humored tweakings of self-importance and pretension demonstrated that. Who could be against winning the war, tolerance, friendliness, and warmth?

And it wasn't, at least in the beginning, discomfort with Rockwell's meticulous realism, although this may have been a factor. As a schoolboy, I was no more aware of Surrealism, Non-objectivism, Cubism, and

Walking to Church (detail), 1953

Abstract Expressionism than I was of high-energy physics or Rosicrucianism. Clement Greenberg's animadversions on kitsch, well-established though they might have been among the intelligentsia, were similarly beyond my notice. And I certainly enjoyed visual detail. I read—or rather scanned—*Life* magazine at home each week with rapt attention, totally absorbed by its detailed and evocative photographs, completely indifferent to their prevailing conservatism and sentimentality. I may have been skeptical about artists who tried to imitate photography, but Norman Rockwell's naturalism was not the source of my concern. It was something else entirely. Paradoxically enough, for an illustrator whose work has usually been presented as comfortable and reassuring, Norman Rockwell provoked some uneasiness in me on several grounds.

First, the people, settings, and situations that appeared with such astonishing regularity were almost entirely alien to my experience, if not to my imagination. In a reflective 1957 essay for *Atlantic Monthly*, Wright Morris declared that "a vote for Norman Rockwell is a vote for the real America" and argued that we recognize his "figures as our neighbors, and the street they live on as our own."[1] This is invariably the basis for any genre art, he pointed out. And that was my problem. This was somebody else's genre. Swimming holes, country newspaper offices, small-town general stores, family prayers, and fishing expeditions seemed as exotic as the meticulously detailed historical scenes and costumed sets that framed figures such as Benjamin Franklin and Ichabod Crane. And even when Norman Rockwell was being quite contemporary, he was no more real to me than when he was self-consciously antiquarian. Thus his art appeared both remote and melodramatic, linked to visions that produced no more sense of connection than did my school textbooks.

But Rockwell's art also appeared authoritative. This was America, it seemed to say, Americans as they were supposed to look and act. To me, as to many another New Yorker, the world resembled Saul Steinberg's celebrated map of the city that once graced *The New Yorker*'s cover. I had made it to Washington, D.C., and Boston, and I had even worked several summers at a camp in Georgia while in high school, but I didn't get to California until after I had been to Europe—in my twenties—and I reached the middle west, where I have now lived for almost thirty years, even later. Rockwell's illustrations, then, stood on a continuum with the radio serials, the movie plots, and the early television sitcoms I was encountering, most of them presenting the voices, faces, and daily rituals of another place. Norman Rockwell's art made me uncomfortable because it suggested deficits to the routines that I knew, alternative ways of acting and appearing. It wasn't endorsing the familiar but celebrating some version of a very different way of life.

Why, I wonder now, did this bother me more than radio, film, and television? Was I more willing to accept dreams and distortions being acted out than those set on paper or canvas? Or was I more easily taken in by the electronic entertainments? Perhaps both. For a second source of anxiety was my growing sensitivity to pictorial propaganda, perhaps even some faint association of the poster-like good looks and rural charms dominating Rockwell's pictures with images favored by Nazi (and Soviet) information engineers. In retrospect, it seems grossly unfair to link Norman Rock-

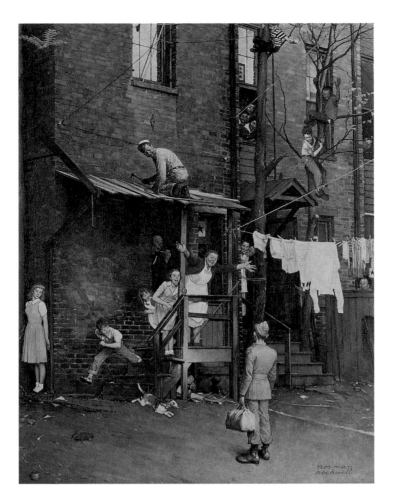

The Homecoming, 1945

well's religion of American simplicity and informality with the art enjoyed by commissars and storm troopers, but, unfair or not, I made that connection. There was more than a touch of suspicion in my mind that I was being fed something so idealized as to be patently false. Rockwell's endorsement of the unfamiliar proclaimed it as a national norm. I found instead a staged series of highly polished vignettes. I reacted as I might have responded to someone else's religious art; while it didn't register with me, it evidently meant a great deal to many others. Why else were Rockwell's covers, calendars, and magazine ads so pervasive unless his audience was both large and enthusiastic? I suspect his images also appealed to some working-class urbanites in ways analogous to the appeal of Cold War America glimpsed by contemporary Russians in the mélange of illustrated uplift and consumerism distributed by our information agencies. This was mythology, how a special race lived, far away in some small-town utopia.

As I inspect these images today, I am less discomfited by them. But I am struck by how rarely Norman Rockwell acknowledged urban America. Perhaps that was the source of my discontent. And when he did incorporate city scenes as subjects, they look even less familiar than the small town. Examples, again, are infrequent. Examining hundreds of *Saturday Evening Post* covers Rockwell painted over many decades (and for a Philadelphia publisher), I find not many more than a dozen or so that could be considered urban by even the broadest of definitions. But they are suggestive. Consider, briefly, four examples: *News Kiosk in the Snow* (page 134), *Roadblock* (page 135), *The Homecoming* (above), and *Walking to Church* (page 140). First of all, can these be read as urban settings? I think so. To be sure, there are no skyscrapers, traffic-filled intersections, bright neon advertisements, promenading crowds, movie palaces, big stores, or other standard urban referents. But other signs of city life abound

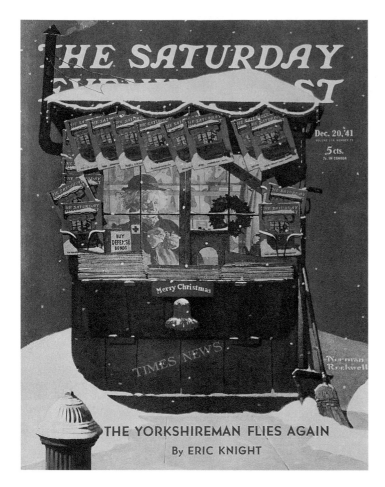

News Kiosk in the Snow, 1941

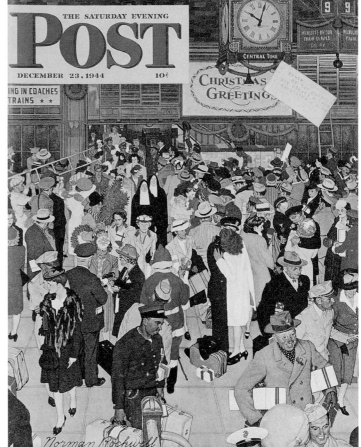

Union Station, 1944

(some of them shared with smaller places): multiple-dwelling houses, stunted trees, narrow alleys, news kiosks, back porches, clotheslines, taverns, and suggestions of slightly contained squalor, though not of actual slum. While the protagonists in Rockwell's city seem cheerful and animated, or at a minimum resistant to the surrounding disorder, they are apparently living under difficulties, even if caught at temporary moments of advantage. The cheerful female news vender, closed off from the snow and cold in what could be called a cabin in the urban wilderness, her enclosure glowing with warmth. The family marching to church, dressed in their Sunday best and doing their utmost to avoid either contamination or distraction by the urban dilapidation that swirls around them, testifies to the power of the spirit (or established rituals) to protect against the weakness of the flesh. When Rockwell's view was reduced to a small neighborhood, as in *The Homecoming* or *Roadblock*, or even the 1944

painting of Chicago's Union Station for the *Post*'s Christmas cover (above), the city resembles a small town with everyone engaged in a common enterprise, such as welcoming home a local hero, greeting a returning relative, or helping a moving van negotiate a crowded alley. But except for these reductions in scale, Rockwell defined the city more emphatically by contrast or withdrawal from it.

In fact, resistance and opposition form themes that run through much of Rockwell's work. Innocents shake up the cynical, thoughtless, lazy, or forgetful, simply by performing simple acts of faith. *The Saturday Evening Post* cover *Saying Grace* (page 54), which depicts a child and his grandmother saying grace in a greasy spoon, surrounded by startled and somewhat shamed diners, is a perfect example of this trope. And a popular one. A 1955 survey asking *Post* readers to select their favorite Rockwell cover made *Saying Grace* the winner with 32 percent of the vote, followed

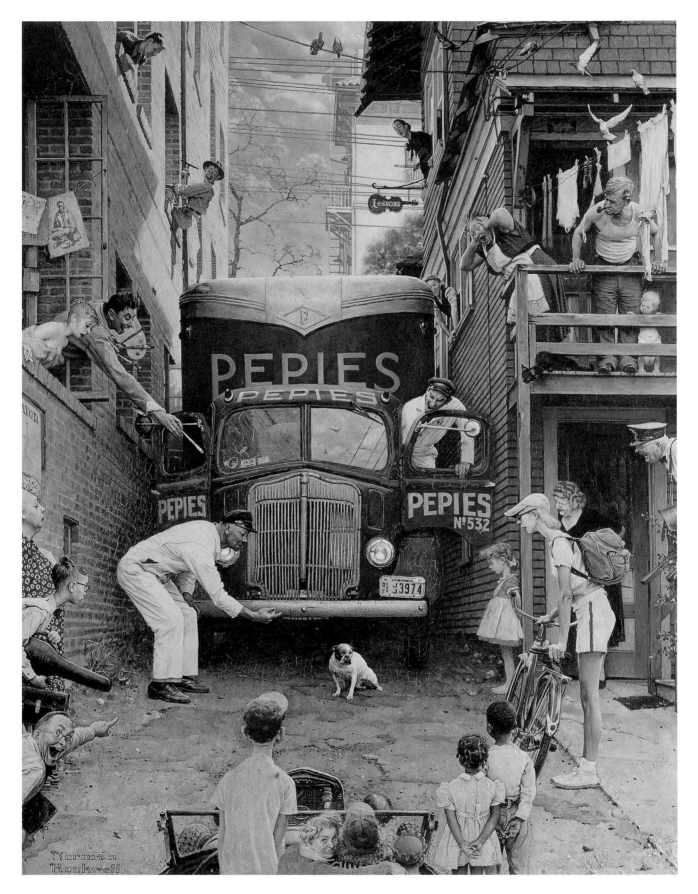

Roadblock, 1949

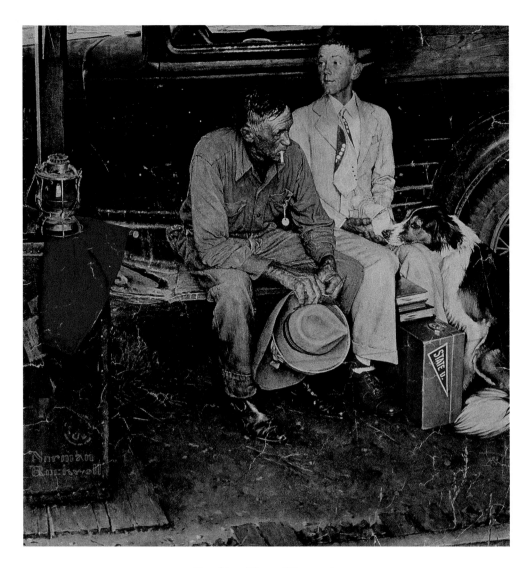

Breaking Home Ties, 1954

closely by *Breaking Home Ties* (above). Thus its placement on the catalogue cover of a 1972 Rockwell retrospective seems as appropriate as the frontispiece of the same catalogue, *Doctor and Doll* (page 137), a *Post* cover done twenty-two years earlier. The two pictures share a good deal and further exemplify the resistance theme running through the urban scenes.

Saying Grace contrasts the smoking, newspaper-reading coffee drinkers clad in workday clothes with the neatly, if somewhat shabbily, dressed woman and child, their heads bowed, hands clasped, umbrella and satchels at their feet. The faces of the onlookers are certainly not unredeemed or even coarsened. No one, not even the skeptical or cynical, is ever really lost to good possibilities in a Rockwell picture. Two of the most prominent onlookers are young and clean-cut,

while another, somewhat older, holds his hat respectfully. There is, it seems to me now, a slight note of reproof in the picture. We are left with the impression that the other diners have not said grace, and that we would not have either, had we been there. If hypocrisy was once the tribute paid by vice to virtue, now it is simply admiration.

Doctor and Doll continues this tone of gentle criticism, here to those who patronize the very young. The doctor who applies his stethoscope to a young girl's doll is attempting to acknowledge her world of enchantment. The expression on his face is as serious and concerned as it might be if he were examining the girl herself. Such a willingness to place professional expertise at the feet of childhood magic serves to remind us, again, of things we have forgotten:

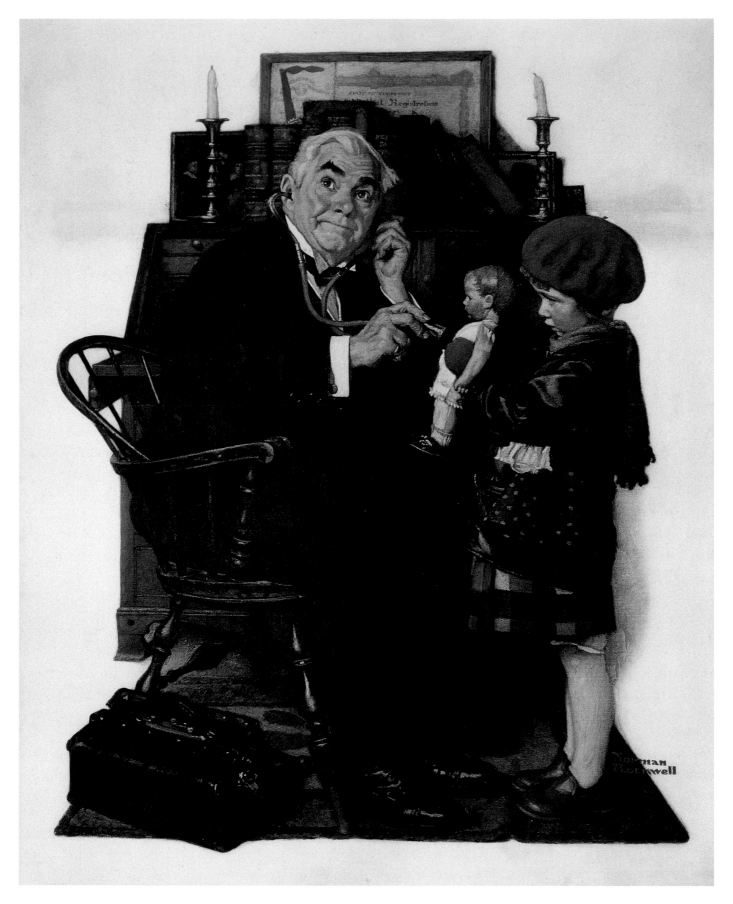

Doctor and Doll, 1929

University Club, 1960

secret kingdoms inhabited by imaginary beings whose needs seemed as real as those of the people around us. Rockwell's physician may appear to take the doll's health seriously as an effort to gain the child's confidence and trust, but his act of sympathy is also one of grace, accepting his patient's needs with cheerful serenity.

A sense of loss, of nostalgia for an earlier stage of life, is present as well in *University Club* (above), an indisputably New York setting at Fifth Avenue and West 54th Street, in which the club members peer out their large windows at the amorous conversation of a young sailor and his girl. They are well dressed, com-

fortably ensconced in their clubhouse designed by McKim, Mead & White, and attended by servants, and their attitude and interest must be seen, in part at least, as wistful recollection of days gone by. This couple has passed beyond the magic-doll stage of the young patient, but their youth and animation are almost as far removed from the elderly club members.

Aging is a burden in the world Rockwell paints, and this may be one reason why cities are conspicuously absent from it. Certainly the parents and grandparents he depicts are vigorous, alert, and active, with no hint of illness or dementia. As Robert Hughes wrote in the artist's obituary, in Rockwell's America

"old people were not thrust like palsied, incontinent vegetables into nursing homes by their indifferent offspring; they stayed basking in respect on the porch, apple-cheeked and immortally spry."[2] Nonetheless, there is sadness in their depiction, regret at the passage of time which inexorably alters and interrupts human relationships and physical landscapes alike.

In some ways, I think now, Rockwell's efforts to freeze the world, to contain its disorder in a set of reassuring snapshots, lay at the heart of my discontent decades ago, and still does. The basis of the urbanism I knew—shared, I think, by most New Yorkers of that day—was change, movement, and congestion. The city was in fact noisy, disorderly, crowded, smelly, and dynamic. Its diverse population was generally agitated and frequently withdrawn. Riding on subways, threading through sidewalk crowds, struggling through shopping lines, strangers avoided eye contact, much less casual conversation and unexpected acquaintance. In sounding the note of withdrawal in his few urban scenes, Rockwell may have been capturing an actual condition, although his bonhomie served to vitiate it.

Actually, just as Rockwell's popularity was peaking, a new kind of urban sensibility was emerging. (The death of Alfred Kazin, which occurred as this essay was written, removed one of its last major shapers.) In the late 1940s and 1950s, a number of critics, historians, novelists, social scientists, and journalists had begun to promote the feel of urban life. Just as the great department stores, neighborhood bakeries, downtown movie palaces, and cavernous railway stations were beginning to disappear, decay, or disintegrate in favor of shopping malls, franchise outlets, and inconveniently placed airports, so a group of city-bred loyalists set out to create what amounted to a new form of urban sentimentalism, bathing in nostalgia the rituals, goods, and services that constituted the city as a way of life. Historians began to suggest that it was the urban laboratory—not the isolated villages near Frederick Jackson Turner's celebrated, if vanishing, frontier—that provided American democracy with its energy and creativity. Heterodox planners were discovering in congestion and intensive social interaction the very basis of community, feuding with those who sought to constrain urban disorder by isolation and cauterization, justifying the massive new housing projects that compartmentalized shopping, recreation, and domestic life.

There has been a long tradition of urban celebration among some American artists and writers who otherwise shared relatively little in common, such as Walt Whitman, O. Henry, the Ashcan painters, Henry James, Theodore Dreiser, several American Impressionist painters, Joseph Stella, Damon Runyan, Hart Crane. Many of them valued the animation and even occasional anarchy of urban struggle. But championing the American city's pedigree as a legitimate historical category and glorifying the immigrant experience as a quintessential national subject reached unprecedented levels after World War II. To the work of urban photographers, historians, novelists, and folklorists was added the activity of architectural preservationists, bent upon retaining for future generations the physical record of the city's achievement. The 1950s witnessed some bitter defeats for preservation, but by the sixties, important battles had been won.

Norman Rockwell may occasionally have shared this new tradition of urban nostalgia, but so rarely that it never actually reached me. To judge from his popularity, many urbanites agreed to reserve the elegiac mood for non-urban settings. They were still willing to accede to a national chronicle that pushed its cities to one side, at least so far as popular values were concerned. There was, to be sure, another urban public, smaller but aloof from rural visions—except for weekends. Such sophisticated cosmopolitans found their popular art in *The New Yorker*, *Vanity Fair*, *Vogue*, *Fortune*, and *Harper's Bazaar*, cementing a graphic relationship that linked urbanity, modernism, popular culture, and high fashion. The covers, photographs, cartoons, and commercial art of these magazines had, in the decades before Rockwell reached his greatest popularity, exuded narcissistic elegance. Witty, irreverent, sardonic, exaggerated, ironic, whimsical, and self-consciously smart (not to say smart-aleck), this was the yin to Rockwell's yang. It poked fun at the dated, the nostalgic, the old-fashioned and eschewed faithful detail in favor of exaggeration.

Forty years ago, these magazines were not a real alternative for me. With the exception of *The New*

Walking to Church, 1953

Yorker, they were publications I did not know, and my *New Yorker* reading focused on the cartoons. But my quest for sophistication was palpable; in dismissing Rockwell's alternate vision, I imagine that I was somehow seeking to share in the glory of artistic urbanity. City air was not only free (and in New York, at least, visible, according to one of its mayors), it was supposedly hostile to pieties that floated unchallenged elsewhere. I alleviated my sense of unease with *The Saturday* *Evening Post* America that Norman Rockwell portrayed by consigning it to irrelevance and moving on.

Aging should bring, if not maturity, at least a broader tolerance. Pieties in the end do seem to have their uses. I will readily admit today that there is something to admire in Norman Rockwell's artistry, even though the static fictions at the heart of his illustrations offer a misleading series of cultural snapshots. He captured only one of many Americas. His pictures

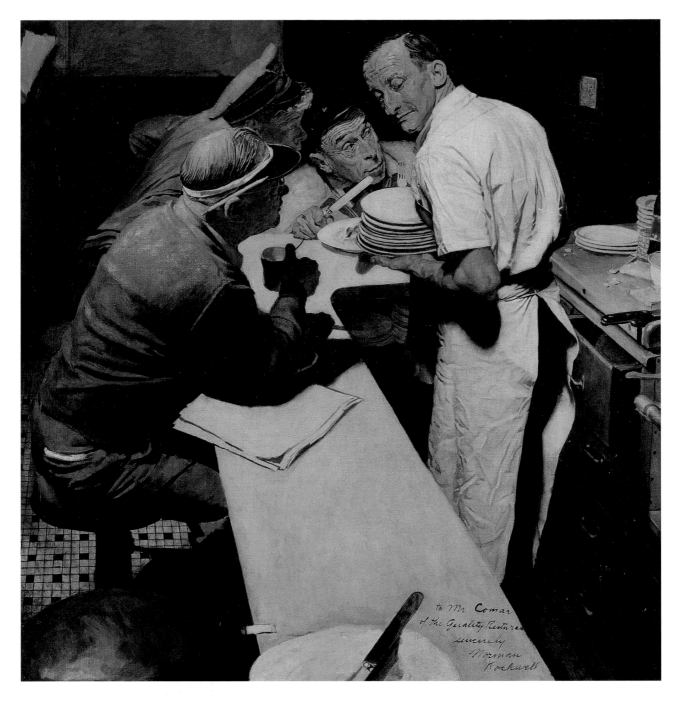

War News, 1945

also simplified unmercifully and reassured inappropriately. But they did finally project a sense of decencies expected that form part of the foundation for any civil society. The vast Rockwell constituency appreciated loving and respectful human relations. It just didn't want much complication.

In an article entitled "Capitalist Realism by Norman Rockwell" in *Ramparts* in 1972, Marshall Singer concluded that the mirror Norman Rockwell held up for America reflected neither the America that was nor even the America "that should have been, but the sugar coating that sweetened the bitter pill."[3] The taste for sugar coatings has only increased in the years since this observation. As long as it survives, Norman Rockwell's art should thrive.

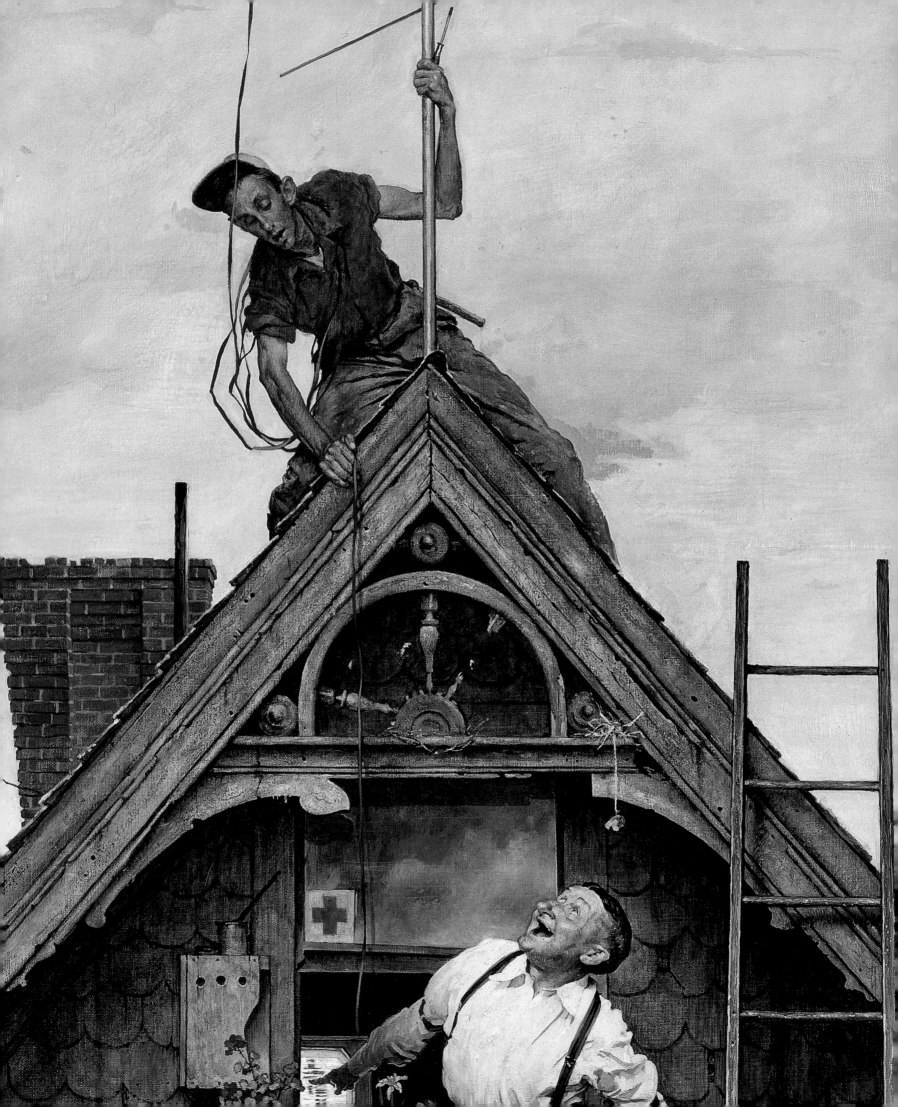

The Saturday Evening Post

When *The Saturday Evening Post* arrived, I would sit on the stair landing, and with the north light coming through the door there was enough illumination to study every detail of Norman Rockwell's covers. Sitting with the *Post* in my hands provided one of my most favorite childhood memories.[1]
—Ellen Baise, Norman Rockwell Museum guide

For virtually three-quarters of the century, Norman Rockwell captured the attention of millions of Americans with his 322 *Saturday Evening Post* covers and countless other illustrations and advertisements. While he is one of the most recognized American artists of the twentieth century, scholars have yet to examine his achievement. Consider that for over seventy years, every week at approximately the same time, millions of households across the country received *The Saturday Evening Post.* The magazine would be read in living rooms, kitchens, bathrooms, and bedrooms, and was touched, ripped, dog-eared, stained, carefully collected, or heedlessly thrown away by a great many Americans. The magazine's casual and shifting viewing context within the home and beyond it—to doctors' offices, barbershops, and dentists' waiting rooms—profoundly influences our understanding of Rockwell's *Post* covers. Their familiarity contributes to the problem that the Norman Rockwell Museum guides have with visitors touching paintings in the galleries. The way most people were introduced to Rockwell images—close up, handheld—makes them think that the conventional rules for looking at fine art do not apply.

Indeed, Rockwell's paintings were not meant to be experienced within the formal and controlled environment of a museum. On a frequent and regular basis, millions of Americans brought Rockwell's art into their homes—viewing his *Post* covers while seated in their favorite chairs, surrounded by personal belongings in the company of their families. This particular reception of Rockwell's art affected the way the images were interpreted by encouraging audiences to impose their own narratives on the pieces. The images themselves also encourage this. Because they are frequently vague about time and place, the

New Television Antenna (detail), 1949

pictures easily adapt themselves to the attitudes, beliefs, and situations of individual viewers. Subscribers could look at a *Post* cover and feel that they were looking at themselves or their neighbors—the naughty child, the doctor, the babysitter, the dentist, the grandfather, the mom and dad. It wasn't until later in Rockwell's career—the 1950s and 1960s—that he began to paint magazine covers of the famous, of "them." For the bulk of his career, Rockwell's magazine covers were about "us."

The intimate contexts in which people saw Rockwell's covers, together with the commercial circumstances that guided his creative process, contributed enormously to the popular appeal of the artist's *Post* covers. Thus it is important to explore how the institutional imperatives of *The Saturday Evening Post* both shaped and were shaped by Rockwell's aesthetic. The *Post*'s innovation was in reaching a mass audience previously ignored by established highbrow magazines such as *Harper's* and *Atlantic Monthly*. It was one of the first magazines to create a national market of readers unified by their similar patterns of consumption. Indeed, the Curtis Publishing Company, which owned the *Post*, was one of the first advertisement-driven media corporations. Because the advertising space, not the subscription price of the magazine, paid expenses and determined profits, one of the preeminent goals of the *Post* was to find and cultivate a broad audience possessing disposable income. The *Post* editors repeatedly used formulas that cut across class and gender lines, such as the ever-popular Horatio Alger story, in which both men and women, regardless of class, achieved financial success through hard work and determination. In doing so, the *Post* helped to define a huge new market—the emerging middle class—and identified that market's needs for its advertisers, who then tailored their advertisements to fit both the magazine's goals and its readers' needs.[2]

These formulas for fiction, articles, editorials, advertisements, and illustrations were established by the first permanent editor of the *Post*, George Horace Lorimer. The most powerful and deeply involved of all the *Post* editors, Lorimer took charge of the magazine in 1898 and played a central role in establishing its mass-market dominance through 1936. And because of

Lorimer's early efforts, the *Post* continued to influence American cultural life until the magazine ceased publication in 1969. Under Lorimer's tenure, the *Post* enjoyed a public influence unrivaled by movies, radio, or other magazines. In 1908, *The Saturday Evening Post* had a weekly circulation of one million and a readership of some ten million; by 1929, those numbers had doubled. The unparalleled dominance of the *Post* gave it an unusually powerful opportunity to shape the beliefs and attitudes of Americans.[3] Indeed, it was one of the first periodicals to create a truly mass market in the United States. Not even the mass-media giants of our own time enjoy a comparable dominance.[4]

Jan Cohn, who has meticulously chronicled the early history of the *Post*, wrote that Lorimer saw the United States as an "unformed, unassimilated nation that lacked a unifying consciousness of Americanism." Accordingly, he set out to "create America" in the pages of the *Post*, delivering it to audiences week after week as "a model against which they could shape their lives." Lorimer realized his goal of using the *Post* to unify readers when they simultaneously received and "came to know, to share in, and to talk to one another about the stories, the articles, the illustrations. . . . To read the *Post* was to become American, to participate in the American experience."[5] And in 1916, when Rockwell began selling paintings to the *Post*, his covers became the visual expression of Lorimer's ideas.

For over a quarter of a century, *The Saturday Evening Post* was unequalled in crafting and mediating a set of attitudes and beliefs that "explained and defined Americanism."[6] The magazine was a major source of political, social, and economic information about the United States and the world. The articles, fiction, illustrations, and advertisements functioned as how-to guides for living in twentieth-century America: they taught readers how to make sense of the vast and rapid changes in their new century; they explained how modern consumers should live and work in a society reshaped by technological advances and mass communication.[7]

Throughout the changes of the twentieth century, the magazine kept its readers current. It gave them the latest information on fashion and recommended which washing machine or television set to buy. It

educated housewives on the best ways to care for their homes and families, and it provided business advice to men, promoting in particular the ideal of the self-made man. In soothing, clarifying prose, *Post* writers explained complicated new inventions. For example, in "Look Ma! There Goes Our House," the reader finds an accessible account of the new technology that allowed engineers to move houses.[8] *Post* writers also educated their readers about international and domestic politics, impassioned them through vivid coverage of sports events, and indulged their fantasies through serialized stories about romance, adventure, and history. The 1954 story "The Cradle Robber," for instance, takes the reader to rustic Maine in the summertime, where a handsome widower falls in love with the beautiful nanny he hired to take care of his two children.[9] Like Rockwell's cover images, this type of fiction spirited readers away from the hectic exigencies of twentieth-century life into the carefree days of another realm.

The *Post* celebrated traditional, old-fashioned values such as hard work, thrift, and common sense; it argued that these virtues were crucial to success in a twentieth-century consumer society—all the while deflecting the contradictions between thrift and consumption, and between hard work and the new, laborsaving devices they advertised. All in all, the *Post* removed the jarring and frightening new aspects of the events, products, and rituals of the twentieth century and presented them in comforting and familiar ways. This is one of the many strategies the *Post* adopted to create its own American ideology, and the paradigm strongly shaped and influenced Rockwell's imagery.

Lorimer, who approved every article, short story, editorial, and illustration before it went to press, had a great deal of control over Rockwell's *Post* images. Rockwell's own description of his meetings with Lorimer reveals how the editor's ambitions and goals for the *Post* determined which images would become covers:

> He never fidgeted over a decision or told me to leave the cover so that he could decide later whether or not to accept it. The first glance, its

first impact was his criterion. "If it doesn't strike me immediately," he used to say, "I don't want it. And neither does the public. They won't spend an hour figuring it out. It's got to *hit* them." He rarely asked me to make minor changes—a red cap instead of a green, more smile on a kid. The cover was either good or bad.[10]

In his autobiography, Rockwell described how he caught on to Lorimer's decision-making process and figured out how to "rig" these meetings so that *he* could control which sketches Lorimer would pick.[11] His *Post* covers, then, resulted from a continual process of negotiation between artist and editor. Moreover, it can be argued that Lorimer's vision of a unifying Americanism shaped not only Rockwell's choice of subject matter, but also his style. In the 1920s, propelled by a need for change, Rockwell went to Europe, where he experimented with modernist styles of painting. When he returned to the United States, he took one of these paintings to Lorimer, who rejected it, deflating Rockwell and dampening his enthusiasm for further modernist experiments.[12] While Rockwell's cover images were chosen by Lorimer, the success of Rockwell's work—his covers sold more magazines than those of other artists—may very well have reinforced Lorimer's determination to continue his ideological course.[13] Rockwell's cover images not only epitomized the magazine's ideology, but also sometimes took good-humored jabs at the very forms of modern mass communication celebrated in the magazine.

The twentieth century saw the invention of brand-new technologies that produced such things as automobiles, televisions, and space travel. The century also saw dramatic changes in the way wars were fought and presidential elections staged. Furthermore, there were tremendous upheavals in the arts and in race relations. Rockwell took these subjects and the impact they had on ordinary Americans as the focus of much of his art. Like the stories in the *Post*, Rockwell's pictures wed the familiar and traditional to the unfamiliar and contemporary, creating reassuring visual narratives about change. Many of these images were meant to suggest that cherished values are not necessarily destined to disappear with the onslaught of

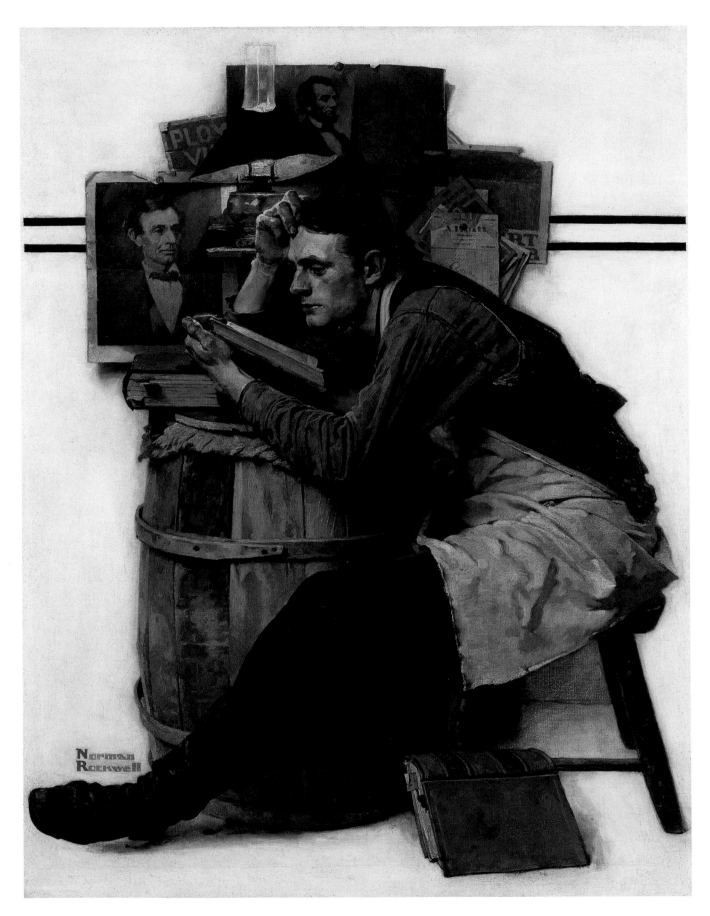

The Law Student (Young Lawyer), 1927

John Frederick Peto, *Old Time Card Rack*, 1900

new influences. Rather, those values can help guide us through the newness and keep us grounded in the familiar.

For example, *The Law Student* (page 146), the February 19, 1927, *Post* cover celebrating Abraham Lincoln's birthday, features a young man in a grocer's storeroom hunched over a cracker barrel, the surface of which is scratched and scraped with use; he is reading law books by the light of a kerosene lamp, much as Lincoln might have done. Posted above the figure are familiar photos of Lincoln by Mathew Brady.[14] The edges of the photos and other bills and cards tacked on the wall are torn, bent, and yellowing with age. The whole scene, with its fading brown and beige color scheme, has an old-fashioned look with no obvious markers of twentieth-century life. The *Post* was reminding its 1927 audience that the qualities Lincoln represented—industry, thrift, determination, honesty —are timeless; indeed they were the important attributes that would help American youth succeed in the twentieth century. Reinforcing this visual homily, many of the themes of the short stories and articles in

that issue explored the idea of hard work bringing success to anyone of any class or gender.[15]

Lincoln, the Horatio Alger model of rags-to-riches achievement, was the archetype of the small-town man who, without the benefit of formal education and through sheer determination and industriousness, created his own fame.[16] The picture's indeterminate time and setting reinforce the implicit message of the Horatio Alger myth—that anyone can prosper if they are industrious, honest, and thrifty. Moreover, the cards and pictures pinned above the student's head recall the late-nineteenth-century American artist John F. Peto's office-board and card-rack still-lifes (above), which frequently included pictures of Lincoln.[17] Rockwell's allusion to Peto strengthens the picture's celebration of the past and tradition.[18] The *Post* used many anniversaries of famous Americans—Abraham Lincoln, George Washington, Benjamin Franklin—as focal points to bring its audience together in a national community. The frequency with which the *Post* relied on these figures from the past suggests a mass-media strategy to forge a widely popular version of American

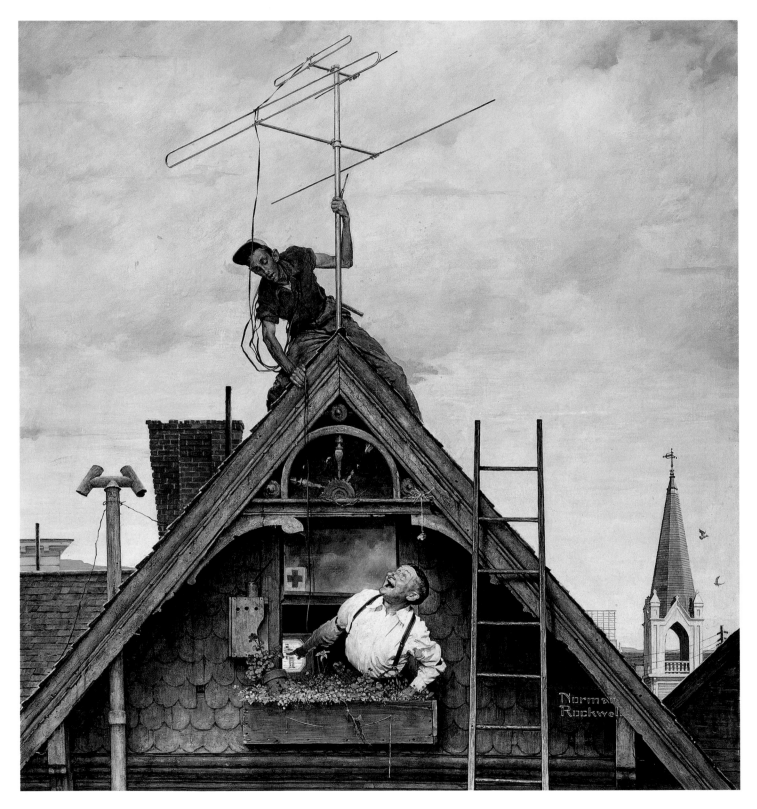

New Television Antenna, 1949

history that could stand as a buffer against the widespread immigration, devastating wars, and vast economic and political shifts of the times. Like the articles, fiction, and editorials of the *Post*, Rockwell's images used the past to represent hope, reassurance, and belief at a time of dizzying change and an uncertain future.

Rockwell's *New Television Antenna* (page 148), "painted in the peak year of the television bonanza—in 1949, when 100,000 sets were sold in a single hectic week," exemplifies how the *Post* introduced and humored its readers into modern technological society.[19] A workman perches on the roof of a weathered Victorian house installing a TV antenna. The owner of the house leans out of the window shouting approval as he points to a shadowy figure that has just materialized on the television screen inside. At a time when old urban neighborhoods like this one were being razed and replaced by modern commercial buildings—derivations of the modernist concrete and glass box—it is telling that Rockwell chose this timeworn architectural setting for a new television set.[20] Moreover, the broken millwork on the gable, the holes in the decorative siding, the bricks missing from the chimney, and the wartime Red Cross flag in the window strongly suggest the passing of an era.[21] Other than the television and antenna, there are no markers of modernity in the image. The house, not the television, is the focus of *New Television Antenna*. The architecture wraps the television into something worn, weary, and familiar, blunting the newness of the technology. Rockwell deliberately used the familiar pyramidal composition of traditional religious paintings to construct his house, with the antenna taking the place of

the cross at the top. He used the stability of this triangular form to invest the television with a sense of tradition. These reassuring signifiers of tradition and the past take the edge off Rockwell's witty observation that mass communication was usurping the power of religion in twentieth-century American culture—the antenna towers over the church spire in the right background of the picture.

Although the setting for the cover illustration is identified in a caption as the Adams Street neighborhood of Los Angeles, there are no signs in the image itself marking the place as California. The house could stand in virtually any town or city across the United States, since all were being transformed by television technology. A letter from one *Post* reader in Deerfield, Illinois, responding to *New Television Antenna*, suggests how people across the country identified with Rockwell's images:

> Your November 5th Rockwell cover gave a vivid portrayal of the new overtaking the old. It brought to my mind an interesting revelation to our small town.
>
> To passers-by on our main street the old frame house was forlorn. Shrubbery had overgrown the yard; the weatherbeaten clapboard lacked shape as well as paint. . . . The front steps had long ago rotted away. . . . What was the great surprise of at least 75% of the town's population to awake one morning to see the unmistakable "cross" of life (television dingus) fastened to the battered gable.
>
> It seems that one of the town's leading tradesmen has always occupied the rear of the

Du Mont television advertisement,
The Saturday Evening Post, November 5, 1949

structure—unobviously until this "sign of the times" appeared on the roof top.[22]

An inspection of this November issue of the *Post* reveals a plethora of advertisements that wed the old with the new as a sales device. An Alcoa aluminum ad compares the twelve-dollar-an-ounce price of aluminum in the mid-nineteenth century to the current price of seventeen-cents-a-pound, underscoring how new technology has made this compound cheaper, and marvelling at all the farm roofs in America made of this "precious metal." Kaywoodie Pipe Maker features a color reproduction of the March 1897 boxing match in which Bob Fitzsimmons knocked out "Gentleman Jim" Corbett, accompanied by the text "Our Pipes were favorites then as they are today."

The most interesting of these is a full-page advertisement for Du Mont Televisions (above). It features a large television encased in a sleek modern box set against a gilded eighteenth-century neoclassical paneled wall. Two women in evening gowns sit on eighteenth-century French salon chairs accompanied by two men in tuxedos—all watching a diva on television. A delicate neoclassical-style urn perches uncomfortably atop the modern box, heightening the contrast (and adding to the oddness of the image). Advertisers attempted to lend legitimacy and familiarity to their products through references to the past, but the wedding of the old and the new often yielded unexpected and strange results. As an advertising illustrator, Rockwell was familiar with this strategy and its pitfalls. Indeed, his cover images also functioned as

Norman Rockwell with television used in *New Television Antenna*, 1949

advertisements in themselves, advertisements that sold the *Post* and routinely relied on contrasts between the old and the new. Unlike the hurried and frequently unskilled creations of advertising agencies, Rockwell's images made brilliant use of the tensions inherent in opposites by dissolving them into humor.

The past offers not only a snug place of calm in a world shaken by change, but also a reassuring sense of stability through basic values that survive the constant pressures of twentieth-century life. In *Girl at Mirror* (page 153), Rockwell explored how makeup assumed a central role in teen culture of the 1950s and became the most visible sign of a girl's passage into womanhood.[23] In the image, a young girl in a modest cotton slip slightly yellowed with age compares her features to those of movie star Jane Russell.[24] The

inevitable passing of time is Rockwell's focus in this image. We know that his heroine is soon going to be changed forever when she leaves her doll and childish demeanor behind and fully embraces the cosmetics industry and Hollywood standards of beauty.

Yet Rockwell imbued this picture with many more signs of the past. The girl sits in a room that is cast in shadow and devoid of any markers of twentieth-century life other than the magazine, the lipstick, and the box of powdered rouge on the floor. The floor's scratched surface revealing layers of old paint, the mirror's worn gilt frame, the spindled legs of the ladderback chair—an early-American style piece—and even the discarded doll from her mother's or grandmother's childhood give the image an air of quaintness.[25] The little girl's hair is plaited and pinned up in

an attempt to mimic Jane Russell's glamorous bob, but the braids only make the girl look more old-fashioned.[26] The slip, with its modest cut and ruffles of eyelet lace (echoed in the antique doll's petticoat), is especially striking in its out-modedness when one considers that Jane Russell would have been wearing something sleek and sexy—the latest in fashion. Even the composition alludes to the centuries-old pictorial tradition of a semi-nude female contemplating her youthful yet evanescent beauty in the mirror.[27] The reassuring signs of the past and tradition outweigh those of the modern era—implying that old-fashioned values will bring the girl safely from the old world (childhood) into the new world (womanhood), just as those values will carry us safely into a new age.

Many women would have looked at this image and smiled to remember their first clumsy, self-conscious experiments with makeup. The visual signifiers of a past era and the vagueness of the details convey this act of remembering. Moreover, Rockwell deliberately erased signs that this scene takes place in a specific region or time, and he also eliminated clothing and furniture that might suggest a particular social class.[28] In combination with the affordability of magazines and cosmetics at the time, this generality suggests that females from a wide variety of class and regional backgrounds could identify with the girl and the makeovers, great and small, that she faces.

It is no coincidence that Rockwell decided to depict this girl considering the effects of cosmetics—products of a newly emerging mass-culture industry. The image is a fitting metaphor for readers of the *Post* considering whether to buy the mass-advertised goods in the pages of the magazine. The *Post* was a deliberate participant in shaping patterns of consumption as it and its advertisers attempted to reach more and more people. Yet the somber colors of the picture and the uncertainty of the child reveal not only her questioning of her own beauty but also possibly the artist's own wistfulness—about the loss of innocence, about how the new mass products of the twentieth century propel us into change at an ever-more-rapid rate.

In order to fully understand the popularity of Rockwell and his covers for *The Saturday Evening Post*, it is crucial to consider how this new and powerful type of magazine shaped Rockwell's art (and was, in turn, shaped by it). Lorimer and the *Post*, and Rockwell in his covers, tried to forge a national community based not on geography or class, but on an artificial ideal of what it meant to be American. This was not an America of the oppressed or the elite. Instead, the *Post* sought out, defined, and spoke to what we now call middle America. The *Post*'s and Rockwell's America was one that was rooted so firmly in the ethics of the past that it could accommodate and internalize the changes of the twentieth century without being overwhelmed by them.

Rockwell's images—with their deliberately non-specific, vaguely old-fashioned settings and lack of obvious economic signifiers—could speak to this broad new base of Americans. His images mediated between an imagined traditional past and the great technological advances and social shifts of the new century. While Rockwell's representations were obviously influenced by Lorimer's goals, he was able to deftly join the past and the present in his own innovative ways. Drawing upon his knowledge of art history and his keen sense of everyday life, Rockwell frequently used humor, sentiment, and earnestness not only to smooth over the pitfalls inherent in this strategy that weds the old and the new, but also to enhance its power and impact. Further, Rockwell's ordinary, familiar images had a particularly strong resonance precisely because of the prosaic manner in which they were regularly delivered to American homes. Finally, it is important to keep in mind that a Rockwell cover image was designed and used to sell three things to a newly defined public: the magazine itself; the goods advertised inside the magazine; and, perhaps most importantly, a vision of who we are and how we should be Americans.

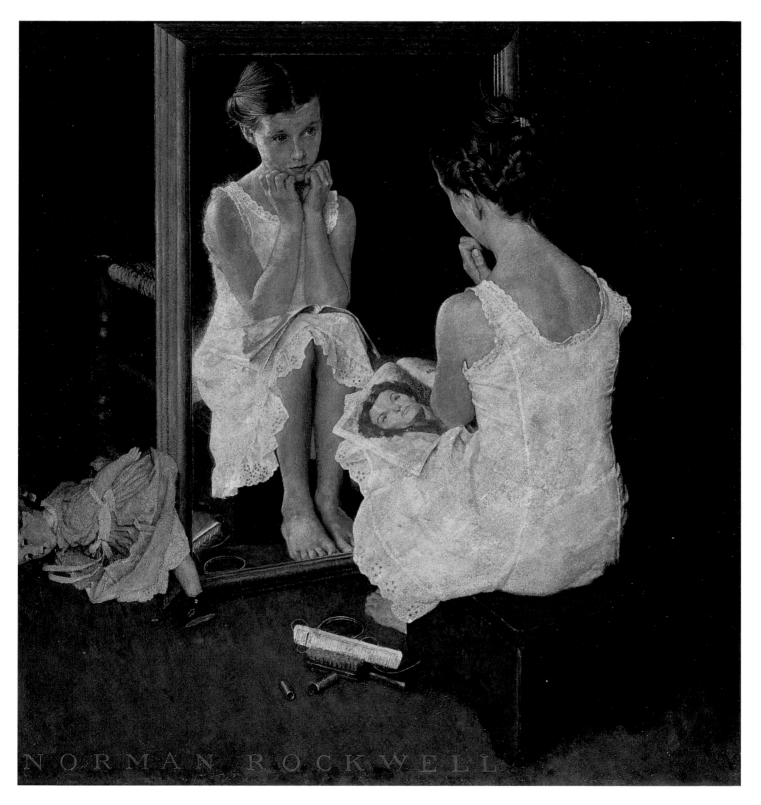

Girl at Mirror, 1954

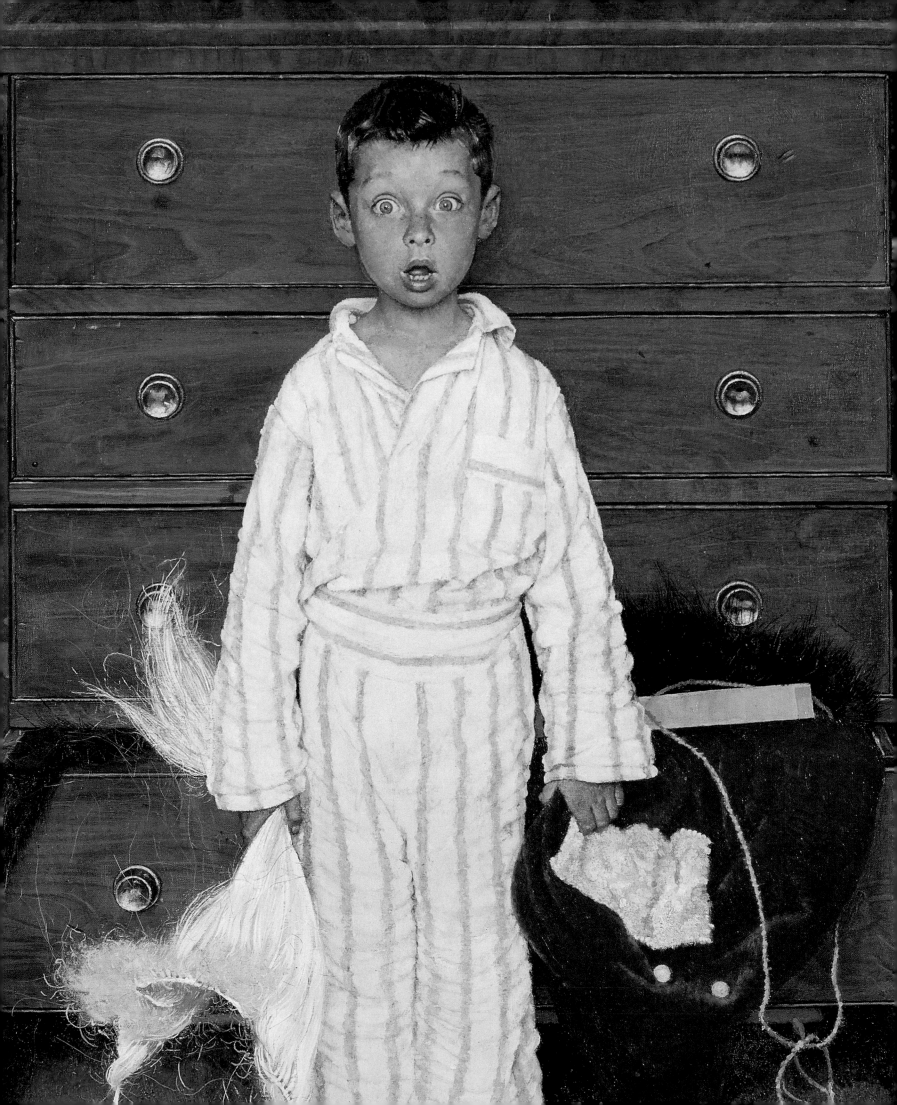

Rockwell's Christmas

"It was always said of him," wrote Charles Dickens of his reformed Mr. Scrooge, "that he knew how to keep Christmas well, if any man alive possessed the knowledge."[1] Norman Rockwell clearly did not, although he had two Christmases a year on which to practice. The first came in the dog days of summer, when the annual holiday covers were due at the editorial offices of the big national magazines. "My brothers and I have startling memories of people dressed in Santa suits wiping the sweat from their faces and drinking iced tea, and our mother hunting all over the house for Christmas wrapping paper in July," says the artist's son, Tom Rockwell.[2] The second Christmas, the Rockwell family Christmas on December 25, was just as full of bustle and business. Rockwell watched the fuss over the stockings and even helped to tidy up the litter of torn wrappings and ribbons. But as soon as the gifts had been opened, he retreated to his studio and got down to work, Christmas or no Christmas. "We used to joke about it as kids because we knew that our mother bought all the presents," Tom recalls.[3]

There is more than a little irony in the eyewitness accounts of Norman Rockwell's lonely Christmases in his studio. For along with a handful of other commercial illustrators of the day—most notably, J. C. Leyendecker and Haddon Sundblom—Norman Rockwell is generally credited with the invention of the modern American Christmas and the tender sentiments attached to it: kindly Santa Clauses who ponder each juvenile request; merry Dickensian travelers bound for home on cold winter nights; cozy hearths; windows aglow with warm light spilling out across the snow; fathers and grandfathers in red suits and beards; sprigs of holly and mistletoe; mysterious packages; tired salesclerks; and exhausted department-store Santas.[4] Rockwell helped to create the outlines of a secular, commercial holiday suffused with the intense feelings of a religious ritual—but a ritual in which he largely declined to participate, except as a shrewd and not unsympathetic observer.

The ways in which Americans celebrate Christmas, and the imagery associated with it, are almost entirely the products of the mass

The Discovery (detail), 1956

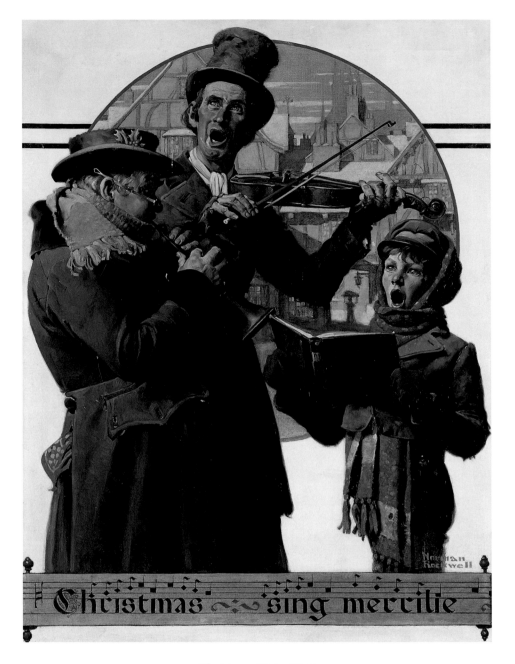

Christmas Trio, 1923

media for which Rockwell worked. Santa Claus, for example, grew from the archaic "right jolly old elf" of Clement Moore's 1822 poem into the fat, avuncular, full-sized wonder-worker of modern times under the auspices of *Harper's Magazine*.[5] In the pages of *Harper's* and *Harper's Young People*, beginning in 1863, political cartoonist Thomas Nast reimagined Santa for a rising generation of girls and boys who looked in store windows for the very latest in toys and eventually told Santa all about them on a newfangled telephone. Nast's Santa Claus was a fully developed character with a sturdy home at the North Pole, a red furry suit with a great big belt, a ledgerbook for the names of good and bad children, and an indulgent smile, even for the bad ones.[6] Advertising art of the early twentieth century showed this canonical Santa with pretty, ready-to-give boxes of candy canes or fountain pens—even towers of Campbell's soup cans —in a setting composed of mantelpieces and stockings and elaborately decorated Christmas trees.[7]

In 1899, editor George Horace Lorimer of *The Saturday Evening Post*, the most influential of the new,

J. C. Leyendecker, *Boy and Santa*, 1923

ad-glutted pictorial magazines, began to mark off the chief festivals of the American holiday calendar with special covers.[8] And just as the start of the season for Christmas shopping and entertaining had steadily crept backward from late December toward Thanksgiving, so the number of annual holiday covers soon expanded to fill that entire period.[9] In 1916, the year of Rockwell's first Christmassy cover for the *Post*, Leyendecker contributed a Thanksgiving picture on December 2, showing an old lady preparing the feast. Then, on December 9, came Norman Rockwell, with a silk-hatted old gent trying on Santa whiskers as he shops for toys (page 158). In the next issue, Leyendecker pictured a street violinist with his dog begging for contributions; although the notion of helping the poor was appropriate to the season, there was no overt Christmas symbolism in the image. And finally, on December 30, came Leyendecker's famous New Year's Baby (invented in 1906) inspecting a globe disfigured by a blot over war-torn Europe. In 1924, the year of Macy's first Santa Claus Thanksgiving Day parade—and the de-

finitive start of an expanded Christmas shopping season—Lorimer commissioned six holiday covers, including a Rockwell Santa, a pretty girl carrying holly, an Olde English steward bringing in a boar's head, and a tin soldier kissing a kewpie doll under the Christmas tree, all sandwiched between a Thanksgiving Pilgrim and a New Year's Baby.

Throughout the 1920s and early 1930s, when Rockwell was competing with Leyendecker for domination of the *Post's* Yuletide covers, the magazine favored three basic types of holiday symbolism: Santas; Olde English scenes with literary overtones; and posh costume pieces that were neo-medieval or even religious in flavor. Leyendecker, Rockwell's older idol, had virtually created all three types. With the exception of one scrawny street-corner model with a faux chimney for donations, his velvet-clad Santa Clauses were the genuine article (above). Weighty and massive, with huge laced boots thrust forward into the viewer's field of vision, a Leyendecker Santa—and he painted the same figure for B. Kuppenheimer clothiers—managed

Man Playing Santa, 1916

to sum up the ideal of benevolence and seasonal cheer in an iconic manner, without the slightest pretense that this was a real gentlemen cuddling a real child.[10] His scenes of Christmas customs in Merrie Olde England —at some indefinite period between the Middle Ages and the publication of Washington Irving's Brace-bridge Hall sketches in the early nineteenth century— showed waits and serving wenches, pages, noble ladies, and jesters dressed in their Hollywood best, preparing for a traditional feast, replete with plum pudding, games, and merriment.[11]

Leyendecker's lush, over-decorated costume pieces for Christmas were most often Madonnas, draped in stiff ecclesiastical robes and glimpsed through elaborate framing devices rendered in the style of a della Robbia ceramic or a carved medieval choir stall.[12] The mood was less reverential than simply gorgeous: religion for a department-store culture. In all his holiday covers, in fact, Leyendecker's real theme was a per-

son or an event ennobled by the artist's consummate skill at burnishing it to a high gloss. The icons of Christmastime appeared as they might in the window of an elegant shop on Fifth Avenue, adorned with rich stuffs designed to grab the eye of the passing shopper.

Rockwell's personal interpretation of Christmas must be appraised against this background. It was Rockwell, for example, who ultimately banished Madonnas and Magi and any hint of the religious significance of the season from *The Saturday Evening Post*. And using the same kinds of secular images that Leyendecker favored—most notably, the Santas and a make-believe Olde English Christmas—he conceived of them in wholly different terms, less as symbols than as idiosyncratic realities. Thus his Santa Clauses are highly problematic figures from the beginning. His first *Post* Santa, of 1916, is an outright fake, a Wall Street stereotype in a fur-collared coat and silk top hat trying on a Santa outfit in a dingy toy store. On a

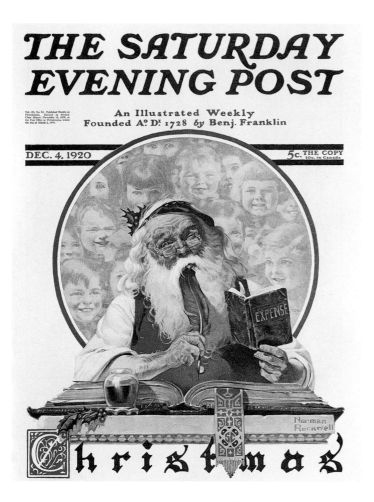

Santa and Expense Book, 1920

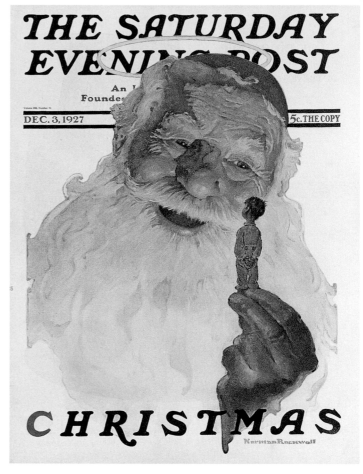

Christmas: Santa Holding Little Boy, 1927

single shelf above the heads of the clerk and her customer are items suitable to other occasions: an Easter basket and a mechanical chick; Halloween masks; a sand pail; a baseball; and an American flag (for the Fourth of July). Far from being magical or unique, Christmas is just another shopping day, represented by the Santa doll and the snowman on the counter, and the stuffed monkey and wrapped package in the pocket of the would-be Santa Claus.[13]

From 1920 through 1927 come Rockwell's disturbed or vaguely disturbing Santas—aged, weary executives, for the most part, entrepreneurs of toys (and juvenile business ethics) weighed down by their corporate responsibilities. They balance their lists of good children against entries in a worn expense book (above). They make careful notations in their ledgers or use them to plot the most efficient route from house to house. Like Leyendecker's St. Nicks, Rockwell's—from time to time they even wear the halos of the dis-

carded Madonnas—are often viewed from a position slightly below the figure, placing undue emphasis on huge carpet slippers and knees. They become giants who tower over the tiny houses of their potential clients, in what might be construed as a child's-eye view of the relationship between size and worth, or value.[14] But the effect is often disquieting and strange, as in Rockwell's cover of December 3, 1927, which pictures the head of an immense Santa-with-a-halo smiling at a tiny boy in Dr. Denton's, who is clasped between his massive thumb and first two fingers (above). No icon, the brown-eyed saint is utterly convincing as a person, which makes his scale seem doubly ominous. The most plausible conclusion to the implicit story Rockwell tells in this illustration is that the looming giant is about to pop the child into his half-open mouth, like a tasty morsel of Christmas candy.[15]

Rockwell did not really believe in icons or symbols. Like the skeptical children in the magazine stories

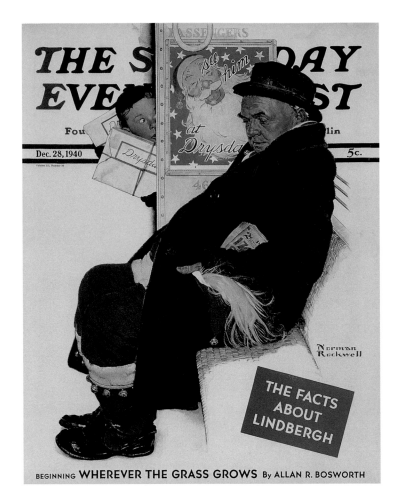

Santa on Train, 1940

of his own youth, who must be coaxed or bullied into a faith in Santa Claus, Rockwell put his trust in tangible facts—in a brown-eyed old man with a beard who is patently not some mythical Santa, although he wears a red cap and a halo.[16] Indeed, Rockwell's most memorable and convincing Santa covers for the *Post* are those that give the Christmas masquerade away entirely.[17] In 1940, a little boy who has just confessed his heart's desires to the Santa at Drysdale's Department Store encounters his hero, worn out, beard crammed into his overcoat pocket, slumped in a compartment on the homebound train, too weary to notice that he is sitting squarely on a prickly sprig of holly (above). In 1956, that same astonished boy (or his little brother) finds telltale whiskers and a red suit in the bottom drawer of his father's bureau (page 161). Rockwell's last Santa cover for the *Post* thus returns to the theme of his first one, forty years earlier. Christmas is most affecting and real when its celebrants admit that the Santas and the magic come from the bureau drawers of the ordinary Americans who put on the whiskers each December and play the old, familiar game again.

Somehow, in their own weary realism, perhaps, Rockwell's Santa Clauses seem tinged with nostalgia or regret for vanished Christmases once upon a time, Christmases that did not need to be manufactured out of red velvet suits and toy-store inventories. This sense of the losses incurred in the process of turning the feast over to Santa and the advertisers and an extended Christmas shopping season matches, in a curious way, the mood of Washington Irving and Charles Dickens, as they set about re-creating—or manufacturing—an Olde English Christmas in the early nineteenth century. In the celebrated Christmas chapters of *The Sketch-Book*, published serially in 1819 and 1820, Irving, as a post-Revolutionary American, falls easy prey to an admiration for the old-time

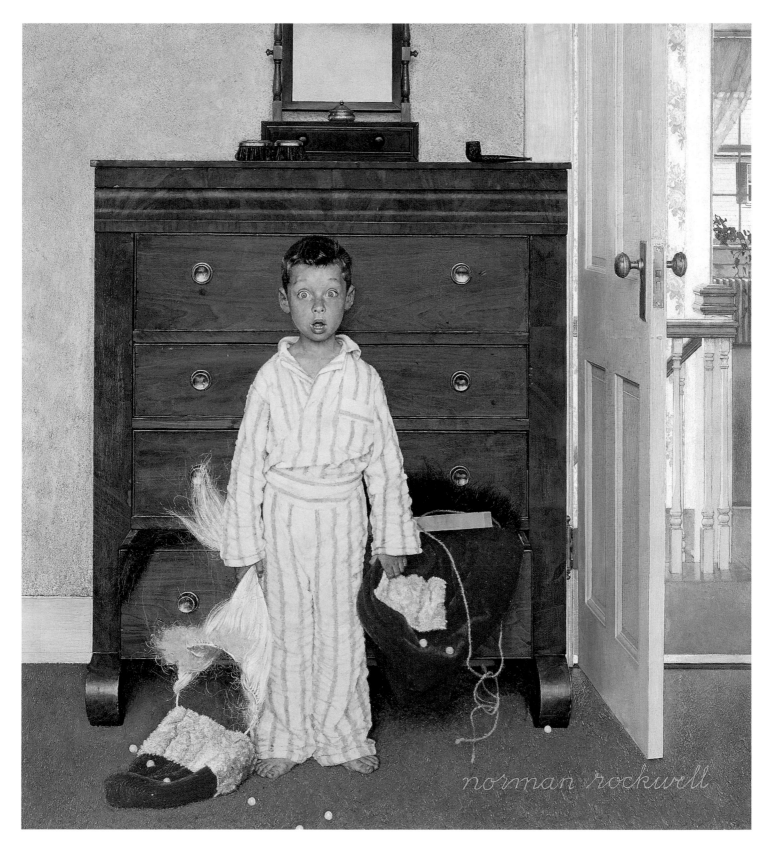

The Discovery, 1956

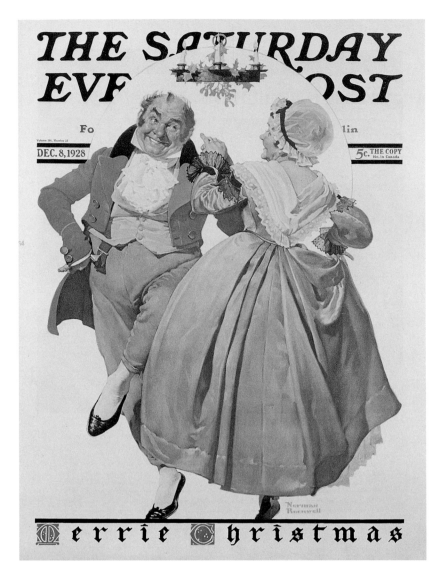

Merrie Christmas: Couple Dancing Under Mistletoe, 1928

customs of the Mother Country and the Christmas revels revived by the Squire of Bracebridge Hall. His own era seems flat and cold in comparison with the splendid Yuletide entertainments concocted by his host—the games and costumes and ritual dishes that stand for an open-handed hospitality and a harmony between rich and poor that Irving finds lacking in his own day. Dickens's *The Pickwick Papers* (1837) takes straight out of Irving its account of the Pickwickians' Christmastime trek to Dingley Dell aboard the Muggleton Coach, along with an urgent drive to reform the present on the model of the past, which finds its clearest expression in his 1843 *A Christmas Carol.*[18]

One of Rockwell's favorite childhood memories

was of his own father, sitting in a pool of lamplight at the dining room table, reading Dickens aloud to his children. "I would draw pictures of the different characters," Rockwell wrote.

Mr. Pickwick, Oliver Twist, Uriah Heep. They were pretty crude pictures, but I was very deeply impressed and moved by Dickens. . . . The variety, sadness, horror, happiness, treachery, the twists and turns of life; the sharp impressions of dirt, food, inns, horses, streets; and people —Micawber, Pickwick, Dombey (and son), Joe Gargery—in Dickens shocked and delighted me. So that, I thought, is what the world is really like. I began to look around me.[19]

John Leech, *Fezziwig's Ball*, 1844

In 1945, Rockwell told *The New Yorker* that his parents agreed to send him to art school after seeing a drawing of Scrooge he had made while listening to his father read *A Christmas Carol*.[20] Not surprisingly, then, his most effective Christmas scenes would draw upon his love for the world of Dickens and the pungent scent of realism Rockwell associated with the Olde England of his childhood memories.

Rockwell did eight such Christmas covers for the *Post* (which had serialized Dickens's *Dombey and Son* in the nineteenth century) between 1921 and 1938; several of the subjects were later reprised as Hallmark cards in the late forties and early fifties.[21] The majority of these holiday designs took as their theme the coach, its driver, and its passengers, or the process of going home for Christmas. The first in the series, for example, is a head-and-shoulders portrait of a genial, apple-cheeked coachman. Related covers include a close-up of another coachman on the box of a London stagecoach, with a schoolboy at his side who is clutching a carpetbag and a tin box of Christmas goodies; a full-length rendition of a portly driver cracking his whip; a figure in greatcoat and mittens toting two bas-

kets loaded with Christmas fare; and a plump passenger with carpetbag, basket, and umbrella, seated under an announcement for a forthcoming departure of the Muggleton Stage-Coach. All the men in these pictures wear holly in their hatbands. Each of the compositions bears the legend "Merrie Christmas."[22]

The *Merrie Christmas* series comes straight from the imagery of *The Pickwick Papers*, and its splendid, bustling picture of Mr. Pickwick and his friends "well wrapped up in great-coats, shawls, and comforters" on the way to Dingley Dell, surrounded by "portmanteaus and carpet-bags" and groceries of all sorts. The inn is wreathed in "sprigs of holly with red berries" to signify the happiness of a blossoming season of homecoming and reminiscence that can, in Dickens's words, "win us back to the delusions of childhood days."[23] The little boy on the box of the London coach may be Paul Dombey; the ubiquitous goose protruding from the wayfarers' baskets may be the one the Cratchits will baste for their Christmas dinner as Scrooge and the spirit come to call.[24] As a cover artist, Norman Rockwell was seldom called upon to illustrate a text.[25] But, by choosing to take his cues from Dickens in this group

Frederick Barnard, *Tiny Tim*, 1885

of covers, Rockwell produced some of the most convincing work of his career. In contrast to his dispirited Santas, who seem incapable of pretending to be evanescent spirits, his Dickensian characters draw vitality from the carefully delineated period costumes they inhabit. Their gaiters and shiny buttons add to the aura of palpable presence that cloaks them like an eighteenth-century overcoat.

There is some evidence that Rockwell also drew upon well-known illustrations of Dickens's works. The 1928 entry in the *Merrie Christmas* series is a case in point (page 162). The cover shows a jolly couple of mature years, dressed in the manner of the eighteenth century, dancing beneath a candleholder wreathed in holly and mistletoe. The capering poses, the disposition of the garments, the prominent seasonal centerpiece, and even the squat face of the gentleman-dancer come from the famous John Leech frontispiece to the first edition of *A Christmas Carol*, published by Chapman and Hall of London (page 163). The scene is old Mr. Fezziwig's Ball, which is visited by Scrooge and the first of his nocturnal visitors, the Ghost of Christmas Past. Leech chose the priceless moment when Old Fezziwig and his wife took to the floor for the Sir

Roger de Coverley and danced so deftly that "a positive light appeared to issue from Fezziwig's calves."[26]

Similarly, Rockwell's Tiny Tim cover of 1934, entitled *"God Bless us everyone," said Tiny Tim* (page 165) takes the pose of Bob Cratchit and Tim—as well as their body types, the treatment of Bob's scarf, and Tim's compacted pose—from a Frederick Barnard steel engraving published in the 1885 *Character Sketches from Dickens* (above). E. A. Abbey, whose work Rockwell admired greatly, had provided wood engravings for an 1876 edition of Dickens, which may also have influenced the stance of Rockwell's Bob Cratchit.[27]

The popularity of Rockwell's Dickensian illustrations surely rests on their fidelity to the spirit of the Olde English Christmas that Dickens helped to create —a spirit of adult nostalgia for childhood, for home, for bygone times, and a universal good cheer and benevolence that stood in marked contrast to the commercial bustle of the modern, Santa Claus holiday. Nor was Rockwell the only purveyor of such imagery. A series of Hallmark cards and wrapping paper designs, introduced around 1925 and popular throughout the 1930s, also used the coach in a snowy landscape, the jolly coachman, the dapper passengers, and carolers to

Tiny Tim and Bob Cratchit, 1934

wish the recipient "An Old Time Christmas."[28] For the 1920s, the message was one of sincere good wishes and absolute authenticity.[29] For the thirties, it was one of hope for the restoration of all good things.

The homecoming theme implicit in the Dickens pictures inspired Rockwell's best Christmas tableaux of the 1940s. In 1945, a young soldier comes home from war—and discovers that he has outgrown his high school clothes. Another young man, in 1948, arrives home with his arms full of luggage and presents. He is shown from behind; the viewer sees only the reaction of his family and friends gathered around the Christmas tree, their faces lit with pleasure at the restoration of the domestic circle (page 2). In 1944, a crowd bustles through a Chicago railroad station (page 134). Sailors kiss their sweethearts under crepe-paper Christmas bells. A soldier sees his new baby for the first time. Mothers watch for sons. Nuns glide by. Grandpas are loaded down with packages. A tipsy reveler staggers through the crowd carrying a wreath and a Christmas tree. A thin, poorly dressed charity Santa, seen from behind, rings his bell listlessly.

Illustrator Haddon Sundblom, who created a new Santa Claus for Coca-Cola in 1931, did so in reaction to the cheap costumes and meager look of the bell ringers in Chicago, where he maintained a thriving commercial studio. Sundblom responded with an image of lavish abundance that ran counter to the darkening mood of the Depression: a jolly figure bursting with happiness; a huge, silky beard; deep fur trim on his red suit; and a waistline "so ample that it required a belt and suspenders."[30] The ultimate emblem of the

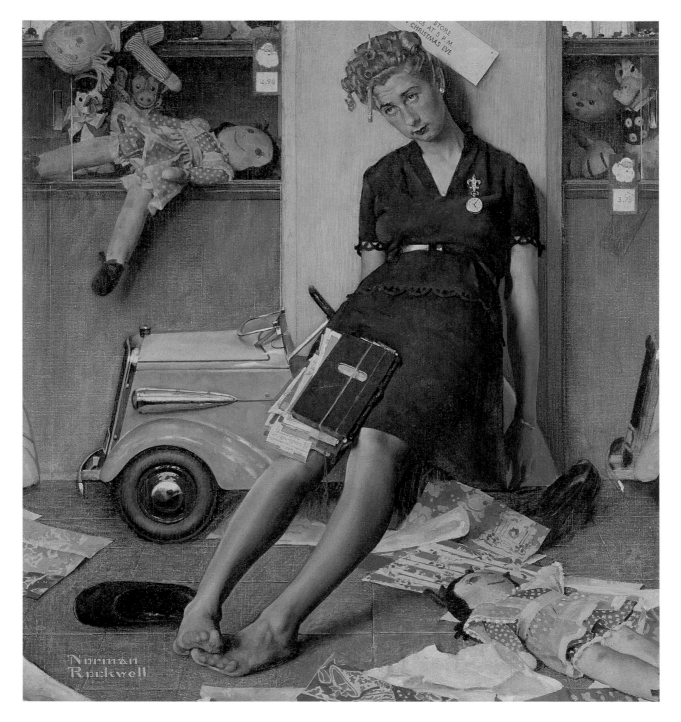

Tired Salesgirl on Christmas Eve, 1947

commercial Christmas, the Sundblom Santa, like Nast's or Leyendecker's, is an abstraction, an icon. Although Sundblom used a friend (and later himself) as a model, his Santa Clauses succeeded because they mirrored a prototype embedded firmly in the imagination. Rockwell's Santas, on the other hand, looked too much like the old men he hired to pose for him, and not enough like the happy, mythic Santa Claus who rode in

parades. Rockwell was drawn instead to the realism of Dickens because it matched his own perspective on art —and on the meaning of Christmas.

Rockwell excoriated the modern, commercial Christmas in two interesting and atypical holiday covers for the *Post*. The 1947 cover (above), painted in July of that year in Chicago during a terrible heat wave, is set in the toy department of Marshall Field's.[31] A sales-

Christmas: Gramps in Snow, 1937

girl, shoeless, slumps in utter exhaustion amid a litter of unsold dolls and scraps of gift wrap. It is 5:05 P.M. on December 24. The time is visible on the woman's pendant watch, and the sign that dangles crookedly above her head notes that on Christmas Eve—and only on Christmas Eve!—the store will close at five o'clock. No more shopping days 'til Christmas. Her pose echoes the limp inertia of the rag dolls scattered around her. They smile big, sewn-on smiles. But she does not. Santa looks on disinterestedly from the red Christmas tags that tell a story of last-minute price reductions. Merry Christmas, indeed!

The 1937 cover (above) uses a compositional device favored by Rockwell's elders: Leyendecker and Coles Phillips both employed the flat cover sheet itself,

on occasion, as a pictorial element. Here, an elderly man out Christmas shopping has fallen into a snow-bank—represented by the white paper of the cover. His body disappears into the snow, leaving behind only glimpses of his purchases: boxes wrapped in white paper with bright bows and wisps of holly, a hobby horse, a drum, a dolly turned upside down so as to be almost unrecognizable.[32] Chaos. Disorder. A world turned upside down. The very opposite of Olde Christmases long ago. And in the very center, just below the upside-down dolly, a card, adrift on the snow: Merry Christmas! Bah! Humbug!

Steven Heller

Rebelling Against Rockwell

No American illustrator has had a greater effect on popular culture or a more profound influence on generations of American illustrators than Norman Rockwell. He had a gift for reflecting his times through representations of everyday life that became the official art of this nation. From the 1920s through the 1950s, his style set the standard for commercial artists who used realism to illustrate books, magazines, and advertisements. Although none surpassed Rockwell's unerring ability to capture the quintessential human moment, they filled countless pages with representational and romantic paintings that typified the art and craft of illustration. Paradoxically, though, Rockwell's art was both a model of excellence and a blueprint for cliché.

The subjects Rockwell chose to portray, and the way he modeled his characters and applied his paint, all derived from an intuitive sense of what would appeal to average Americans, who were unaware of European modernism and enjoyed pictures that represented their own heroic, yet commonplace, lives. Owing to his success, many commercial illustrators aped Rockwell's manner—which itself owed a debt to Michelangelo and other Renaissance artists—but most failed to match Rockwell's genius for presenting the ordinary through extraordinary composition and the telling gesture. Rockwell liberated American illustration from its reliance on archetypes; he introduced real-life protagonists to take the place of cardboard heroes. Yet he was the leader of an art form that in lesser hands (and there were many) was an abyss of romanticism and sentimentality. "Rockwell was all about energy," explains Dugald Stermer, chair of the California College of Arts and Crafts Department of Illustration. "His people were subtly exaggerated just bordering on caricature to heighten drama and capture the moment. But by comparison, most other illustrators of his day, including those working for *The Saturday Evening Post*, were flat." [1]

Rockwell ran one step ahead of cliché, while his acolytes lagged a mile behind. "They copied what they thought Norman Rockwell should be, not what he *was*," adds Stermer. Indeed, Rockwell's most popular and populist paintings, *The Four Freedoms* (pages 97–99, 101),

The Gossips (detail), 1948

Cobbler Studying Doll's Shoe, 1921

were just brushstrokes away from mere propaganda about traditional American values. However, by skillfully balancing honest sentiment with uncompromising enthusiasm, and by remaining faithful to natural expression and body language, Rockwell elevated these idealized virtues to manifestoes of faith. "The least well known, but one of his best pictures," observes illustrator Brad Holland, "is *Freedom from Fear,* showing a husband and wife tucking their kids into bed. It is simple and unrhetorical. It is like Vermeer: a genre painting that rises to the level of philosophy."

Similar themes also appeared in the most banal greeting cards and advertisements by artists who ap-

propriated Rockwell's themes and borrowed his mannerisms, but lacked his vision. Rockwell is not to blame for the mediocrity that followed in his wake (and not all commercial artists of the day were bankrupt), but he became the touchstone for a generational schism, partly because his work was misinterpreted by loyalist and rebel alike. Even today, proponents may celebrate his work for the wrong reasons: "He's more highly regarded for his sentimentality than for his genius with faces," asserts Holland about Rockwell's gift for intense emotional characterization. "He's the American Dickens, and one has to overlook much of what made him popular to realize just how good he was."

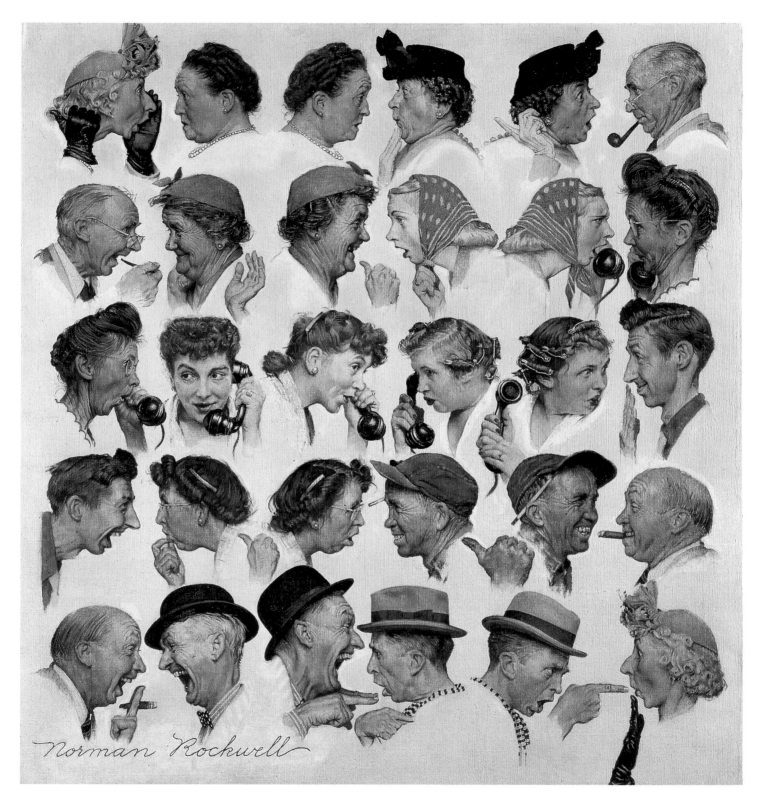

The Gossips, 1948

Forgotten Facts about Washington, 1932

Rockwell, the spiritual descendant of the great illustrator-storytellers Winslow Homer, Howard Pyle, and N. C. Wyeth, is a marker in the evolutionary progression of American illustration. His career took hold in the early 1920s, around the time that photography completely transformed graphic journalism by making reportorial illustration virtually obsolete. But Rockwell steadfastly refused to let illustration descend into triviality. He used the camera as a tool—a means of freezing gesture and expression for future reference. His paintings of American life gave bolder expression and more full-color dimension to his subjects than the black-and-white halftones commonly reproduced in national magazines. While most illustrators, especially those working for *The Saturday Evening Post*, stayed the course and produced reams of quixotic scenes and sight gags, Rockwell maintained a standard of excel-

lence that far transcended the norm in a profession that was more concerned with servicing clients than making lasting art.

Despite his best efforts, by the late 1940s Rockwell was in the vanguard of a waning discipline. Seismic shifts in technology and challenges by modernist art idioms conspired to relegate conventional realistic illustration to the lesser status of commercial art. By remaining true to his own idiom, Rockwell unwittingly appeared to oppose the rising tide of abstraction and expressionism as they influenced trends in illustration. While he maintained a loyal core audience, stylistic novelties in the publishing and advertising industries were weaving in and out of fashion. Rockwell's art was becoming anachronistic.

If Rockwell was a hero to many illustrators, he was also something of an institution—a symbol of the old

Checkers, 1928

The Trouble With the State Department By Stewart ALSOP

Also: Margaret Mead Speaks Out on the Changing Status of Women

POST
The Saturday Evening

Mar. 3, 1962 20¢

Dick Sargent, *Baby's First Shot*, 1962

order. For the younger generation of postwar illustrators and graphic designers who embraced the European modern movements—such as Cubism, Futurism, Dada, and Surrealism—he was a relic of antiquity. He represented the "Uncle Joe school of illustration," recalls Paul Rand, the American graphic-design pioneer, who argues that Rockwell's stubborn insistence on detail and verisimilitude denied the mystery of art. "He was the enemy," asserts Seymour Chwast, co-founder in 1954 of Pushpin Studios, the illustration and design firm that launched the first attack against turgid postwar narrative illustration. Chwast and other critics cite formal differences, such as realism versus abstraction, detail versus allusion, and mannerism versus expressionism, as separating the old guard from the new wave. But there were also philosophical issues that distinguished the urban artist, raised on comics and political cartoons, from the middle-American artist, brought up on Rockwell's vision.

As a child in Freemont, Ohio, in the early 1950s, Brad Holland, who became a pioneer of conceptual editorial art in the late 1960s, reveled in Rockwell's

Saturday Evening Post depictions of an America that he could easily recognize in his own hometown. Chwast, however, had a very different vantage point, living in Brooklyn during the Depression-weary 1930s and the postwar 1940s: "Rockwell not only painted every detail on his canvas, he also presented details of America that really didn't exist; a happy America, a fake America." Similarly, another New Yorker, Art Spiegelman, author of *Maus* (a comic-strip biography of his parents' lives during the Holocaust), asserts that "Rockwell's paintings were visuals with an agenda; he took the real and turned it into symbols." In his own work, Spiegelman continues to subvert these symbols by satiric recasting. He was influenced by the acerbic parodies in *MAD* magazine in the late 1950s by satiric artist Will Elder, who intensely studied Rockwell's technique. In vignettes that looked like the real thing but were instead scabrous commentaries on Rockwell's (and by extension America's) idyllic fantasies, Elder "achieved perfect pitch, mastered the innocent surface, and then bit its tail off," says Spiegelman. Indeed, Rockwell's legacy can be mea-

John Falter, *Broken Antique Chair*, 1959

Amos Sewell, *Blown Fuse*, 1956

sured as much by the parodies of his work as by his own enduring icons.

As unambiguous as Rockwell's work appeared on the surface, it was interpreted differently by different artists. Holland recalls that as a child he liked Rockwell's magazine covers because "they looked like photographs, but in the end, I liked the faces—they weren't pretty necessarily, but they had soul." At the same time, Chwast argues that looking at a Rockwell painting after World War II "was to see America as it could never be again." Yet Stermer, who published one of Rockwell's paintings when he was art director of *Ramparts* magazine—a 1960s-era left-wing political muckraking journal—points to Rockwell's 1964 painting *The Problem We All Live With* (pages 106–107), which shows an African American girl being marched by U.S. marshals into a newly desegregated elementary school. He says about Rockwell's ability to transcend political controversy, "No other illustrator could have pulled this off the way that he did, when he did."

Yet for all of Rockwell's complexity, indeed because of it, he was a catalyst for change. "You wouldn't

have needed to make him an enemy if he was a hack," says Stermer. In fact, Rockwell was such a seminal figure, and his work was so ubiquitous, that in hindsight it seems axiomatic that he would have incited rebellion among certain of his followers. "Since Rockwell was a giant in popularity, I'm sure a lot of people felt that to compete with him they had to level him," asserts Holland. "I could see wanting to *be* Rockwell—to be as original as he had been—*but* not wanting to be *like* him. And that's the challenge posed by every distinctive artist: the essence of tradition is to invite the challenge that redefines it." Hence, Rockwell drew respectful fire from the young rebels, but his many imitators earned their contempt.

Seymour Chwast readily admits that he used "Rockwell" as a catchall term for artists rooted in the tried-and-true representational manner that dominated most American commercial art from roughly the mid-1930s until the mid-1950s. Rockwell's influence on the genre was widespread, and those who slavishly followed his surface style were published in all the magazines and illustration yearbooks. The

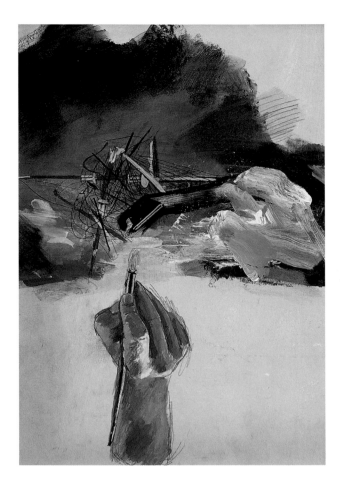

Robert Weaver, Untitled, 1979

Robert Weaver, *When You Risk Becoming an Artist, You Risk Taking Your Talent Seriously,* 1983

verisimilitude that Rockwell accomplished so well, and which imitators attempted, was anathema to the new breed of "expressive" artists who sought to liberate editorial (and possibly even advertising) illustration from the stranglehold of realism and to reinvest it with idiosyncrasy. Most of all, they sought to make illustrations that complemented rather than mimicked a text.

By the 1950s, a new generation of editorial illustrators was unwilling to remain faithful to the prevailing realist aesthetics that were championed by art directors for such magazines as *Colliers, The Saturday Evening Post, Reader's Digest*, and *American Magazine*. Even if the majority of readers preferred Uncle Joe's blemish-free realism, dissent was becoming stronger, and alternative styles were emerging in some of the more progressive editorial venues.

Illustrative style had shifted throughout the twentieth century, but until the postwar period the changes had been incremental. The hierarchy of the American publishing and advertising industries was such that style was dictated by "word people." Editors determined the visual content of magazines, with art directors serving as go-betweens who related their editors' preferences for composition, characterization, and even color to freelance and staff artists. Similarly, copywriters dominated advertising, often providing their own sketches for layouts, which illustrators were then required to finesse. Word people were reluctant to disrupt this convention. Commercial illustrators were, then, routinely treated as appendages—hands in the service of a product or idea—and they dutifully followed editorial dictates. Rockwell himself was above the fray—he answered to an art director and editor but the relationship was of equals—but lesser illustrators had their work closely scrutinized by editorial overseers, who demanded accuracy, clarity, and obedi-

Alan E. Cober, *Why People in Dallas Are Arming Themselves*, 1982

ence. Independent ideas and concepts were discouraged in favor of precise compositions that rendered most illustrations as formal exercises.

During the late 1940s and early 1950s, a school of younger artists represented by the Charles E. Cooper Studios—a leading New York advertising art talent agency—helped fill advertising and editorial pages with realistic artwork that left little to the imagination or interpretation of the viewer. In the service of editors and advertising account executives who feared hidden agendas and ambiguous images, even the most accomplished commercial artists were concerned almost exclusively with style—how their work looked rather than what it said. Although paintings by the Cooper Studios luminaries Coby Whitmore and Jon Whitcomb were formally looser and less detailed than Rockwell's—and so looked more up-to-date—they avoided any semblance of abstraction or allusion that would have given their work additional levels of meaning. At *The Saturday Evening Post*, where Rockwell worked for over four decades, other leading illustrators offered approaches that complemented the master's. And although Stevan Dohanos, John Falter, and Amos

Sewell among them, were not carbon copies of Rockwell (in fact, their focus shifted from New England and Middle America to the Long Island and Connecticut suburbs), their comic vignettes of life in white middle-class America followed the formula that Rockwell originated (pages 174, 175).

The cult of Rockwell was further promoted by his well-publicized association with the Famous Artists School of Westport, Connecticut, the East Coast's largest correspondence art school. During the 1950s and 1960s, the work of most faculty members—including leading advertising and editorial illustrators known collectively as the Westport School—was rooted in sentimental, romantic, and heroic representation. Together they dominated the illustration market and received the major awards from New York's venerable Society of Illustrators. With advertisements for the Famous Artists School frequently appearing in commercial and trade magazines, and with Rockwell as its titular head, the group was firmly implanted as the illustration establishment. However, at the same time, fashion was gradually shifting from tight realism to a more casual style.

Brad Holland, *The Inspector*, 1985

In the early 1950s, the satiric American artist Robert Osborn introduced an expressionistic, brush-and-ink drawing style in his acerbic graphic commentaries about society and politics. But it was not until the mid-1950s that editorial illustrators who had assimilated the lessons of modern art—including Robert Weaver (page 176), Robert Andrew Parker, Tom Allen, and Phil Hayes—broke through the wall of convention guarded by older agency and editorial art directors. Their illustration was more abstract, influenced by such artists as Mark Rothko, Franz Kline, and Willem de Kooning, and their content appeared to be rooted more in their own psychology than an author's text. Where Rockwell was controlled, the "neo-expressionists" were free. Where Rockwell and his disciples relied on photographic references, the younger artists drew from life *and* imagination. They rejected the precisely rendered human form or landscape in favor of subjectively filtered recollections.

It was not that Rockwell's days were numbered by the late 1950s. He continued to have a huge following even after he left *The Saturday Evening Post* in the mid-1960s for *Look*. But the style that Rockwell had influenced was overtaken by fundamental editorial and design changes throughout the publishing and advertising industries. One significant consequence of the shift from illustration to photography was that illustration was no longer required to convey precise details, but only to evoke ambient moods. In this tidal shift, the responsibility of the illustrator was no longer to mimic a text, but rather to convey a message. "Mine was no longer the era of Norman Rockwell, where everything was easy, obvious, and on the surface," said Robert Weaver, the leader of the new illustration of the 1950s, referring to the new content in specialized magazines. "How would Rockwell illustrate the problem of left-handedness?" he asks rhetorically, thinking of one of his own assignments for *Psychology Today*.

Moreover, monumental, heroic, and romantic illustration was anachronistic in a media environment

Marshall Arisman, *I'm in Hell*, 1988

dominated by television. In fact, the so-called "big ideas" of advertising's creative revolution of the 1960s —sophisticated and witty word and image concepts— rendered the overly narrative Rockwellian method passé.

Illustration turned the corner in the 1960s, becoming more diverse in both form and content. Keepers of the traditional flame—including organizations such as the Society of Illustrators, of which Rockwell was a member in good standing—continued to propagate the illustrator as a painter of narrative tableaux. But the so-called new conceptualists—illustrators such as Brad Holland (page 178), Alan E. Cober (page 177), and Marshall Arisman (above), who conveyed ideas through styles influenced by Surrealism, Symbolism, Expressionism, and Dadaist collage and montage— had made important inroads, thanks to their acceptance by a new generation of editorial art directors, who were full creative contributors. By this time, although Rockwell was still respected, he was no longer

considered a force in the future of illustration. As Cober once stated about the passing of the torch, "I didn't know I was a young Turk. I just thought it was my turn."

After some initial resistance, the Society of Illustrators recognized the new trends and exhibited examples along with more traditional work. In the early 1980s, an annual competition and book called *American Illustration* were founded to promote alternative methods and encourage illustration that pushed the boundaries. By the late 1980s, a form of *l'art brut*— an untutored and naive mannerism representing a fervently personal approach to illustration—was accepted and continues to be a leading style.

Although realism and representation were never entirely rejected, they have evolved away from Rockwell's style, if only because the role of contemporary illustration is different now. For one thing, illustration was then one of the primary visual mechanisms of mass media. Today, illustration is subservient to other

Family Home from Vacation, 1930

visual forms in both print and electronic media, and at its best it provides intellectual stimulation rather than documentary supplementation.

Rockwell's legacy continues to affect millions for whom his paintings distill the real and imagined essence of a bygone age. He launched an epoch that served the masses crisp and clean realism, but he also spawned a rebellion that rejected narrative transpar-

ency for emotional complexity. Perhaps the best way to appreciate Rockwell is to celebrate his paintings as monuments of American history and to accept that they represent a great moment in the continuum of this popular American art.

Babysitter with Screaming Infant (The Babysitter), 1947

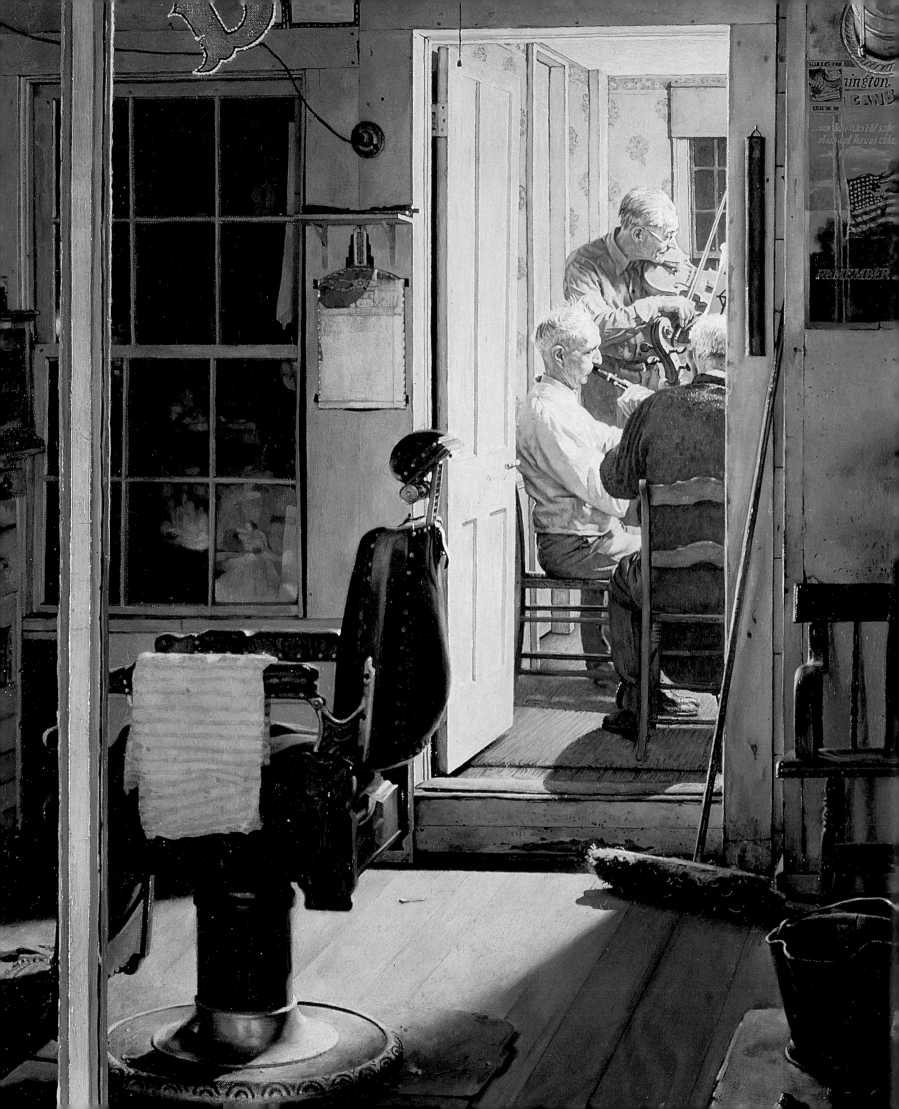

Robert Rosenblum

Reintroducing Norman Rockwell

Norman Rockwell keeps pricking my art-historical conscience. First, there was the Wadsworth Atheneum in 1985, where, to my disbelief, I saw hanging, right in the midst of Picasso, Mondrian, and Miró, a picture of a spunky little girl, smiling proudly over her newly acquired black eye as she waits outside the principal's office for her comeuppance (page 127). An adventurous new curator, Gregory Hedberg, had elevated this Rockwell canvas from the storeroom to the twentieth-century pantheon upstairs, and there it stuck out like a sore but mesmerizing thumb. I had been taught to look down my nose at Rockwell, but then, I had to ask myself why. If it had already become respectable to scrutinize and admire the infinite detail, dramatic staging, narrative intrigues, and disguised symbols of Victorian genre paintings, why couldn't the same standards apply here?

I shelved the question until 1996, when, almost by accident, I passed by Stockbridge, Massachusetts, and thought I'd like to see Robert A. M. Stern's 1993 shrine to Rockwell and, while there, the art as well. Stern's postmodern housing for this revered popular master turned out to be the wittiest fusion of squeaky-clean colonial revival and sophisticated neoclassical detail, but it was the contents that floored me. Inside, without the distractions of modern art, I became an instant convert to the enemy camp, wondering how anybody but the most bigoted modernist could resist not only the mimetic magic of these paintings, but the no-less-magical way they transformed a mind-boggling abundance of tiny observations—a choice of tie, an upholstery pattern, a hairdo, a plate of celery—into essential props for the story told. And lest we think we've been had by a shallow conjuror, we can turn to respectable authorities to uphold the pro-Rockwell view. As Karal Ann Marling pointed out in her 1997 monograph on Rockwell, a reservoir of information delivered in the sprightliest way, John Updike—an amateur art writer who is better than most professionals—is also a fan, and once troubled to explain why.[1]

We are learning that there are many fresh approaches to Rockwell, even psychobiographical ones, since both his personal and professional life were fraught with crises ranging from a recurrent

Shuffleton's Barbershop (detail), 1950

insecurity about being pigeonholed as a lowly illustrator to a serious midlife depression that landed him in the hands of the German psychoanalyst Erik Erikson, himself a student of Anna Freud. But the most fruitful context for Rockwell is probably the big saga of twentieth-century American history, in both the headlines and the small print. In literature, Rockwell takes us from Horatio Alger to Sinclair Lewis; in architecture and design, from the colonial revival (seen at its most ambitious in Rockwell's Yankee Doodle mural for Princeton's impeccably proto-postmodernist Nassau Inn) to George Nelson's Brave New World interiors and the Eames chair; in social history, from the advice of *Saturday Evening Post* editor George Horace Lorimer "never to show colored people [on the *Post*'s cover] except as servants"[2] to the consciousness-raising images Rockwell made for *Look* in the 1960s documenting the traumatic realities of desegregation in the South. Beginning with quaint myths of American innocence, when the most shocking crime was a bunch of Booth Tarkington kids who dare to ignore a "No Swimming" sign (page 13), we end up in a world so ugly that—as recorded in John Steinbeck's *Travels with Charlie* (1962) and captured forever in Rockwell's *The Problem We All Live With* (pages 106–107)—an immaculately dressed little black girl named Ruby Bridges has to be accompanied to her New Orleans school daily under the protection of four U.S. marshals, while white crowds threaten and jeer. Rockwell may have agonized about being more of an illustrator than a "fine" artist, but his best work, such as this outing of a hideous American secret, makes such hierarchies as irrelevant as the old-fashioned prejudice that photography must be a lower art than painting. Who

can forget the shrill contrast of this tidy, regimented march to school against a city wall bearing the partly effaced graffiti scrawl "NIGGER" (which parallels the artist's signature below, rendered in mock-schoolboy, lower-case penmanship) and the remnants of a tomato that's just been hurled, a visceral burst of skin and pulp that looks like the bloody aftermath of a firing squad?

Or perhaps the wall looks like a painting by Cy Twombly, one of those occasional shocks of familiarity that helps place Rockwell within expectations of twentieth-century art. Such reminders, overt and subliminal, keep making unexpected appearances in his work. His *The Connoisseur* (page 86) pinpoints the puzzlements of newfangled modern art, even inventing a plausible Jackson Pollock, whose drip techniques Rockwell apparently enjoyed imitating, even in his sixty-eighth year. Do we have here a Mike Bidlo *avant la lettre*? And for a new kind of spine-chilling social realism, his *Southern Justice* (page 45), an eerily lit document of the murder of three civil-rights activists in Mississippi, previews both Mark Tansey's painted sepia photographs and Leon Golub's close-up accounts of contemporary brutality.

Such connections may be fortuitous, but there is no doubt that Rockwell, who was unhappy to think he occupied so low a rung on the ladder of high art, demonstrated again and again that he was knowledgeable about museum-worthy traditions and even the latest mode in modern art, which lured him to Paris in 1923. His *Triple Self-Portrait* (page 77) tells all: a bittersweet joke of the lightweight Yankee facing not only his own bemused mirror image and a big white canvas, but also a tacked-on anthology of small reproductions offering

noble precedents for self-portraiture—Dürer, Rembrandt, van Gogh, and, most surprising, a particularly difficult Picasso that mixes an idealized self-portrait in profile with an id-like female monster attacking from within. He once avowed that Picasso was "the greatest," and it might be wondered whether *Girl at Mirror* (page 153), in which a young girl compares herself to a glamour-puss photo of Jane Russell, is Rockwell's homespun homage to The Museum of Modern Art's masterpiece. And if Rockwell nodded humbly in Picasso's direction, there's no doubt that Mondrian played a role, too, in a work like *Shuffleton's Barbershop* (page 5), which offers an almost humorous marriage of the modern Dutch master's severely rectilinear and asymmetrical geometries, translated into the perpendicular mullions of a barbershop window, to the American version of Dutch seventeenth-century realism, with a view through the darkened barbershop to a bright, distant room where, after hours, the locals relax with amateur music-making. And considering Rockwell's witty allusion to Mondrian, perhaps he also threw in a bit of Cubism in the free-floating verbal snippets of the old-fashioned gilded letters on the shop window that identify this homey place: BARBER, SHUFFLETON PROP.

But I, for one, am happy now to love Rockwell for his own sake, and not because he learned some tricks from Mondrian and other artists represented in museums. Taut planar geometries may provide the armature for *New Television Antenna* (page 148), but more important, the picture distills that delirious, worldshaking moment in 1949, when suddenly all Americans (this one living in a symbolically derelict Victorian gabled attic) attached to their roofs TV antennas that superseded the spires on nearby churches. And if we are far enough away from World War II to relish nostalgically some cheerleading from the home front, Rockwell offers *Rosie the Riveter* (page 30), in which Michelangelo's Isaiah becomes a muscular, lipsticked redhead equipped with a lunch box, a phallic rivet gun, a white-bread ham sandwich, and a copy of *Mein Kampf* kept underfoot. These days, gallons of academic ink could be spilled over the feminist issues foreshadowed in this campy icon of macho womanhood at war.

It's a tribute to Rockwell's diverse powers that his art now seems to look in so many directions, including transatlantic ones. The recent revival of interest in the Swede Carl Larsson's popular illustrations of turn-of-the-century domestic bliss provides some European parallels to Rockwell's early fantasies of Pleasantville. Back on this side of the Atlantic, his art gains new dimensions when seen in the context of not only his commercial contemporaries, such as the illustrator J. C. Leyendecker, but also later populist artists such as Ben Shahn, whose social evangelism Rockwell would eventually share. But the larger point is that, just in time for the new millennium, we may have a new Rockwell. Now that the battle for modern art has ended in a triumph that took place in another century, the twentieth, Rockwell's work may become an indispensable part of art history. The sneering, puritanical condescension with which he was once viewed by serious art lovers can swiftly be turned into pleasure. To enjoy his unique genius, all you have to do is relax.

The Stay at Homes (Outward Bound), 1927

Notes to the Essays

The People's Painter

1. Arthur Danto, "Freckles for the Ages," *New York Times Book Review*, September 28, 1986, p. 12.

2. Norman Rockwell, lecture delivered at the Art Center College of Design, Los Angeles, February 24, 1949, Norman Rockwell Archive, Collections of The Norman Rockwell Museum at Stockbridge.

3. Norman Rockwell, "Commonplace," *The American Magazine*, May 1936, p. 11.

4. Tom Wolfe, introduction to *Illustrators 30: The Society of Illustrators 30th Annual of American Illustration* (New York: Madison Square Press, 1989), n.p.

5. Ibid.

6. Rufus Jarman, "Profiles," *The New Yorker*, March 17, 1945, p. 37.

7. Stephen J. Dubner, "Steven the Good," *The New York Times Magazine*, February 14, 1999, p. 38.

8. *Norman Rockwell, An American Dream*, Concepts Unlimited Film, 1971.

9. Norman Rockwell, as told to Thomas Rockwell, *Norman Rockwell: My Adventures As an Illustrator* (New York: Harry N. Abrams, Inc., 1994), p. 35.

10. Paul Richard, "Norman Rockwell, American Master—(Seriously!)," *The Washington Post*, June 6, 1993, p. G1.

11. John Updike, "An Act of Seeing," *Art & Antiques*, December 1990, p. 98.

12. Paul Johnson, "And Another Thing," *Spectator*, August 1, 1998, p. 25.

13. Robert Hughes, *American Visions: The Epic History of Art in America* (New York: Alfred A. Knopf, Inc., 1997), p. 509.

14. Robert Hughes, "The Rembrandt of Punkin Crick," *Time*, November 20, 1978, p. 66.

15. Robert Rosenblum, see p. 185 in this volume.

16. Norman Rockwell completed 321 commissions for *The Saturday Evening Post*. One painting, *Portrait of John F. Kennedy* (page 31), was used on two covers, making a total of 322 Rockwell covers for the *Post* between 1916 and 1963.

Norman Rockwell: A New Viewpoint

1. Norman Rockwell, "Commonplace," *The American Magazine*, May 1936, p. 11.

2. Ibid.

3. Ibid.

4. Norman Rockwell, as told to Thomas Rockwell, *Norman Rockwell: My Adventures As an Illustrator* (New York: Harry N. Abrams, Inc., 1988), p. 35.

5. Ibid., p. 106.

6. Rufus Jarman, "Profiles," *The New Yorker*, March 17, 1945, p. 45.

7. Stuart Murray and James McCabe, *Norman Rockwell's Four Freedoms: Images that Inspire a Nation* (Stockbridge, Mass.: Berkshire House and The Norman Rockwell Museum at Stockbridge, 1993), p. 66.

8. Richard Reeves, "Norman Rockwell Is Exactly Like a Norman Rockwell," *The New York Times Magazine*, February 28, 1971, p. 42.

9. Letter to Norman Rockwell from G. L. LeBon, January 1964, *Look* correspondence file, Norman Rockwell Archive, Collections of The Norman Rockwell Museum at Stockbridge.

10. Reeves, "Norman Rockwell," p. 36.

11. Rockwell, *My Adventures As an Illustrator*, p. 35.

12. Peter Rockwell, "My Father's Paintings about Paintings," *Norman Rockwell*, exhibition catalogue (Rome: Electra, 1990), p. 32.

13. For a deeper analysis of Rockwell and the colonial revival, see Karal Ann Marling, *Norman Rockwell* (New York: Harry N. Abrams, Inc., in association with the National Museum of American Art, Smithsonian Institution, 1997), pp. 47–61.

14. Many of Rockwell's working photographs are preserved in the archives of the Norman Rockwell Museum in Stockbridge. There are few working photographs from before 1943, and it is presumed that most of them were destroyed in the studio fire of that year.

15. Rockwell, *My Adventures As an Illustrator*, p. 399.

16. Peter Rockwell, "My Father's Paintings," p. 26.

17. Rockwell, *My Adventures As an Illustrator*, p. 14.

Some Comments from the Boy in a Dining Car

Peter Rockwell was often one of his father's models, as in *Boy in a Dining Car*.

1. The titles of the *Post* covers are taken from Laurie Norton Moffatt, *Norman Rockwell: A Definitive Catalogue*, 2 vols. (Stockbridge, Mass.: The Norman Rockwell Museum at Stockbridge, 1986). As far as I know, my father did not give titles to his *Post* covers; they acquired titles over time.

2. See Karal Ann Marling, *Norman Rockwell* (New York: Harry N. Abrams, Inc., in association with the National Museum of American Art, Smithsonian Institution, 1997), p. 111, for a different interpretation of this painting. I think that our difference may be based on looking at different reproductions of the same painting. The reproduction in Moffatt, *Norman Rockwell: A Definitive Catalogue*, on which I am basing my interpretation, as well as my memory of assisting in the actual painting process (my wife Cynthia and I helped paint the Pollock imitation), is considerably cooler in tone than the reproduction in Marling's book. Since my father painted almost exclusively for reproduction, the changes that occur in reproduction as well as the differences between reproductions is a subject that deserves some study.

Ways of Seeing

I thank Tirza Latimer for research assistance; Linda Szekely for helping me in the Rockwell archives; Ken Aptekar, Rolf Diamant, and Nora Mitchell for their clarifying observations; Kris Kelley and Steven Spielberg for making it possible for me to study the painting; and David Cateforis for reading a draft of this essay and suggesting refinements.

1. The painting of *The Connoisseur* was made in 1961 and published on the cover of *The Saturday Evening Post* on January 13, 1962. The fullest discussion of it to date is Karal Ann Marling, *Norman Rockwell* (New York: Harry N. Abrams, Inc., in association with the National Museum of American Art, Smithsonian Institution, 1997), pp. 131–132.

2. None of Rockwell's practice Pollocks appear as polished or as convincing as the one in the final painting. For illustrations of them, see Laurie Norton Moffatt, *Norman Rockwell: A Definitive Catalogue*, 2 vols. (Stockbridge, Mass.: The Norman Rockwell Museum at Stockbridge, 1986), 1:235–236.

3. "The Wild Ones," *Time*, February 20, 1956, pp. 70–75; "Posh Pollock," *Time*, December 15, 1958, p. 58.

4. For example, art historian David Anfam wrote that Rockwell "reduces Pollock's delicate lines to a wall of splashes that leaves the spectator cold." *Abstract Expressionism* (London: Thames and Hudson, 1990), p. 9.

5. Harold Rosenberg, "The American Action Painters," *Art News* 51 (December 1952): 49. My thanks to David Cateforis for reminding me of Rosenberg's coining of this term.

6. I informally polled friends and family as to how they interpreted this image and received a range of answers. Those in my informal group who presumed Rockwell to be an artistically and politically conservative painter consistently felt he had to have been ridiculing modern art. In my final reading of *The Connoisseur*, I think such presumptions stem from a modernist typecasting of Rockwell as a purveyor of middlebrow, kitsch art and not from a close look at his paintings, where he reveals his curiosity about and sympathy for all kinds of art-making, including modern paintings.

7. *The Saturday Evening Post*, February 17, 1962, 5.

8. For an examination of the popular press coverage of Abstract Expressionism, see Bradford R. Collins, "*Life* Magazine and the Abstract Expressionists, 1948–51: A Historiographic Study of a Late Bohemian Enterprise," *Art Bulletin* 73 (June 1991): 283–308.

9. I am indebted here to Michael Fried's descriptions and interpretations in *Absorption and Theatricality: Painting and Beholder in the Age of Diderot* (Chicago: University of Chicago Press, 1988). See especially chapter one, "The Primacy of Absorption."

10. See the catalogue *Three Generations of Twentieth-Century Art, The Sidney and Harriet Janis Collection of The Museum of Modern Art* (New York: The Museum of Modern Art, 1972).

11. See *The New Yorker Album of Art and Artists* (Greenwich, Conn.: New York Graphic Society, 1970) for a large selection of cartoons the magazine has run about modern art. They fall generally into three categories: those that poke fun at the public's efforts to understand abstract art; those that ridicule the art itself as overblown and egocentric; and those that make the impoverished artist in his garret, slumped in existential angst, the butt of jokes.

12. The editors for *The Saturday Evening Post*, writing of the cover in the table of contents for the January 13, 1962, issue, remarked that it was not clear what the "prosperous-looking art collector" was thinking. "Cover artist Norman Rockwell won't say. 'If I were young now I might paint that way myself,' he explains. 'Recently I attended some classes in modern art techniques. I learned a lot and loved it.'"

13. See Clement Greenberg, "Avant-Garde and Kitsch," *Art and Culture: Critical Essays* (Boston: Beacon Press, 1961), pp. 3–21. On pages 3 and 14, he cites both Norman Rockwell and *Saturday Evening Post* covers as examples of kitsch.

14. "A *Life* Round Table on Modern Art: Fifteen Distinguished Critics and Connoisseurs Undertake to Clarify the Strange Art of Today," *Life*, October 11, 1948, pp. 56.

15. Russell Lynes, "Highbrow, Lowbrow, Middlebrow," *Harper's Magazine*, February 1949, pp. 19–28.

16. *Life*, April 11, 1949, pp. 99–102.

17. Fried, *Absorption and Theatricality*, p. 157.

18. "An interview with Jackson Pollock (1950)," in Francis V. O'Connor, *Jackson Pollock* (New York: The Museum of Modern Art, 1967), p. 79.

19. Mark Rothko once recommended that the viewer be as close as eighteen inches to his abstract paintings. John Gage, "Rothko: Color as Subject," in Jeffrey Weiss, *Mark Rothko* (Washington, D.C.: National Gallery of Art; New Haven, Conn.: Yale University Press, 1998), p. 262.

20. From photographs taken while he was working on *The Connoisseur*, we know that Rockwell carefully thought about how much of the Beholder should be "in" the painting. He used a cut-out of the Beholder and moved him up and down against the Painting in order to select the relationship he wanted. See Moffatt, *Norman Rockwell*, p. 236, C505a, for one of his trial runs in which less of the Beholder's legs are in the painting and, as a result, the composition is much less intense. Rockwell at one point also considered putting a second viewer into his painting, a female spectator seen in profile. This idea, too, is less riveting than the final version.

21. It seems appropriate that Steven Spielberg, a filmmaker who is himself a master of special effects and emotional manipulation, owns and treasures this painting as well as others by Rockwell.

The Four Freedoms

1. James McGregor Burns, *The Crosswinds of Freedom* (New York: Alfred A. Knopf, 1989), p. 666.

2. Intelligence Report 35, August 7, 1942. Papers of Archibald MacLeish, Box 52, Collections of the Manuscripts Division, Library of Congress.

3. Rufus Jarman, "Profiles," *The New Yorker*, March 17, 1945, p. 38.

4. Norman Rockwell, as told to Thomas Rockwell, *Norman Rockwell: My Adventures As an Illustrator* (New York: Harry N. Abrams, Inc., 1988), pp. 312–314.

5. Letter to Norman Rockwell from Thomas D. Mabry, April 23, 1943, Four Freedoms correspondence file, Norman Rockwell Archive, Collections of The Norman Rockwell Museum at Stockbridge.

6. Letter to James C. McCabe from Rona Roob, Museum Archivist, The Museum of Modern Art, November 13, 1992.

7. Sydney Weinberg, "What to Tell America: The Writers' Quarrel in the Office of War Information," *The Journal of American History* 55, no. 1 (January 1968): 73–77.

8. Memo to Archibald MacLeish from Ulric Bell and William B. Lewis, February 3, 1942. See Richard Polenberg, *War and Society: The United States 1941–1945* (Philadelphia: J. B. Lippincott Co., 1972), p. 53.

9. Allan M. Winkler, *The Politics of Propaganda: The Office of War Information 1942–1945* (New Haven, Conn.: Yale University Press, 1978), p. 63.

10. Weinberg, "What to Tell America," p. 85.

11. Ibid., p. 86.

12. Polenberg, *War and Society*, p. 53.

13. Rockwell, *My Adventures As an Illustrator*, p. 314.

14. Ibid., p. 315.

15. Ibid.

16. Stuart Murray and James McCabe, *Norman Rockwell's Four Freedoms: Images that Inspire a Nation* (Stockbridge, Mass.: Berkshire House and The Norman Rockwell Museum at Stockbridge, 1993), p. 51.

17. Rockwell, *My Adventures As an Illustrator*, p. 315.

18. Jarman, "Profiles," p. 34.

The View from the City

1. Wright Morris, "Norman Rockwell's America," *Atlantic Monthly*, December 1957, p. 134.

2. Robert Hughes, "The Rembrandt of Punkin Crick," *Time*, November 20, 1978, p. 110.

3. Marshall Singer, "Capitalist Realism by Norman Rockwell," *Ramparts*, November 1972, p. 45.

The Saturday Evening Post

Special thanks to Elizabeth Thomas, Linda Merrill, H. Nichols B. Clark, and Jan Cohn for their thoughtful readings of various drafts of this essay.

1. Quote from Norman Rockwell Museum guide Ellen Baise in "Exhibition In the Making, 1999–2000—A Cultural Exploration of *The Saturday Evening Post*," *The Portfolio*, The Norman Rockwell Museum newsletter, summer 1998, p. 13.

2. For example, in 1897 the *Post's* intended readership was middle-class businessmen, and what advertisements there were presumably targeted this group. However, as the century turned, it became clear that while these men were the principal money-earners, their wives were the primary purchasers of goods and services for the household, including the majority of goods and services advertised in the magazine. To bring this huge group of consumers to its pages, the *Post* announced on June 20, 1908, that it was welcoming women to its fold of readers. Articles, fiction, and editorials slowly began to reach out to women. In response to this new initiative, advertising revenue, along with circulation, increased dramatically. See Jan Cohn, *Creating America: George Horace Lorimer and the Saturday Evening Post* (Pittsburgh: University of Pittsburgh Press, 1989), pp. 9, 60–99; C. E. Brookeman, "Norman Rockwell and The Saturday Evening Post: Advertising, Iconography and Mass Production, 1897–1929," in Marcia Pointon, ed., *Art Apart: Art Institutions and Ideology Across England and North America* (Manchester, England, and New York: Manchester University Press, 1994), p. 155.

3. By contrast, the traditional and highbrow magazines such as *Harper's* and *Atlantic Monthly* never reached these circulation numbers. For example, in the twenties, *Harper's* reached a peak of 75,000 readers, while *Atlantic Monthly* was closer to 100,000 readers. See Theodore Peterson, *Magazines in the Twentieth Century* (Urbana: University of Illinois Press, 1964), pp. 406–412.

4. Cohn, *Creating America*, pp. 5, 300.

5. Ibid., pp. 9–10.

6. Ibid., pp. 5–6.

7. Ibid.

8. Victor Boesen, "Look Ma! There Goes Our House," *The Saturday Evening Post*, November 5, 1949, p. 20.

9. Phyllis Duganne, "The Cradle Robber," *The Saturday Evening Post*, March 6, 1954, p. 20+.

10. Norman Rockwell, as told to Thomas Rockwell, *Norman Rockwell: My Adventures As an Illustrator* (New York: Harry N. Abrams, Inc., 1994), pp. 145–146.

11. Ibid., p. 146.

12. Ibid., pp. 194–195.

13. Laurie Norton Moffatt, *Norman Rockwell: A Definitive Catalogue*, 2 vols. (Stockbridge, Mass.: The Norman Rockwell Museum at Stockbridge, 1986), 1:72.

14. Karal Ann Marling, *Norman Rockwell* (New York: Harry N. Abrams, Inc., in association with the National Museum of American Art, Smithsonian Institution, 1997), pp. 56, 58.

15. For example, the short story "Neighbors" by Clarence Budington Kelland revolves around the life of Warren Cross, a man of humble means, who rises through the ranks of Consolidated Lumber Company through hard work and determination, p. 3+. Another story by Fannie Kilbourne, "Chivalry is Not Dead," describes the life of Claire, who through determination and hard work climbs up through the ranks of Miller Advertising Agency, leaving her modest beginnings behind her. Phillips, her coworker, is from an upperclass background. His laziness almost costs him his job until Claire teaches him the value of hard work and literally helps him keep his job, p. 14+. Editorials that focus on the value of hard work for anyone of any class include "Getting On in the World," p. 136, and "On Driving a Milk Wagon," p. 136+.

16. Also included in this issue was an advertisement for Hickok belts and buckles that prominently featured a bust of Lincoln next to representations of the products. It was not entirely clear how Lincoln related to the product advertised, but such copy as "character," "rigid quality standard," "careful workmanship," and "finished correctness" suggests connections with Lincoln's stature and character.

17. John Wilmerding, *Important Information Inside: The Art of John F. Peto and the Idea of Still-life Painting in Nineteenth-Century American Art* (Washington, D.C.: National Gallery of Art, 1983), pp. 183–236.

18. While only a small number of *Post* readers would likely recognize this reference, it is nonetheless significant, as it shows Rockwell using art-historical details as well as details from everyday life to create visual narratives of compelling depth. Except for an occasional display in a drugstore or tavern, Peto's work did not become part of the popular visual culture until the 1930s with the revival of American folk art and craft, the resurrection of William Harnett's work by Edith Halpert, and the widely publicized discovery of a number of works attributed to Harnett that were really Peto's. Harnett did a few late-nineteenth-century office-board still-lifes very similar to Peto's. Unlike Peto, Harnett regularly displayed his work in drugstores, department stores, factories, and fairs. Since Harnett's work was more a part of popular visual culture than Peto's, it is possible that some of Rockwell's viewers would have made the connection between this and Harnett's paintings. See Doreen Bolger, Marc Simpson, and John Wilmerding, eds., *William M. Harnett*, exhibition catalogue (New York: Harry N. Abrams, Inc., The Metropolitan Museum of

Art, 1992). See especially Elizabeth Johns's essay, "Harnett Enters Art History," pp. 101–112.

19. *The Saturday Evening Post*, cover, November 5, 1949. Marling, *Norman Rockwell*, p. 81.

20. Rockwell included a vague suggestion of a modernist-style edifice in the far left background of the picture as a foil for his weathered Victorian architecture.

21. Rockwell had working photographs taken of most of the elements in this picture. It is significant that in one of the photographs, the gable of the house is in very good condition with none of the holes and cracks that appear in the final picture. Rockwell deliberately added these signifiers of age to make a startling contrast between old and new; see Norman Rockwell Museum Archive, working photographs, Box 57.

22. *The Saturday Evening Post*, November 19, 1949. Letter from Susan G. McGuire of Deerfield, Illinois.

23. Kathy Peiss, *Hope in a Jar: The Making of America's Beauty Culture* (New York: Metropolitan Books, 1998), pp. 252–253.

24. See one of the working photographs for this painting which includes the magazine *Movie Spotlights* with Jane Russell on the cover. Rockwell used photographs such as this in the process of creating *Girl at Mirror*. Norman Rockwell Museum Archive, working photographs, Box 72.

25. Thanks to Donald Peirce, Curator of Decorative Art, High Museum of Art, for helping me identify the style of chair and how it would have been interpreted by Rockwell's audience. The doll's age was verified by Deirdre Donohue, Librarian, Costume Institute, The Metropolitan Museum of Art, in a fax transmission of December 15, 1998.

26. See also Marling's discussion of this painting in *Norman Rockwell*, pp. 44–45.

27. Old master artists such as Velázquez painted famous images of women looking into mirrors; see, for example, his *Rokeby Venus*. Rockwell had prints and books of Velázquez's work in his studio. David Brenneman, Francis B. Bunzl Family Curator of European Art, High Museum of Art, alerted me to the similarities between *Girl at Mirror* and a 1932 print entitled *Adolescence* of a nude girl looking into a mirror by British artist Gerald Brockhurst, whose work was widely known in the United States by the 1950s. I have not yet ascertained whether Rockwell knew of this work, but it would make for an interesting study. See *The Art of Gerald Brockhurst*, exhibition catalogue (Athens: Georgia Museum of Art, University of Georgia, 1993), p. 128.

28. Deirdre Donohue said that the slip's cut and its lace trim "are of a generic style seen from the 1920s to the 1950s." Something like it could be found easily in the Sears and Roebuck catalogs. Fax transmission of December 15, 1998.

Rockwell's Christmas

1. Charles Dickens, *"A Christmas Carol": The Original Manuscript* (New York: Dover, 1967), p. 142.

2. Tom Rockwell, "Christmas with my Father," *Ladies' Home Journal*, December 1988, p. 152.

3. Tom Rockwell, "Rockwell on Rockwell," *The Saturday Evening Post*, November 1985, p. 100.

4. See, e.g., John Kirk, *Christmas with Norman Rockwell* (Edison, N.J.: Chartwell Books, 1997).

5. Clement Clarke Moore, *The Night Before Christmas or A Visit of St. Nicholas* (New York: Putnam and Grosset Group, 1989), unpaginated. On Moore, see Stephen Nissenbaum, *The Battle for Christmas* (New York: Knopf, 1996), pp. 76–89. On Nast, see Thomas Nast St. Hill, introduction to *Thomas Nast's Christmas Drawings* (New York: Dover, 1978), pp. vi–vii.

6. See, e.g., Thomas Nast, "The Shrine of St. Nicholas," *Harper's Young People*, December 12, 1892, p. 89.

7. See, e.g., advertisements for Stevens rifles, *The Saturday Evening Post*, December 6, 1902, p. 23; Waterman pens, p. 27; Edison General Electric Company, *The Saturday Evening Post*, December 5, 1903, p. 24; Peoples Savings Banks, *The Saturday Evening Post*, December 12, 1903, inside front cover; Campbell's Soup, *The Saturday Evening Post*, December 24, 1910, p. 33.

8. Jan Cohn, *Covers of the Saturday Evening Post: Seventy Years of Outstanding Illustration from America's Favorite Magazine* (New York: Viking Studio, 1995), p. 8. By 1908, the *Post* was also regularly observing New Year's Day, Valentine's Day, Easter, and the Fourth of July.

9. In 1924, Macy's department store staged the first of its famous Santa Claus parades in New York City on Thanksgiving Day, confirming the boundaries of the new holiday season; see William Leach, *Land of Desire: Merchants, Power, and the Rise of a New American Culture* (New York: Pantheon, 1993), pp. 334–335.

10. See, e.g., Leyendecker's Santa covers for the *Post* for 1912, 1918, 1919, 1923, 1925, and 1930.

11. Washington Irving, *The Sketch-Book* (New York: Oxford University Press, 1996), pp. 163–206, describes the narrator's visit to a manor house (ca. 1819–20) in which the owner aims to re-create Christmas in Olde England before the Puritan revolution banished mince pies and boar's heads from the winter solstice. See also Leyendecker's Irvingesque *Post* covers for 1904, 1924, 1926, 1929, 1931, 1932, 1933, and 1934.

12. See Leyendecker's Madonna covers for the *Post* for 1927 and 1928, or his Magi cover of 1900 for *Success*. See also *The J. C. Leyendecker Poster Book* (New York: Watson-Guptill, 1975), and Kent Steine and Frederic B. Taraba, *The J. C. Leyendecker Collection* (Portland, Or.: Collectors Press, 1996).

13. For discussion of this cover, see Starkey Flythe, Jr., *Norman Rockwell and the "Saturday Evening Post"* (New York: MJF Books, 1994), 1:13–14. For Rockwell's other early Santas, see Laurie Norton Moffatt, *Norman Rockwell: A Definitive Catalogue*, 2 vols. (Stockbridge, Mass.: The Norman Rockwell Museum at Stockbridge, 1986), 1:4, 5, 10, 18, and passim.

14. See Rockwell's Santa covers for the *Post* for 1920, 1922, 1924, 1926, and 1927.

15. A rejected idea for a Coca-Cola ad, ca. 1935, uses the same conceit: a giant Santa holds a very small Coke glass. See Moffatt, *Norman Rockwell*, 1:346.

16. The child-as-skeptic story was a staple of Christmas issues of children's magazines throughout the second half of the nineteenth century; see, e.g., Hope Ledyard, "Polly: A Before-Christmas Story," *St. Nicholas*, November 1877, pp. 19–21, and M. E. K., "The Christmas Fairies," *St. Nicholas*, December 1882, pp. 82–85.

17. Rockwell's other *Post* Santas include a prosaic old character with U.S. mail bags (1935); a prewar Santa plotting his route on a map just as the movements of troops might appear on a newsreel map of Eastern Europe (1939); and a wartime Santa who pokes his head through a newspaper bearing dire headlines to remind the world to pause for the holidays (1942).

18. Charles Dickens, *The Pickwick Papers* (New York: Penguin, 1964), pp. 414–437. See also Cedric Dickens, *Christmas with Dickens* (Arlington, Va.: Belvedere Press, 1993), pp. x–xiv.

19. Norman Rockwell, as told to Thomas Rockwell, *Norman Rockwell: My Adventures As an Illustrator* (New York: Harry N. Abrams, Inc., 1994), pp. 27–28.

20. Rufus Jarman, "Profiles," *The New Yorker*, March 24, 1945, p. 38.

21. For the Christmas cards, see Moffatt, *Norman Rockwell*, 1:417–429. See also "Christmas Card Design: The Story Behind One of Our Leading Art Industries," *Design* 50 (December 1948): 7–8, 19. Rockwell also did a Dickensian gift card for *Reader's Digest* in 1937.

22. See Dickensian *Post* covers for 1921, 1925, 1929, 1932, and 1938.

23. Charles Dickens, *The Pickwick Papers*, pp. 414–417.

24. Charles Dickens, *The Christmas Books* (New York: Penguin, 1971), 1:93.

25. An exception is Rockwell's "To Father Christmas," an inside-the-book illustration of a passage from *Pickwick* published in *Ladies' Home Journal*, December 1931, p. 3. See also a second *Pickwick* scene, a rare inside illustration in *The Saturday Evening Post*, December 28, 1935, pp. 18–19.

26. Dickens, *The Christmas Books*, 1:38, 77.

27. For these illustrations, see Dan Malan, *Charles Dickens' "A Christmas Carol"* (St. Louis: MCE Publishing, 1996), pp. 70, 74, 80.

28. Hallmark Cards, Kansas City, Missouri, kindly allowed me access to their corporate archives in May 1998.

29. The remaining Rockwell Christmas cover with a Dickensian theme is *Christmas Trio* of 1923, showing three ragged street musicians (two appear in other Rockwell scenes) with a view of London behind them (page 156). There are also three generic costume pieces, for 1930, 1931, and 1936: a medieval guardsman; bewigged fiddlers; and a cavalier kissing a maid under the mistletoe.

30. Haddon Sundblom, *Dream of Santa: Haddon Sundblom's Vision* (Washington, D.C.: Staples and Charles, 1992), p. 16.

31. Donald Stoltz and Marshall L. Stoltz, *Norman Rockwell and the "Saturday Evening Post,"* 3 vols. (New York: MJF Books, 1994), 3:67.

32. Perhaps because he did his Christmas covers out of season, Rockwell often depicted gifts wrapped in white paper, adorned

with a sprig of holly. After 1917 or so, this was distinctly passé: printed wrapping paper had swept the market. Leyendecker's 1936 *Post* cover—a family of frantic shoppers in a department store—shows the printed and colored papers and ready-made decorated boxes more common at the time. Rockwell's use of white tissue may be another gesture in the direction of an old-fashioned Christmas.

Rebelling Against Rockwell

1. All quotations are from personal communications with the author.

Reintroducing Norman Rockwell

This is an enlarged version of an essay, "American Studies," first published in *Bookforum* (summer 1998): 3.

1. John Updike, "An Act of Seeing," *Art & Antiques*, December 1990, pp. 93–98. See Karal Ann Marling, *Norman Rockwell* (New York: Harry N. Abrams, Inc., in association with the National Museum of American Art, Smithsonian Institution, 1997), p. 8.

2. Richard Reeves, "Norman Rockwell is Exactly Like a Norman Rockwell," *The New York Times Magazine*, February 28, 1971, p. 42.

Checklist of the Exhibition

Norman Rockwell rarely assigned titles to his paintings. Over time, many of the images have acquired titles from a variety of sources. The titles listed here and the catalogue numbers in each entry are from *Norman Rockwell: A Definitive Catalogue*, by Laurie Norton Moffatt. The checklist is in chronological order, and dates reflect a work's first publication.

Scouting with Daniel Boone, 1914
Boys' Life, July 1914
Story Illustration, "Daniel Boone, Pioneer Scout."
Oil on canvas, 20 × 12½ inches, S176
Collection of The Norman Rockwell Museum at Stockbridge
Page 35

Scouting with Daniel Boone, 1914
Boys' Life, September 1914
Story Illustration, "The road led through the passes of the hills."
Oil on canvas, 17⅛ × 28 inches, S182
Collection of The Norman Rockwell Museum at Stockbridge, Gift of the Estate of Samuel and Lillian Whinston
Page 36

Boy with Baby Carriage, 1916
The Saturday Evening Post, May 20, 1916
Cover
Oil on canvas, 20¾ × 18⅝ inches, C190
Collection of The Norman Rockwell Museum at Stockbridge, Norman Rockwell Art Collection Trust
Page 38

Cousin Reginald Spells Peloponnesus (Spelling Bee), 1918
Country Gentleman, February 9, 1918
Cover
Oil on canvas, 30 × 30 inches, C46
Collection of The Norman Rockwell Museum at Stockbridge
Page 56

The U.S. Army Teaches Trades (Telegrapher), 1919
U.S. Army, 1919
Poster
Oil on canvas, 19½ × 29½ inches, A812
Collection of The Norman Rockwell Museum at Stockbridge
Page 41

Cobbler Studying Doll's Shoe, 1921
Literary Digest, April 30, 1921
Cover
Oil on canvas, 33 × 28½ inches, C147
Collection of The Red Lion Inn, Stockbridge, Massachusetts
Page 170

No Swimming, 1921
The Saturday Evening Post, June 4, 1921
Cover
Oil on canvas, 25¼ × 22¼ inches, C228
Collection of The Norman Rockwell Museum at Stockbridge, Norman Rockwell Art Collection Trust
Pages 13, 128

Thanksgiving—Ye Glutton, 1923
Life, November 22, 1923
Cover
Oil on canvas, 31 × 22 inches, C121
Collection of The Norman Rockwell Museum at Stockbridge
Page 50

Christmas Trio, 1923
The Saturday Evening Post, December 8, 1923
Cover
Oil on board, 28¼ × 21½ inches, C251
Collection of The Norman Rockwell Museum at Stockbridge, Norman Rockwell Art Collection Trust
Page 156

The Law Student (Young Lawyer), 1927
The Saturday Evening Post, February 19, 1927
Cover
Oil on canvas, 36 × 27½ inches, C283
Collection of The Norman Rockwell Museum at Stockbridge
Page 146

The Stay at Homes (Outward Bound), 1927
Ladies' Home Journal, October 1927
Story Illustration
Oil on canvas, 39¼ × 32½ inches, S368
Collection of The Norman Rockwell Museum at Stockbridge, Norman Rockwell Art Collection Trust
Page 186

Good Friends, 1927
Boy Scouts of America Calendar, 1927
Calendar
Oil on canvas, 27 × 25 inches, A48
Courtesy of the Don McNeill Family
Page 22

Checkers, 1928
Ladies' Home Journal, July 1928
Story Illustration
Oil on canvas, 35 × 39 inches, S371
Collection of The Norman Rockwell Museum at Stockbridge
Page 173

Doctor and Doll, 1929
The Saturday Evening Post, March 9, 1929
Cover
Oil on canvas, 32 × 26¼ inches, C303
Private Collection
Page 137

Welcome to Elmville, 1929
The Saturday Evening Post, April 20, 1929
Cover
Oil on canvas, 33 × 27 inches, C304
Collection of The Norman Rockwell Museum at Stockbridge
Page 21

Fruit of the Vine, ca. 1930
Sun-Maid Raisins
Advertisement
Oil on canvas, 31 × 27 inches, A780
Sun-Maid Growers of California, Inc.
Page 43

Girl Running with Wet Canvas (Wet Paint), 1930
The Saturday Evening Post, April 12, 1930
Cover
Oil on canvas, 35¼ × 28½ inches, C314
Courtesy of Emmet, Toni, and Tessa Stephenson
Page 79

Gary Cooper as the Texan, 1930
The Saturday Evening Post, May 24, 1930
Cover
Oil on canvas, 35 × 26 inches, C315
Private Collection
Page 18

Family Home from Vacation, 1930
The Saturday Evening Post, September 13, 1930
Cover
Oil on canvas stretched over masonite,
40 × 32 inches, C318
Courtesy of Mr. Phillip Grace
Page 180

Forgotten Facts about Washington, 1932
Ladies' Home Journal, February 1932
Story Illustration, "When Washington failed—
Because I did not wait until ye ladye was in ye
proper mood."
Oil on canvas, 24¼ × 21 inches, S377
Courtesy of Mr. Baxter Jones
Page 172

Love Ouanga, 1936
American Magazine, June 1936
Story Illustration, "Spice slumped on a bench.
The Blood of the Lamb congregation gaped and
wondered. A city gal sho' nuff—what did she
want with them?"
Oil on canvas, 30 × 62 inches, S49
Courtesy of the American Illustrators Gallery,
New York City; Collection of the National
Museum of American Illustration, Newport,
Rhode Island
Page 26

Tom Sawyer (Whitewashing the Fence), 1936
Heritage Press
Book Illustration, "Well, I don't see why I
oughtn't to like it. Does a boy get a chance
to whitewash a fence everyday?"
Oil on canvas, 17½ × 13¾ inches, B206
Farnsworth Art Museum, Rockland, Maine.
Bequest of Mr. Clifford Smith, 1985
Page 72

Road Line Painter's Problem, 1937
The Saturday Evening Post, October 2, 1937
Cover
Oil on canvas, 31 × 25 inches, C365
Private Collection
Page 15

Ichabod Crane, 1937
Unpublished
Oil on canvas, 49½ × 24½ inches, M43
Collection of The Norman Rockwell Museum at
Stockbridge, Norman Rockwell Art Collection
Trust
Page 51

The Most Beloved American Writer, 1938
Woman's Home Companion, February 1938
Story Illustration, "Jo concocted a thrilling tale,
dressed herself in her best and boldly carried it
to the editor of the Weekly Volcano."
Oil on canvas, 24 × 19 inches, S708
Courtesy of Illustration House, Inc., New
York City
Page 39

Artist Facing Blank Canvas (Deadline), 1938
The Saturday Evening Post, October 8, 1938
Cover
Oil on canvas, 38½ × 30½ inches, C370
Collection of The Norman Rockwell Museum at
Stockbridge, Norman Rockwell Art Collection
Trust
Page 68

Football Hero, 1938
The Saturday Evening Post, November 19, 1938
Cover
Oil on canvas, 30 × 24 inches, C371
Collection of The Norman Rockwell Museum at
Stockbridge, Gift of Connie Adams Maple
Page 48

A Scout Is Helpful, 1941
Boy Scouts of America
Calendar, 1941
Oil on canvas, 34 × 24 inches, A61
Collection of The Norman Rockwell Museum
at Stockbridge
Page 37

Strictly a Sharpshooter, 1941
American Magazine, June 1941
Story Illustration, "The crowd expected to see a
hard-hitting youngster spar with a punch-drunk
bum. Instead they saw the battle of the ages—a
blue-eyed blonde as the stake."
Oil on canvas, 30 × 71 inches, S75
Collection of The Norman Rockwell Museum
at Stockbridge
Not illustrated

Aunt Ella Takes a Trip, 1942
Ladies' Home Journal, April 1942
Story Illustration, "Aunt Ella was beautiful in
my eyes. Not too tall, and a lovely plump front.
'Lots of things you're too young to know,' she
had said. "You never know a man till you live
with him. And stinginess is an awful sin!'"
Oil on canvas, 23 × 60 inches, S394
Collection of The Norman Rockwell Museum
at Stockbridge
Pages 24–25

Let's Give Him Enough and On Time, 1942
U.S. Army, 1942
Poster
Oil on canvas, 42 × 50 inches, A813
U.S. Army Center of Military History
Page 41

Freedom of Speech, 1943
The Saturday Evening Post, February 20, 1943
Story Illustration
Oil on canvas, 45¾ × 35½ inches, S565
Collection of The Norman Rockwell Museum at
Stockbridge, Norman Rockwell Art Collection
Trust
Page 101

Freedom to Worship, 1943
The Saturday Evening Post, February 27, 1943
Story Illustration
Oil on canvas, 46 × 35½ inches, S566
Collection of The Norman Rockwell Museum at
Stockbridge, Norman Rockwell Art Collection
Trust
Page 97

Freedom from Want, 1943
The Saturday Evening Post, March 6, 1943
Story Illustration
Oil on canvas, 45¾ × 35½ inches, S567
Collection of The Norman Rockwell Museum at
Stockbridge, Norman Rockwell Art Collection
Trust
Page 98

Freedom from Fear, 1943
The Saturday Evening Post, March 13, 1943
Story Illustration
Oil on canvas, 45¾ × 35½ inches, S568
Collection of The Norman Rockwell Museum at
Stockbridge, Norman Rockwell Art Collection
Trust
Page 99

Rosie the Riveter, 1943
The Saturday Evening Post, May 29, 1943
Cover
Oil on canvas, 52 × 40 inches, C403
Private Collection
Page 30

My Studio Burns, 1943
The Saturday Evening Post, July 17, 1943
Story Illustration
Charcoal on paper, 21¼ × 17 inches, S581
Private Collection
Page 42

Mine America's Coal (Portrait of a Coal Miner),
1943
U.S. Office of War Information
Poster
Oil on canvas, 21 × 14 inches, A821
Collection of The Norman Rockwell Museum
at Stockbridge
Page 52

Tattoo Artist, 1944
The Saturday Evening Post, March 4, 1944
Cover
Oil on canvas, 43⅛ × 33⅛ inches, C408
The Brooklyn Museum of Art, Gift of the
Artist, 69.8
Page 6

Thanksgiving: Mother and Son Peeling Potatoes,
1945
The Saturday Evening Post, November 24, 1945
Cover
Oil on canvas, 35 × 33½ inches, C423
Private Collection
Page 64

War News, 1945
Unpublished
Oil on canvas, 41¼ × 40½ inches, M51
Collection of The Norman Rockwell Museum
at Stockbridge
Page 141

Charwomen in Theater, 1946
The Saturday Evening Post, April 6, 1946
Cover
Oil on canvas, 42½ × 33 inches, C427
Private Collection
Page 10

Boy in a Dining Car, 1946
The Saturday Evening Post, December 7, 1946
Cover
Oil on canvas, 38 × 36 inches, C432
Collection of The Norman Rockwell Museum
at Stockbridge
Page 73

*Norman Rockwell Illustrator (NR from
the Cradle to the Grave)*, 1946
Watson-Guptill Publications, 1946
Book Illustration
Wolfe pencil on posterboard, 6¾ × 32 inches,
B359
Collection of Mr. T. Marshall Hahn, Jr.
Page 69

Going and Coming, 1947
The Saturday Evening Post, August 30, 1947
Cover
Oil on canvas, each 16 × 31½ inches, C437
Collection of The Norman Rockwell Museum at
Stockbridge, Norman Rockwell Art Collection
Trust
Page 34

*Babysitter with Screaming Infant
(The Babysitter)*, 1947
The Saturday Evening Post, November 8, 1947
Cover
Oil on canvas, 28 × 26 inches, C438
Courtesy of the Burlington Public School
District, Vermont
Page 181

The Gossips, 1948
The Saturday Evening Post, March 6, 1948
Cover
Oil on canvas, 33 × 31 inches, C441
Ken and Katharine Stuart Collection
Page 171

Christmas Homecoming, 1948
The Saturday Evening Post, December 25, 1948
Cover
Oil on canvas, 35½ × 33½ inches, C446
Collection of The Norman Rockwell Museum
at Stockbridge
Page 2

Game Called Because of Rain (Tough Call), 1949
The Saturday Evening Post, April 23, 1949
Cover
Oil on canvas, 43 × 41 inches, C448
National Baseball Hall of Fame and Museum,
Inc., Cooperstown, New York
Page 16

New Television Antenna, 1949
The Saturday Evening Post, November 5, 1949
Cover
Oil on canvas, 46⅛ × 43⅜ inches, C451
Los Angeles County Museum of Art, Gift of
Mrs. Ned Crowell
Page 148

Shuffleton's Barbershop, 1950
The Saturday Evening Post, April 29, 1950
Cover
Oil on canvas, 46¼ × 43 inches, C452
Collection of The Berkshire Museum, Pittsfield,
Massachusetts
Page 5

Saying Grace, 1951
The Saturday Evening Post, November 24, 1951
Cover
Oil on canvas, 42 × 40 inches, C458
Ken and Katharine Stuart Collection
Page 54

Day in the Life of a Little Girl, 1952
The Saturday Evening Post, August 30, 1952
Cover
Oil on canvas, 45 × 42 inches, C462
Collection of The Norman Rockwell Museum
at Stockbridge
Page 126

The Day I Painted Ike, 1952
The Saturday Evening Post, October 11, 1952
Story Illustration, "The campaign? Instantly, he
was deeply serious. No punch-pulling for him.
He'd rather lose the election than not tell the
people just what he thinks."
Oil on canvas, 11 × 8 inches, S683
Collection of The Norman Rockwell Museum
at Stockbridge
Page 122

Walking to Church, 1953
The Saturday Evening Post, April 4, 1953
Cover
Oil on canvas, 18¾ × 17¾ inches, C465
Ken and Katharine Stuart Collection
Page 140

Girl with Black Eye, 1953
The Saturday Evening Post, May 23, 1953
Cover
Oil on canvas, 34 × 30 inches, C466
Wadsworth Atheneum, Hartford, Connecticut,
Gift of Kenneth Stuart
Page 127

Girl at Mirror, 1954
The Saturday Evening Post, March 6, 1954
Cover
Oil on canvas, 31½ × 29½ inches, C470
Collection of The Norman Rockwell Museum at
Stockbridge, Norman Rockwell Art Collection
Trust
Page 153

Art Critic, 1955
The Saturday Evening Post, April 16, 1955
Cover
Oil on canvas, 39½ × 36¼ inches, C474
Collection of The Norman Rockwell Museum
at Stockbridge
Page 61

Art Critic (study), 1955
Charcoal on board, 38 × 36 inches, C474b
Collection of The Norman Rockwell Museum at
Stockbridge, Norman Rockwell Art Collection
Trust
Page 59

Art Critic (study), 1955
Pencil and charcoal on paper, 11 × 7½ inches,
C474c
Collection of The Norman Rockwell Museum at
Stockbridge, Norman Rockwell Art Collection
Trust
Page 58

Art Critic (study), 1955
Charcoal and pen on board, 11⅜ × 8 inches,
C474d
Collection of The Norman Rockwell Museum at
Stockbridge, Norman Rockwell Art Collection
Trust
Page 59

Art Critic (study), 1955
Oil on acetate board, three studies, each 10½ ×
5½ inches, C474f
Collection of The Norman Rockwell Museum at
Stockbridge, Norman Rockwell Art Collection
Trust
Pages 58–59

Art Critic (study), 1955
Charcoal on paper, 11½ × 8¼ inches, C474h
Collection of The Norman Rockwell Museum at
Stockbridge
Page 59

Art Critic (study), 1955
Pencil on paper, 4¾ × 3¾ inches, C474k
Collection of The Norman Rockwell Museum at
Stockbridge, Norman Rockwell Art Collection
Trust
Page 58

The Marriage License, 1955
The Saturday Evening Post, June 11, 1955
Cover
Oil on canvas, 45½ × 42½ inches, C475
Collection of The Norman Rockwell Museum at
Stockbridge, Norman Rockwell Art Collection
Trust
Page 49

The Discovery, 1956
The Saturday Evening Post, December 29, 1956
Cover
Oil on canvas, 35¼ × 32½ inches, C481
Collection of The Norman Rockwell Museum at
Stockbridge, Norman Rockwell Art Collection
Trust
Page 161

After the Prom, 1957
The Saturday Evening Post, May 25, 1957
Cover
Oil on canvas, 31⅛ × 29⅛ inches, C483
Private Collection
Page 117

The Runaway, 1958
The Saturday Evening Post, September 20, 1958
Cover
Oil on canvas, 35¾ × 33½ inches, C490
Collection of The Norman Rockwell Museum at
Stockbridge, Norman Rockwell Art Collection
Trust
Page 129

Family Tree, 1959
The Saturday Evening Post, October 24, 1959
Cover
Oil on canvas, 46 × 42 inches, C495
Collection of The Norman Rockwell Museum at
Stockbridge, Norman Rockwell Art Collection
Trust
Page 62

Triple Self-Portrait, 1960
The Saturday Evening Post, February 13, 1960
Cover
Oil on canvas, 44½ × 34¾ inches, C496
Collection of The Norman Rockwell Museum at
Stockbridge, Norman Rockwell Art Collection
Trust
Page 77

Portrait of John F. Kennedy, 1960
The Saturday Evening Post, October 29, 1960,
and December 14, 1963
Cover
Oil on canvas, 16 × 12 inches, C500
Collection of The Norman Rockwell Museum
at Stockbridge
Page 31

Golden Rule, 1961
The Saturday Evening Post, April 1, 1961
Cover
Oil on canvas, 44½ × 39½ inches, C502
Collection of The Norman Rockwell Museum at
Stockbridge, Norman Rockwell Art Collection
Trust
Page 103

Lincoln for the Defense (Abe Lincoln), 1962
The Saturday Evening Post, February 10, 1962
Story Illustration
Oil on canvas, 49¾ × 17½ inches, S689
Collection of The Norman Rockwell Museum at
Stockbridge, Norman Rockwell Art Collection
Trust
Page 51

The Problem We All Live With (study), 1963
Oil on board, 13 × 20½ inches, S400a
Collection of The Norman Rockwell Museum at
Stockbridge, Norman Rockwell Art Collection
Trust
Page 108

The Problem We All Live With (study), 1963
Archival photograph—original art whereabouts
unknown
Collection of The Norman Rockwell Museum
at Stockbridge
Page 109

The Problem We All Live With (study), 1963
Archival photograph—original art whereabouts
unknown
Collection of The Norman Rockwell Museum
at Stockbridge
Page 110

The Problem We All Live With (study), 1963
Archival photograph—original art whereabouts
unknown
Collection of The Norman Rockwell Museum
at Stockbridge
Page 111

The Problem We All Live With, 1964
Look, January 14, 1964
Story Illustration
Oil on canvas, 36 × 58 inches, S400
Collection of The Norman Rockwell Museum
at Stockbridge
Pages 106–107

Portrait of Linda Gunn, ca. 1964
Unpublished
Oil on board, 11 × 10½ inches, P54
Collection of The Norman Rockwell Museum at
Stockbridge, Norman Rockwell Art Collection
Trust
Page 113

Southern Justice (Murder in Mississippi), 1965
Unpublished
Oil on canvas, 53 × 42 inches, S409
Collection of The Norman Rockwell Museum
at Stockbridge
Page 45

Southern Justice (Murder in Mississippi) (study),
1965
Look, June 29, 1965
Story Illustration
Oil on board, 15 × 12¾ inches, S409a
Collection of The Norman Rockwell Museum at
Stockbridge, Norman Rockwell Art Collection
Trust
Page 44

The Peace Corps (J.F.K.'s Bold Legacy), 1966
Look, June 14, 1966
Story Illustration
Oil on canvas, 45½ × 36½ inches, S412
Collection of The Norman Rockwell Museum at
Stockbridge, Norman Rockwell Art Collection
Trust
Page 65

New Kids in the Neighborhood, 1967
Look, May 16, 1967
Story Illustration
Oil on canvas, 36½ × 57½ inches, S420
Collection of The Norman Rockwell Museum at
Stockbridge, Norman Rockwell Art Collection
Trust
Pages 46–47

*The Final Impossibility: Man's Tracks on the Moon
(Two Men on the Moon)*, 1969
Look, December 30, 1969
Story Illustration
Oil on canvas, 36 × 55 inches, S431
The National Air and Space Museum,
Smithsonian Institution, Washington, D.C.
Page 53

322 Covers for *The Saturday Evening Post*
Each 14 × 11 inches

Other Illustrated Works

Norman Rockwell

Man Playing Santa, 1916
The Saturday Evening Post, December 9, 1916
Cover
Magazine tearsheet, C195
Collection of The Norman Rockwell Museum
at Stockbridge
Page 158

Santa and Expense Book, 1920
The Saturday Evening Post, December 4, 1920
Cover
Magazine tearsheet, C225
Collection of The Norman Rockwell Museum
at Stockbridge
Page 159

Christmas: Santa Holding Little Boy, 1927
The Saturday Evening Post, December 3, 1927
Cover
Magazine tearsheet, C291
Collection of The Norman Rockwell Museum
at Stockbridge
Page 159

Merrie Christmas: Couple Dancing Under Mistletoe,
1928
The Saturday Evening Post, December 8, 1928
Cover
Magazine tearsheet, C300
Collection of The Norman Rockwell Museum
at Stockbridge
Page 162

Tiny Tim and Bob Cratchit, 1934
The Saturday Evening Post, December 15, 1934
Cover
Oil on canvas, 55 × 31 inches, C344
Private Collection
Page 165

Christmas: Gramps in Snow, 1937
The Saturday Evening Post, December 25, 1937
Cover
Magazine tearsheet, C366
Collection of The Norman Rockwell Museum
at Stockbridge
Page 167

Santa on Train, 1940
The Saturday Evening Post, December 28, 1940
Cover
Magazine tearsheet, C387
Collection of The Norman Rockwell Museum
at Stockbridge
Page 160

News Kiosk in the Snow, 1941
The Saturday Evening Post, December 20, 1941
Cover
Magazine tearsheet, C393
Collection of The Norman Rockwell Museum
at Stockbridge
Page 134

Fireman, 1944
The Saturday Evening Post, May 27, 1944
Cover
Magazine tearsheet, C410
Collection of The Norman Rockwell Museum
at Stockbridge
Page 70

Union Station, 1944
The Saturday Evening Post, December 23, 1944
Cover
Oil on canvas, 32 × 25 inches, C415
Private Collection
Page 134

The Homecoming, 1945
The Saturday Evening Post, May 26, 1945
Cover
Oil on canvas, 28 × 22 inches, C418
Collection of Mrs. Edith K. Hibbs
Page 133

Framed, 1946
The Saturday Evening Post, March 2, 1946
Cover
Magazine tearsheet, C426
Collection of The Norman Rockwell Museum
at Stockbridge
Page 71

Tired Salesgirl on Christmas Eve, 1947
The Saturday Evening Post, December 27, 1947
Cover
Oil on canvas, 30¼ × 28 inches, C439
Private Collection
Page 166

April Fool: Girl with Shopkeeper, 1948
The Saturday Evening Post, April 3, 1948
Cover
Magazine tearsheet, C442
Collection of The Norman Rockwell Museum
at Stockbridge
Page 75

The Gossips (study), 1948
Pencil and charcoal on paper, 31 × 28¼ inches
The Norman Rockwell Museum at Stockbridge,
Norman Rockwell Art Collection Trust
Endsheets

Roadblock, 1949
The Saturday Evening Post, July 9, 1949
Cover
Oil on board, 30 × 23 inches, C449
Private Collection
Page 135

Breaking Home Ties, 1954
The Saturday Evening Post, September 25, 1954
Cover
Magazine tearsheet, C473
Collection of The Norman Rockwell Museum
at Stockbridge
Page 136

Two Old Men and Dog: No Swimming, 1956
Brown and Bigelow, 1956
Calendar
Oil, 14½ × 13½ inches, A146
Stolen from Elayne Galleries, Minneapolis,
Minnesota, in 1978
Page 128

University Club, 1960
The Saturday Evening Post, August 27, 1960
Cover
Magazine tearsheet, C498
Collection of The Norman Rockwell Museum
at Stockbridge
Page 138

The Connoisseur, 1962
The Saturday Evening Post, January 13, 1962
Cover
Oil on canvas mounted on board,
37¾ × 31½ inches, C505
Collection of Steven Spielberg
Page 86

The Connoisseur, 1962
The Saturday Evening Post, January 13, 1962
Cover
Magazine tearsheet, C505
Collection of The Norman Rockwell Museum
at Stockbridge
Page 85

Lunch Break with a Knight, 1962
The Saturday Evening Post, November 3, 1962
Cover
Magazine tearsheet, C506
Collection of The Norman Rockwell Museum
at Stockbridge
Page 123

Other Artists

Hans Namuth
Jackson Pollock Painting Autumn Rhythm, 1950
Photograph, 8 × 10 inches
Collection of the Pollock Krasner House and
Study Center, East Hampton, New York
Page 83

Jackson Pollock
Number 3 1949: Tiger, 1949
Oil, enamel, metallic enamel, string, and ciga-
rette fragment on canvas mounted on fiber-
board, 62⅛ × 37¼ inches
Hirshhorn Museum and Sculpture Garden,
Smithsonian Institution, Washington, D.C.,
Gift of Joseph H. Hirshhorn
Page 84

Unknown Artist
The Auction, 1770
Engraving, 6 × 3¾ inches
The British Museum, London
Page 88

Honoré Daumier
Le Connoisseur, 1860–65
Pen and ink, wash, watercolor, conté crayon,
and gouache over black chalk on wove paper,
17¼ × 14 inches
The Metropolitan Museum of Art, New York,
H. O. Havemeyer Collection, Bequest of
Mrs. H. O. Havemeyer, 1929
Page 89

George Segal
Portrait of Sidney Janis with Mondrian Painting,
1967
Plaster figure with Mondrian's *Composition*,
1933, on an easel
Figure 66 inches high; easel 67 inches high,
overall 69⅞ × 56¼ × 27¼ inches
The Museum of Modern Art, New York,
The Sidney and Harriet Janis Collection
Page 89

Barney Tobey
The New Yorker cartoon, December 31, 1955
Page 90

Peter Arno
The New Yorker cartoon, September 23, 1961
Page 91

Herbert Gehr
Highbrow, Lowbrow, Middlebrow
Life, April 11, 1949
Page 92

Jean-Honoré Fragonard
The Swing, 1767
Oil on canvas, 32⅜ × 25⅝ inches
The Wallace Collection, London
Page 118

Jacques-Louis David
Belasarius Receiving Alms, 1781
Oil on canvas, 115 × 125 inches
Musée des Beaux-Arts, Lille
Page 119

Jean-Baptiste Siméon Chardin
House of Cards, 1736–37
Oil on canvas, 24⅛ × 28¾ inches
National Gallery, London
Page 120

Nicolas Poussin
Venus and Adonis, 1628–29
Oil on canvas, 38¾ × 53 inches
Kimbell Art Museum, Fort Worth, Texas
Page 121

John Frederick Peto
Old Time Card Rack, 1900
Oil on canvas, 30 × 25¼ inches
The Phillips Collection, Washington, D.C.
Page 147

Du Mont television advertisement
The Saturday Evening Post, November 5, 1949
Page 150

J. C. Leyendecker
Boy and Santa, 1923
The Saturday Evening Post, December 22, 1923
Cover
Oil on canvas, 28¼ × 21 inches
Illustration House
Page 157

John Leech
Fezziwig's Ball, 1844
A Christmas Carol, 1844
3⅞ × 3½ inches
The Pierpont Morgan Library, New York
Page 163

Frederick Barnard
Tiny Tim, 1885
Character Sketches from Dickens, 1885
Steel engraving
Dickens House Museum, London
Page 164

Dick Sargent
Baby's First Shot, 1962
The Saturday Evening Post, March 3, 1962
Cover
Page 174

John Falter
Broken Antique Chair, 1959
The Saturday Evening Post, June 20, 1959
Cover
Page 175

Amos Sewell
Blown Fuse, 1956
The Saturday Evening Post, January 28, 1956
Cover
Page 175

Robert Weaver
Untitled, 1979
Print magazine, 1979
19½ × 15 inches
Estate of Robert Weaver
Page 176

Robert Weaver
*When You Risk Becoming an Artist, You Risk
Taking Your Talent Seriously*, 1983
School of Visual Arts
Acrylic on poster board, 41 × 27 inches
Collection of Silas H. Rhodes
Page 176

Alan E. Cober
Why People in Dallas Are Arming Themselves, 1982
Dallas Times-Herald, 1982
Ink and watercolor, 12 × 16 inches
Collection of Ellen Cober
Page 177

Brad Holland
The Inspector, 1985
Science 85, 1985
Acrylic on masonite, 9 × 12 inches
Page 178

Marshall Arisman
I'm in Hell, 1988
Texas Monthly Magazine, 1988
Oil on canvas, 23 × 21 inches
Page 179

Notes on Contributors

Dr. Robert Coles is a research psychiatrist for Harvard University Health Services and Professor of Psychiatry and Medical Humanities at the Harvard Medical School. He is also James Agee Professor of Social Ethics at Harvard University.

Wanda M. Corn is Professor of Art History at Stanford University.

Neil Harris is Preston and Sterling Morton Professor in the Department of History at the University of Chicago.

Steven Heller is the Art Director of *The New York Times Book Review* and Chair of the MFA/Design Department of the School of Visual Arts.

Maureen Hart Hennessey is Chief Curator at The Norman Rockwell Museum at Stockbridge and Co-curator of the exhibition *Norman Rockwell: Pictures for the American People.*

Dave Hickey is a freelance writer of fiction and cultural criticism, and serves as Professor of Art Criticism and Theory at the University of Nevada, Las Vegas.

Thomas Hoving was Director of The Metropolitan Museum of Art from 1967 to 1977, Editor-in-Chief of *Connoisseur* magazine from 1981 to 1991, and is the author of twelve books.

Anne Knutson is Guest Curator at the High Museum of Art and Co-curator of the exhibition *Norman Rockwell: Pictures for the American People.*

Judy L. Larson is Executive Director of The Art Museum of Western Virginia and Co-curator of the exhibition *Norman Rockwell: Pictures for the American People.*

Karal Ann Marling is Professor of Art History and American Studies at the University of Minnesota and the author of *Norman Rockwell* (New York: Harry N. Abrams, Inc., in association with the National Museum of American Art, Smithsonian Institution, 1997) and other books.

Laurie Norton Moffatt is Director of The Norman Rockwell Museum at Stockbridge and the author of *Norman Rockwell: A Definitive Catalogue* (Stockbridge, Mass.: The Norman Rockwell Museum at Stockbridge, 1986).

Ned Rifkin is Nancy and Holcombe T. Green, Jr. Director of the High Museum of Art.

Peter Rockwell is a sculptor and the son of Norman Rockwell.

Robert Rosenblum is Professor of Fine Arts, New York University, and Curator of Twentieth-Century Art, Solomon R. Guggenheim Museum, New York.

Photo Credits